# The Emptiness of the Image

There has long been a politics concerning the way in which women are represented, with objection not so much to specific images as to a *regime* of looking which places the spectator in a particular relationship to the woman. Artists have sometimes avoided the representation of women altogether, but they are now producing images which challenge the regime. How do these images succeed in their challenge?

*The Emptiness of the Image* offers a psychoanalytic answer. Parveen Adams argues that, despite flaws in some of the details of its arguments, psycho-analytic theory retains an overwhelming explanatory strength in relation to questions of sexual difference and representation. She goes on to show how the issue of desire changes the way we can think of images and their effects. Throughout she discusses the work of theorists – Hélène Deutsch, Catherine MacKinnon – and the work of artists and film-makers – Mary Kelly, Francis Bacon, Orlan, Michael Powell and Della Grace.

*The Emptiness of the Image* shows how the very space of representation can change to provide a new way of thinking the relation between the text and the spectator. It shows how psychoanalytic theory is simple enough to slide into and transform the most unexpected situations.

**Parveen Adams** teaches psychoanalysis in the Department of Human Sciences at Brunel University. She was co-founder and co-editor of the predominantly psychoanalytic feminist journal *m/f* (1978–86) and a selection from it was published as *The Woman in Question*, now a land-mark text.

# The Emptiness of the Image

## Psychoanalysis and Sexual Differences

*Parveen Adams*

London and New York

First published 1996
by Routledge
11 New Fetter Lane, London EC4P 4EE

Simultaneously published in the USA and Canada
by Routledge
29 West 35th Street, New York, NY 10001

© 1996 Parveen Adams

Typeset in Perpetua by
J&L Composition Ltd, Filey, North Yorkshire
Printed and bound in Great Britain by
Biddles Ltd, Guildford and King's Lynn

*British Library Cataloguing in Publication Data*
A catalogue record for this book is available from the British Library

*Library of Congress Cataloguing in Publication Data*
A catalogue record for this book has been requested

ISBN 0–415–04621–1 (hbk)
ISBN 0–415–04622–X (pbk)

*For Mark Cousins*

# Contents

# Illustrations

ix

# Acknowledgements

I would like to thank the following editors, journals and publishing houses where my work first appeared: *Diacritics* and Johns Hopkins University Press for 'The Bald Truth'; *Differences* and Indiana University Press for 'Waiving the Phallus'; *The Journal of Philosophy and the Visual Arts* and Academy Editions for 'The Violence of Paint'; *October* and MIT Press for 'The Truth on Assault' and 'The Art of Analysis: Mary Kelly's *Interim* and the Discourse of the Analyst'; *Oxford Literary Review* for 'Symptoms and Hysteria'; Mieke Bal and Inge Boer and The University of Amsterdam Press for 'The Three (Dis)Graces'; Teresa Brennan and Routledge for 'Of Female Bondage'; Joan Copjec and Verso for 'Father, Can't You See I'm Filming?'; James Donald and Macmillan for 'Per (Os)cillation'.

# Thanks

All my thanks are for Mark Cousins

# Introduction

This book is an argument for psychoanalysis and for its importance in the field of representation. It remains concerned throughout with the question of the changing relations and representations of the woman and it seeks to analyse these changes using psychoanalytic concepts.

There has been a great deal of work on psychoanalysis and sexual difference over the last twenty years. Where this work has been sympathetic, it has led either to a blanket defence of the central concepts of psychoanalytic theory, or to a somewhat partisan assertion that certain unpalatable concepts must go. The first five chapters of this book certainly raise questions about what actually constitutes sexual difference. Does it have to be governed by 'masculinity' and 'femininity'? Does it imply heterosexuality as the norm? Simultaneously, the central concepts – castration, the Oedipus complex, the phallus – are retained. Despite the questioning, it is shown that these concepts are necessary – by spelling out the dire consequences of the 'rectification' of castration in the theories of Hélène Deutsch; by showing the sadistic consequences of Catherine MacKinnon's collapse of representation onto the event (that is, the denial of the Oedipal taboo); by demonstrating that the concept of the phallus is precisely what allows us to distinguish certain contemporary sexual practices as *not* being perverse, that is to say that the concept enables us to identify different psychical structures, including entirely new ones.

So psychoanalysis is not a moribund set of propositions, but on the contrary, has great explanatory power. Far from decrying women, it shows what is at stake in their making: a case then for the flexibility and power of

psychoanalysis. In some sense, this claim is then 'tested' in the six chapters that follow. Can we analyse a film, a painting, a photograph, so as to grasp something of the psychical level of its effects? Does it matter that the question of representation is treated not as a simple referential relation, but as a complex psychical event? Does it matter that the question of vision is upstaged by the issue of desire, the spectator's and the artist's?

The issue of desire introduces a novel way of thinking about art and spectatorship, for it changes the space of representation. This space can no longer be thought of as only physical, architectural or institutional. We must introduce the idea of psychical space. Here Lacan's discursive spaces serve us well. His four discourses, that of the Master, the University, the Hysteric and the Analyst, are introduced and shown to be immensely productive in the analysis of Mary Kelly's work. Once the space of the gallery is transformed, there arises the question of transference, and dramatic consequences follow for the question of female spectatorship. For what goes on in a space is a complex affair and images organise the space and hence the way in which they are looked at.

This intrication of the social and the psychical works because not only the Symbolic and the Imaginary, but the Real are involved. The chapters on art work with Lacan's *objet petit a*, the object which is the left-over of the Real. It is a crucial term of analysis for the study of culture.

This complex and difficult idea unfolds as the analyses of different works proceeds. At the same time the Lacanian idea is altered and shaped to new ends, in particular through the development of Lacan's concept of anamorphosis. These chapters show how psychoanalysis can be used to pinpoint and understand changes in the *regime* of vision. Psychoanalysis shows how meaning can be emptied out; here, what is shown is the condition under which what is emptied out is the definition of woman. It is not the image of a woman as such that is crucial, but how the image organises the way in which the image is looked at.

Moments of emptying out occur in unexpected places. They are often moments which appear perverse or violent at the surface level. But what might appear to the spectator in this way may turn out to be moments of a powerful emptying out of meaning, including perverse and violent meanings. This is shown in the chapters on Michael Powell's *Peeping Tom*, Francis

2

Bacon, *The Three Graces* by Della Grace, and Orlan's cosmetic surgery on video.

So this book puts forward a completely novel approach to the issue of what happens between the spectator and the art object, an approach which is modelled on the relation of analyst and analysand. This book shows that psychoanalytic theory is not resistant to change.

# 1

# Symptoms and hysteria

Some years ago, in preparing a course in a department of psychology, I decided that I would question some of the assumptions of the medical model as used within psychiatry by introducing Freud's concept of hysteria. In fact, I was able to use only one short paper dating from 1893, 'Some Points for a Comparative Study of Organic and Hysterical Motor Paralyses'. It is an excellent paper and one that served my purpose well. While ostensibly a tribute to Charcot, this paper actually undermines his notion of the 'functional lesion' as an explanation of hysteria. Freud's achievement here is that he establishes the hysterical symptom in the domain of the psyche. This symptom is the conversion symptom, taken as paradigmatic of hysterical disorder. But it became clear to me in reading Freud on hysteria that I didn't understand what hysteria was for Freud. The conversion paradigm did not seem to work. How was I to relate hysterical identification or the analysis of Dora to it? Furthermore, reading a more general literature raised the question 'does hysteria exist today?' This question is not unrelated to the relative rarity of the conversion symptom today. And one explanation of this fact appears to be that Freud's own discoveries caused the disappearance of hysteria. But then, by the same token, is Freud's work now out of date? And if I was to understand all this, what would I find concerning the relation of women to hysteria?

After thinking about these questions I have come to a provisional conclusion – that there are two concepts of hysteria in Freud to which correspond two concepts of the symptom. Of the two concepts of hysteria, one is developed and elaborated around conversion symptoms while the

other is present in fragmentary form in the use of the concepts of identification and bisexuality. What is at stake in making this distinction is the very identity of hysteria, a point to which I will return. So, the first theory of hysteria: Freud's work on conversion symptoms leads, of course, to the important discoveries of psychoanalysis, the unconscious, repression, resistance, transference. We will see that these in turn leave their mark on the hysterical symptom. Freud signals what he has learned about the mechanism of hysteria by using the term 'defence hysteria'. This term is mainly aimed against the view that an idea becomes pathogenic because it has been experienced in a special psychic state dissociated from the ego, a view held by both Janet and Breuer. For Freud, the unconscious idea is pathogenic because the ego expelled and repressed it. Freud starts from the existence of two incompatible ideas, one of which is then repressed and may lead to pathological reactions. The unconscious pathogenic idea is prevented from becoming conscious by a psychical force and this is the defence of the ego against the distressing thought which is usually sexual in nature. The idea is weakened by divorcing it from its affect and in hysteria this affect is transformed into something somatic – the conversion symptom is formed. Conversion is the characteristic factor in hysteria. This is, of course, a familiar account.

Let us look a little more closely at the formation of the hysterical symptom, for hysteria is explained by a mechanism that explains its *symptoms*. The hysteric and the obsessional neurotic both have an unconscious, repression, defence and resistance. But Freud needs to distinguish the two and he suggests that the mechanism of repression works differently in the two cases. There is, of course, a general schema for the neuroses laid out by Freud. An instinctual representative is subjected to a first repression which leads to the formation of a substitute which is the primary symptom; there follows a stage of successful defence, but finally there is the return of the repressed and the formation of new symptoms which are the illness proper. Now in hysteria many substitutes are formed, all of which are part of the repressed instinctual representation itself. But in this case, contrary to the schema, these substitutes *are* the symptoms.

It is quite different in obsessional neurosis, where the substitutive formation produces an alteration in the ego in the form of increased conscientiousness which in itself is not a symptom marking the obsession.

6

Here repression has been brought about by reaction-formation. It is only after the failure of this initial repression that the affect returns as social and moral anxiety and self-reproach. And it is only at this point that the symptoms of the neurosis are formed.

Both in hysteria and in obsessional neurosis then, the symptom remains an essential part of the pathological conditions, *crucial* to their definition. But there is an asymmetry – hysterical symptoms are defined not so much by their relation to other pathological symptoms but by their proximity to the effects of the unconscious as such, as in the phenomena of dreams, slips of the tongue, etc. To see this we must note the close connection between hysteria and dreams which is laid out in *The Interpretation of Dreams* (*SE* IV, V).[1] Freud's summing up:

> In view of the complete identity between the characteristics of the dream work and those of the psychical activity which issues in psychoneurotic symptoms, we feel justified in carrying over to dreams the conclusions we have been led to by hysteria.
>
> (*SE* V: 597)

Freud explicitly compares the over-determination of the hysterical symptom and the over-determination of the dream. Yet this is hardly a comparison; it is a question, rather, of the same process.[2] The hysterical symptom and the dream element are alike; the symptom is the part which, by a process of condensation, draws the whole cathexis onto itself.

I have already pointed out that the hysterical symptom is not elaborated further. Given that it is so very much like the dream, it remains somewhat of a mystery as to what differentiates it, apart, of course, from the element of conversion. I stress the proximity of the hysterical symptom to the effects of the unconscious because I will argue later that whatever it is that is called a symptom in hysteria retains only the mark of unconscious processes and that it is by virtue of that alone that it is a symptom.[3] For the moment, however, conversion remains defining of hysteria.

In the first theory, then, hysteria equals an ungendered bodily symptom proximate in its mechanism to unconscious processes in general. There is no need to consider sexual difference. Freud has, of course, introduced sexuality, but he has done so in a way that does not bear on the question of why hysterics are women, which empirically, on the whole, they are. There are

7

some remarks to the effect that they might be *more* vulnerable to sexual thoughts and feelings but this would seem to be a contingent matter, suggesting no intrinsic relation between women and hysteria. Certainly Freud does not make the link which one would expect him to make through the concept of femininity.

Let us jump to 1926 when 'there is no doubt' according to Freud in *Inhibitions, Symptoms and Anxiety* 'that hysteria has a strong affinity with femininity, just as obsessional neurosis has with masculinity' (*SE* XX: 143). He says no more about the former. But Freud now has a clearer idea of the Oedipus complex and its function in the differentiation of masculinity and femininity. Hysteria, the affliction of women, could then reasonably be regarded in relation to the problem of femininity. However, it is important to note that this invocation of sexual difference marks a shift in Freud's conception of hysteria, a shift that has been prefigured in his work on identification and bisexuality. I want to say that this shift is made possible by jettisoning the conversion theory. Hysteria has to become something else.

This is where Freud's new view of the symptom comes in. The question of the formation of symptoms is now handled through mechanisms of identification and it is this mechanism of identification in relation to symptom formation that is crucial to my argument. Freud presented this relation in *Group Psychology and the Analysis of the Ego* (*SE* XVIII). There he distinguishes three kinds of symptom formation, all illustrated by reference to the girl. The first kind supposes a girl who develops the same painful cough as her mother and it may be that this has come about through an identification with the mother within the Oedipus complex. The girl had a hostile desire to take her mother's place; the symptom expresses object-love towards the father. The cough signals that she now is the mother, at least in so far as her sufferings are concerned. Notice that while this still remains a bodily symptom, it is not ordered by the structure of the conversion mechanism. We are concerned here with a single trait, certainly, but it does not signify the expression of a portion of the material of the instinctual representation; that is, it is not a symptom produced through the condensation which is such a characteristic feature of over-determination. The symptom now expresses hostile and loving impulses towards others. Of course Freud had already interpreted symptoms as resulting from repressed desires – as in the case of Elisabeth von R. and her brother-in-law (*Studies on*

*Hysteria*, *SE* II: 155–8). What is different in the girl's cough is that she puts herself in the place of someone else within the structure of the Oedipal triangle.

These remarks also hold for Freud's second type of relation between identification and the symptom. He instances Dora's cough, a symptom deriving from her *father's* cough. Here there is identification with the object choice. Object choice has regressed to identification. This makes sense when you remember that identification is the earliest and original form of emotional tie.

'There is a third particularly frequent and important case of symptom formation', writes Freud, and here the identification leaves entirely out of account any object-relation to the person (*SE* XVIII: 106–7). There follows the famous example of the girls in the boarding school. One of them receives a letter from someone with whom she is secretly in love, the letter arouses her jealousy and she has a fit of hysterics. The other girls catch the fit. This identification is based on the desire of putting oneself in the same situation – they too would like a secret love affair. The desire shared in common is here the *basis* of the identification. The symptom marks the coincidence between two egos which has to be kept repressed.

There are two important points to note about this third particularly frequent and important case of symptom formation. First, it is a case of symptom formation that is not peculiar to hysteria. It is true Freud had already noted this type of identification in *The Interpretation of Dreams* in relation to the smoked salmon dream and had called it hysterical identification. But in *Group Psychology and the Analysis of the Ego* twenty-one years later, he reserves this term for the first type of identification. Second, the frequent and important case of symptom formation does not necessarily yield somatic effects. Undoubtedly the example given of such a symptom is the hysterical fit. But let us turn to the smoked salmon dream, the dream of a hysteric patient described in *The Interpretation of Dreams* (*SE* IV: 146–51). She wanted to give a supper-party but only had a little smoked salmon. It was a Sunday and the shops were shut. So she had to abandon her wish to give a supper-party. Without going into the details uncovered by the interpretation of the dream, we can say that what Freud makes clear is that the wish is the desire for an unfulfilled desire. On the way to this conclusion he identifies and explains a symptom of a quite different kind from the hysterical fit. The

symptom in this case is the production of an unfulfilled wish both in the dream and in reality – in the dream she cannot give her supper-party; in real life she would like a caviare sandwich every morning but has expressly asked her husband, the butcher, not to give it to her. This does not look anything like a conversion symptom to me.

But the symptom *is* a hysterical one which has come about through two identifications, one with a friend with an insatiable appetite for smoked salmon, and the other with her husband who she imagines might desire this friend, thus showing that he was not satisfied with her. What she has registered is the lack in the Other, to use Lacanian terms, and she has identified with that lack, thus sustaining her own desire. In 'The Direction of the Treatment and the Principles of its Power', Lacan writes:

> Far from imprisoning her, this impasse [wanting and not wanting a caviare sandwich] provides her with the key to the fields, the key to the field of the desires of all the witty hysterics, whether butchers' wives or not, in the world.
>
> (Lacan 1977c: 261)

Though the impasse has to be interpreted, of course.

My point is that these three forms of identification are general mechanisms that do not produce conversion symptoms. It is not that the symptoms are not hysterical symptoms or necessarily lack bodily character; it is rather that the bodily symptom as such does not characterise a pathological condition, hysteria. Nor is the symptom distinguished as a hysterical symptom by any special mechanism. The bodily symptom comes about from unconscious processes as all symptoms always did, but the bodily element no longer distinguishes the hysterical symptom from others. The hysterical symptom was very like the dream element from the start but had to be distinguished initially by the phenomenon of conversion since the symptoms of other neuroses also relied on all the psychical mechanisms that the study of hysteria had uncovered. We now have symptoms that may well be of the body, symptoms that spring from unconscious mechanisms, but they can only be called hysterical to the extent that any subject of the unconscious is hysterical by virtue of being a speaking subject. This does not allow us to distinguish a category of hysteria based on a specific kind of symptom. It is not possible to retain the conversion theory.

10

However, we *can* retain the new concept of hysteria which is incipient in Freud's work, a concept which in Lacan's hands makes of hysteria the problem of sexual difference for the woman. And there is no contradiction in saying that the third form of identification may properly be called hysterical as Freud had called it in the first place, when it is the mechanism utilised in the problem of the feminine condition, the hysteric's working out of the relations of desire between men and women.

I would like to touch on the problem of bisexuality at this point. Lacan has suggested that the hysteric's question is 'Am I a man or a woman?' This problem involves bisexuality and bisexual identifications. Freud had always emphasised that hysterics had fantasies arising from both hetero- and homo-sexual sexual impulses. In the Dora case, he registers her many identifications with men; a few years later he gives a striking example of a hysterical attack in which the patient simultaneously plays both parts in the underlying bisexual fantasy – she presses her dress up against her body with one hand (as the woman), while she tries to tear it off with the other (as the man). But while linking hysteria and bisexuality on the one hand and, much later, bisexuality and femininity on the other, Freud left the links between all *three* unexplored. Freud never explicitly recognises the problem of hysteria as the problem of femininity; for him hysteria retains a separate identity with 'a strong affinity to femininity'. This is to say that he fails to recognise the two concepts of symptom in his own work.

It is time for a set of concluding points. I have said that conversion symptoms have lost their theoretical dominance. Symptoms in the new sense of the term, symptoms produced through identification, no longer necessarily signify an illness, a pathological condition of a definite kind as is suggested by common usage. There are a whole variety of bodily symptoms that remain as symptoms only in Freud's new sense; these are not any more specific to hysteria than are slips of the tongue or dreams. It is not that there are no conversion symptoms today, though it is undoubtedly true that the paralysed arm is a much rarer phenomenon. But this is interesting – hysteria's special relation to the body has been displaced not only in theory, but in reality.[4] I am not sure that the virtual disappearance of conversion symptoms *can* be explained from within the framework of psychoanalysis. But what is certain is that *the relations between the woman, the body and hysteria have shifted.*

11

# 2

# Per os(cillation)

It is in the register of the symbolic that femininity comes to acquire its meaning as only its difference from masculinity; and it is not something with a content.

<div align="right">(<em>m/f</em> 1983: 14-15)</div>

This is Juliet Mitchell in an interview with the editors of *m/f*. While I think that the 'femininity' and 'masculinity' that Freud is concerned with, positions taken up through different relations to the phallus, are related to the Freudian symbolic, I will argue that another account of femininity also gets smuggled into Freud's texts. In this account something appears as content which is not derived from the terms of Freud's psychical system. I will show this by tracing some of the relations between identification, object choice and the taking up of a feminine position.

In *Fragment of an Analysis of a Case of Hysteria* (1905) Freud writes of the unconscious fantasy underlying Dora's cough, a fantasy he describes as one of fellatio.

> She pictured to herself a scene of sexual gratification *per os* between the two people whose love affair occupied her mind so incessantly.

<div align="right">(<em>SE</em> VII: 48)</div>

The two people whose love affair occupied her mind so incessantly are Dora's father and his lover Frau K. Through hysterical identification Dora takes up Frau K.'s sexual position in the fantasy; thereby, the *os* of the fantasy is Dora's mouth. Of course, if as Lacan suggests the fantasy is a fantasy of

<div align="center">12</div>

cunnilingus, the *os* of the fantasy is still Dora's mouth but this time via identification with the father. Dora's symptoms can be related to either fantasy intelligibly.

For Freud there is a certain logic of the relation between identification and object choice, for if Dora identifies with Frau K. (as Freud would have it), she is thereby deemed to have her father as love object. And he would prefer her not to identify with her father for such an identification would mean that Dora's choice of love object was a woman.

It seems that it is important to specify the underlying fantasy because it concerns Dora's sexual position; that is, she takes up a masculine position if she identifies with her father, a feminine one if she identifies with Frau K. But is this the case? Once Dora identifies with the one, does she not also identify with the other? For fantasy is laid out in scenarios and the subject can take up now one position, now another in the scenario. Freud had pointed out as early as 1905 in *Three Essays on the Theory of Sexuality* that a sadist is always also a masochist. And in 'Instincts and Their Vicissitudes' in 1915 the interchangeability of these positions is reiterated and extended to the positions of voyeur and exhibitionist. On the same grounds a further extension can be made, as we will see – Dora must suck and be sucked.

So Dora must take the active place *and* the passive place in the fantasy, the man's place *and* the woman's place. Given the fantasy of a scene of sexual gratification *per os*, it matters little whether we say that she is identifying with a male mouth or with a female mouth. For Dora's object choice cannot be specified through such an identification. Whether or not Dora oscillates *per* her *os*, she oscillates between a masculine and a feminine position. I will argue that it is not possible to determine sexual position through identification.

Freud's concept of hysterical identification rests on a triangular situation which bears the Oedipal marks of object choice of one sex and rivalry and identification with the other sex. I will show that Freud's logic of object choice and identification collapses by looking at the identifications involved in the hysteric's dream of an unfulfilled wish for a supper-party, the famous smoked salmon dream, the example with which the concept of hysterical identification is first introduced in 1900 in *The Interpretation of Dreams* (*SE* IV); and also at the identifications involved in the example of Dora's fantasy which I have already referred to. For where there is identification with the

woman there is also identification with the man. Hysterical identification is characterised, it turns out, by oscillation. Of course I know that Freud recognised the bisexual identifications of the hysteric. But it is one thing to say that the hysteric identifies with both men and women and quite another to say that where there is identification with one there is also identification with the other.

## Identification in dreams

Here is the full text of the hysteric's dream of the supper-party as reported by Freud:

> I wanted to give a supper-party, but I had nothing in the house but a little smoked salmon. I thought I would go out and buy something, but remembered then that it was Sunday afternoon and all the shops would be shut. Next I tried to ring up some caterers, but the telephone was out of order. So I had to abandon my wish to give a supper-party.
>
> (*SE* IV: 147)

The hysteric's associations to this dream refer to three people: herself, her husband the butcher, and a woman friend known to them both. The woman friend liked smoked salmon though she begrudged it to herself; the hysteric herself would like a caviare sandwich every morning but had expressly asked her husband *not* to give it to her. The friend had wanted to be invited for supper. The husband, for his part, had announced that *he* was going to lose weight and to this end would accept no more invitations to supper-parties. He himself liked ample women; nonetheless, he sang the praises of the woman friend who was thin.

Freud makes two successive but not contradictory analyses of the dream. Both rely on a triangular situation between the butcher, his wife the hysteric, and their mutual female friend. That is to say that Freud gives the hysteric's jealousy of her friend as the explanation or motivation of the dream. Freud's first interpretation of the dream is that the wife is unable to give any supper-parties because she wishes not to help her friend to grow any plumper since her husband admires plump women and is already singing her praises. Freud's second interpretation claims that the butcher's wife has *identified* herself with her friend, has put herself in her friend's place. This identity is

14

expressed through the creation of a symptom, a renounced wish, both in the dream where she has to abandon her wish to have a supper-party, and in real life where her friend grudges herself smoked salmon and where she herself, the butcher's wife who would love a caviare sandwich every morning, has expressly asked her husband not to give her one.

This is the moment of Freud's introduction of the concept of hysterical identification. Identification has resulted in a symptom and what the symptom signifies is 'sexual relations'. A hysterical woman identifies in her symptoms most readily with people with whom she has had sexual relations or with people who have had sexual relations with the same people as herself. Freud adds that for purposes of identification, mere thoughts of sexual relations would suffice. So the butcher's wife is simply following the rules of hysterical processes in expressing her jealousy of her friend through identification with her. Freud expresses the thought processes of the dream in detail: my patient put herself in her friend's place in the dream because her friend was taking my patient's place with her husband and because she (my patient) wanted to take her friend's place in her husband's high opinion. Here, in embryo, we have the Oedipal triangle and an emphasis on object choice.

Now, it is perfectly possible to construct another interpretation, standing alongside the first, the patient's identification with her friend, which is its equal in every respect. That interpretation concerns the hysteric's identification with her *husband*, the butcher. And it rests on the same triangular situation and the emphasis on object choice. So why has Freud failed to note the hysteric's identification with her husband, especially when the associations to the dream have been so replete with references to him? I will return to this question in a moment.

Freud's argument for the hysteric's identification with her friend is as follows: the dreamer's wish is that her friend's wish (for a supper-party) remain unfulfilled; instead, she dreams that one of her own wishes is unfulfilled; she has thereby put herself in her friend's place. I am saying that in a perfectly parallel fashion she has also put herself in her husband's place. The identification with the husband is given in the following argument: the dreamer's wish is that her husband's wish (for plump women) remain unfulfilled; instead she dreams that one of her own wishes is unfulfilled; she has thereby put herself in her husband's place.

15

What elements of analysis might uphold such an identification? In real life, the hysteric grudges herself a caviare sandwich every morning, her friend deprives herself of smoked salmon *and* the husband has announced *his* intention of depriving himself of supper-parties because he is too plump. However, the element crucial to my interpretation is that the hysteric has asked her husband *not* to give her a caviare sandwich every morning even though she'd like one. This connects the husband to an unfulfilled wish and this is a wish whose fulfilment would otherwise make her plump! So she goes so far as to stop herself being plump in order that her husband's wish for plump women not be fulfilled. If she stops herself from being plump *and* the friend's wish for supper-parties remains unfulfilled, then the husband's wish for plump women remains unfulfilled. It all fits together.

Nonetheless Freud does not appear to have noticed his patient's identification with the husband. We may suppose that is because, precisely, it all fits together. Which makes the identification with the husband redundant for Freud's purpose which was to explain the hysteric's dream in terms of sexual relations. The identification with the husband would add nothing to this. But for my purpose the hysteric's identification with both the man and the woman *is* important. For it shows that identification doesn't identify object choice. Perhaps it leaves open the question whether the point of identification is identification itself.

Now when Freud analyses his own dreams, he does not use the qualifier 'hysterical'. Indeed, in tracking down his own identifications, Freud makes no reference to object choice or sexual explanations. And neither will I. Instead of trying to explain his dream in terms of the analysis of the smoked salmon dream, I want to show how the smoked salmon dream works in some respects just like Freud's dream of the uncle with the yellow beard, which appeared a little later in *The Interpretation of Dreams*. Because the dream of the uncle demonstrates that identification is the whole point of the dream.[1]

Here is the dream of the uncle with the yellow beard, itself in two parts, first a thought, then a picture. The thought: 'my friend R. was my uncle – I had a great feeling of affection for him.' The picture: 'I saw before me his face, somewhat changed. It was as though it had been drawn out lengthwise. A yellow beard that surrounded it stood out especially clearly' (*SE* IV: 137).

Freud feels a resistance in interpreting the dream which he tries to say is

nonsense. He gradually realises through his associations that if his friend R. was his uncle Joseph he would be saying that R. was a simpleton. But the uncle was also a criminal; what comparison was he trying to make? The preamble to the dream tells us that in 1897 Freud had been recommended for appointment as Professor Extraordinarius. But he had reasons for not having great expectations of this. Then he had been visited one evening by a friend in the same position, this friend having pressed an official at the Ministry to clarify his chances and to ask whether it was not his being a Jew that was causing the delay. He was met by prevarications and excuses and of course this strengthened Freud's feeling of resignation. . . . Now, while trying to understand the dream, Freud remembered another conversation with another colleague, N., who had also been recommended for a profess-sorship but had explained that there had been an attempt to blackmail him and that the Ministry might use this against him. Freud, he said, had an unblemished character. Freud concludes that N. was the criminal he was seeking. There was reason for R. and N. not being appointed, but these were not denominational. The facts Freud constructed were that one was a simpleton, and the other a criminal. Freud's hopes could then remain untouched.

Freud insists that he did not really consider R. a simpleton, or N. a criminal, but the dream had indeed expressed his wish that it might be so. He then proceeds to analyse the feeling of affection in the dream as a cover, precisely, for the thoughts about his colleagues. Thus the feeling of affection serves the purpose of distortion in the dream. For the time being this is the end of the analysis of the dream which has been discussed in a chapter dealing with distortion in dreams. But fifty pages later Freud takes it up again, this time in a section on infantile material. 'To our surprise', Freud says, 'we find the child and the child's impulses still living on in the dream'. Freud now produces another interpretation of the dream just as he had done with the smoked salmon dream, which leads once again to the moment of identification in the dream.

Let us see how Freud arrives at the identification which sets this dream in motion. Freud again takes up his worry about the contradiction in his waking and dreaming thoughts about R. and N. He insists that he does not recognise in himself the pathological ambition described in his analysis of the dream. But ambition there was, and Freud traces it back to two occasions, one

dating from the time of his birth, the other from his childhood. The first occasion was the prophecy of an old peasant woman at the time of his birth that he would be a great man. On the second occasion he was told by a poet that he would probably grow up to be a Cabinet Minister. This had impressed him greatly. Freud now sees that in mishandling his colleagues R. and N. because they were Jews and in treating one as a simpleton and the other as a criminal, he was behaving like the Minister, he had put himself in the Minister's place. 'He had refused to appoint me *professor extraordinarius* and I had retaliated in the dream by stepping into his shoes' (*SE* IV: 193). These are Freud's own words. The Minister's shoes are the place of the grown-up, the powerful, the superordinate. I would like to call this stepping into The Bigger Shoes, for beside them there will always also be laid out The Smaller Shoes. After all, Freud's identification with his unfortunate colleagues suffuses the entire account of the dream; it is the backdrop against which the identification with the Minister is highlighted.

Certainly, the fulfilment of the dream appears to be the act of identification itself. Retrospectively, it has become clear to Freud that his view of his colleagues is only the means to a deeper wish, the wish to identify with the Minister. Freud's wish to think ill of his colleagues then becomes what I will call an *intermediate* wish and in a moment we will locate what might correspond to this wish in the smoked salmon dream.

*

So far, the way in which we have presented the dream has suggested that it fits with Freud's account of hysterical identification. Freud says that identification 'expresses a resemblance and is derived from a common element which remains in the unconscious' (*SE* IV: 150). This common element is often sexual in hysteria. Since the mere thought of sexual relations suffices, the friend qualifies as the figure to be identified with. The identification produces a symptom, in this case the renounced wish. This wish meets the condition that hysterical identification be marked by the similarity of symptoms, since the friend's symptom is also a renounced wish.

In this account, the hysteric's wish that her friend's wish be unfulfilled is an expression of her jealousy in relation to her friend and to her husband. But there is another possible explanation of the hysteric's wish. For this wish plays the same part in the analysis of the dream as the intermediate wish did

18

in Freud's own dream. That is to say that thinking ill of R. and N. was only a means of identifying with the Minister, and similarly, in the smoked salmon dream, the wish that the friend's wish be unfulfilled is merely a means to the identification. So surely the hysteric no more *really* wishes her friend to remain thin than Freud *really* wished to pass derogatory judgements on his colleagues.

Of course, the same can be said for the intermediate wish I constructed for the hysteric in relation to her husband – her wish that his wish for plump women remain unfulfilled. Surely she doesn't *really* wish that – for it applies directly to her husband and herself!

I include both the friend and the husband in the summary of my interpretation of the dream. If the butcher's wife denied herself caviare and a supper-party it was because she wished to identify herself with her friend and with her husband. Denying herself caviare marks the identification already present in real life. In order to maintain the identification which has been made on the basis of the renunciation of a wish, the hysteric has little choice but to wish that her friend's wish for supper-parties and her husband's wish for plump women be denied. It is clear that she cannot have her friend eating her favourite smoked salmon for that would lead to the collapse of her identification with her friend. And since the friend would be plump if she ate all the smoked salmon she wanted, then the hysteric's identification with the husband would also collapse. In other words, if the friend eats, the friend's wish is fulfilled and the identification collapses; if the hysteric eats she also gets plump and then her husband's wish would be satisfied and so that identification would collapse.

What follows if we accept such a reading in which identification is the aim and the relation of our hysteric to both friend and husband is secondary? Must we not reject Freud's model of hysterical identification in the dream? For that model takes the common element in hysteria to be sexual. The difficulty indeed revolves around how we understand the notion of common element because the common element does not appear to be some unconscious sexual element. In the hysteric's dream it is the renounced wish which is the basis of identification and in Freud's dream it is the derogatory judgement of R. and N. which is the common element. The common element appears to be something contingent which helps to set up the identification.

## Identification and object choice in 'Dora'

I would now like to turn to the case of Dora and ask if it serves to provide examples of hysterical identification in Freud's sense of the term. What is Dora's relation to the Oedipal triangle? I will try to give some kind of answer by considering how identification and object choice are to be separated in the account of the case, which shows precisely both bisexual object choice and identification.

Does identification with a man, a masculine identification, imply the choice of a woman as object? Does identification with a woman, a feminine identification, imply the choice of a man as love object? The answer in this case at first appears to be 'no'. Dora's identification with her father does not imply the choice of a female object. But perhaps this is a special case because the hysteric can regress to identification while maintaining the attachment to the object. That is to say that she can identify with the love object. With this exception, which in this case is tantamount to making an exception of Dora's identification with her father, it does seem that the identification with one sex implies that the object chosen is that of the opposite sex. And this holds regardless of whether the identification is with a man or a woman. But of course this bisexuality of identification so typical of the hysteric complicates the question of object choice for there are multiple object choices as there are multiple identifications. There is no basis for presupposing who is loved (that Herr K. is still young and attractive hardly constitutes an argument that Dora loves him), but neither can it be deduced from identification whom Dora loves (when Dora identifies with a male point of view it *doesn't* follow that she loves Frau K.).

My point is that the matter is even more complicated. For not only are there identifications with the man and with the woman, but an identification with one *implies* an identification with the other. Let's take as an example one of Freud's interpretations of Dora's cough, the one that takes the cough to mark an identification with Frau K. through a fantasy of fellatio. Here is Freud's argument: Dora had insisted that Frau K. only loved her father because he was a 'man of means'. Freud can demonstrate that this phrase indicates its opposite, 'a man without means', a man who is impotent. Dora indeed confirms this but she knows that there is more than one way of obtaining sexual gratification, that parts of the body other than the genitals

20

can be used for this purpose. But Dora refuses to recognise that the irritation in *her* throat and mouth could have anything to do with this.

However, Freud insists that

> the conclusion was inevitable that with her spasmodic cough, which, as is usual, was referred for its exciting cause to a tickling in the throat, she pictured to herself a scene of sexual gratification *per os* between the two people whose love affair occupied her mind so incessantly.
>
> (*SE* VII: 48)

From this Freud infers a fantasy of fellatio, hence an identification with Frau K.

This inference has not gone unchallenged. What Freud is accused of is a phallocentric option. As Neil Hertz has put it in his article 'Dora's Secrets, Freud's Technique', from Freud's sentence 'she pictured to herself a scene of gratification *per os*' it is not clear 'who is gratifying whom, *per* whose *os* the pleasure is being procured, or with whom Dora is identifying' (Hertz 1985: 129). What precisely is left open is the possibility that the fantasy is a fantasy of cunnilingus. And indeed Hertz quotes Lacan's correction of Freud, 'everyone knows that cunnilingus is the artifice most commonly adopted by "men of means" whose powers begin to abandon them'. Freud is thus accused of the phallocentric option because he has come up with the wrong fantasy.

I think this a mistaken conclusion which has ignored the fact of the interchangeability of positions within a fantasy, something established in Freud's 1915 paper 'Instincts and Their Vicissitudes'. Though Hertz himself refers to an interchangeability of positions, he restricts this to the possibility that the mouth, the *os* of the fantasy, might be a female *or* a male mouth. The one yielding the fantasy of cunnilingus, the other yielding the fantasy of fellatio. Hertz wants a decision on this and he doesn't like Freud's decision that the fantasy is one of fellatio.

But surely the thesis of the interchangeability of positions means in this case that whichever fantasy one may opt for, Dora will take a masculine *and* a feminine position: Dora must suck and be sucked regardless. In fact, there is a close parallel between the image of Dora sucking her thumb with a profound oral gratification and the diagram Freud sets out for scopophilia and exhibitionism in his paper, 'Instincts and Their Vicissitudes'. Dora is

21

both subject and object of sucking in just the same way as oneself looking at a sexual organ = a sexual organ being looked at by oneself. It is this preliminary stage of the scopophilic instinct where there is a looking at one's own sexual organ which seems to me just like Dora sucking at an organ of her own body and thus simultaneously being sucked. In 'Instincts and Their Vicissitudes' Freud insists, using the concept of ambivalence, that the active and passive forms of the instinct coexist and that we know this through the mechanism of the instinct's satisfaction. Coexistence, then, does not mean that a choice is available between the two forms but rather that whatever the choice, the opposite form of the instinct is also gratified.

However, Freud himself says nothing of the kind in 'Dora'. He takes the persistent thumb sucking of childhood as providing the necessary somatic prerequisite for a fantasy of fellatio even in the absence of direct knowledge of such perverse practices. After all, the thumb was prefigured, as Dora's memories make clear, by her nurse's breast. Freud simply substitutes 'the sexual object of the moment', the penis, for both the nipple and the thumb. And that is why his interpretation involves a fantasy of fellatio. Even if we assume that Freud had dubious 'phallocentric' reasons for talking about fellatio, it still remains the case that converting that fantasy into a fantasy of cunnilingus changes nothing. Certainly the upholders of this latter interpretation are making the same mistake as Freud in failing to take the thesis of the interchangeability of positions seriously. Perhaps this is because both sides are caught up in the web of the relations of identifications and objects. Certainly both sides fail to see that it is only as a consequence of the fact that Dora must suck and be sucked regardless that she identifies both with the woman *and* the man. They thereby fail to see that object choice is not primary.

Certainly there has been much crowing over Freud's tardiness in seeing the importance of the group of thoughts which indicate that the object of Dora's love is Frau K. It is as though it were a question of right and wrong conclusions: it is right to say Dora loves a woman, Frau K.; it is wrong to say Dora loves the man, Herr K. I do not think the problem is about whom Dora loves. Dora identifies Frau K. as a woman, which is not the same thing as saying that Dora identifies with Frau K. or that she chooses her as love object. This is where the point of identification does indeed seem to be the

22

identification itself. What is it like to be the man for the woman or the woman for the man?

Freud, of course, does try to establish that Frau K. is Dora's object of love. I will consider one of his arguments for this conclusion, an argument which stems from his distinction between knowledge gained from oral sources and knowledge gained from encyclopedic ones. On the one hand, he assumes the woman to be the oral source of sexual knowledge, and on the other, he assumes the encyclopedia to be a male source of knowledge. So the argument revolves around Dora's identification with the man's point of view (since her associations betray a knowledge of technical words that could only have been learned from an encyclopedia), an identification which allows Freud to propose an underlying fantasy of defloration from that male point of view. Frau K. is then taken to be the object of this fantasy of defloration. By now you should expect that Dora will, in her turn, figure as the object of defloration in the fantasy. And indeed, Freud also speaks of Herr K. in relation to the fantasy of defloration where it is Dora herself who is deflowered (an implication Freud draws from her fantasy of childbirth). Dora is both subject and object of the phantasy.

Having indicated that Freud's means of establishing the nature of Dora's relations to Frau K. are insufficient to determine that relation, I want to comment on the oral/written distinction itself. First it should be clear, though Freud is not explicit on this, that if there is an identification with male discourse, then there must also be identification with female discourse. Freud is saying that there are oral and written sources of sexual knowledge for Dora and that these coincide with female and male sources of knowledge. Insofar as Dora speaks of female anatomy with encyclopedic men's words she puts herself in a male place. By the same token, then, Dora's use of sexually ambiguous words that could only have been picked up from women's speech must put her in a female place.

Having said that the identification with male discourse must be matched by an identification with female discourse, we should perhaps interrogate Freud's logic in the first place. That logic suggests that reading encyclopedias is a male activity and that any woman who reads encyclopedias must be identifying with a male position. Has Freud simply fabricated the oral/written distinction here? Is this sheer male nineteenth-century prejudice? Or might it be that Dora herself is utilising this distinction to some end, albeit

unconsciously? The fabricated oral/written distinction we are dealing with fits well with a familiar mapping of, on the one hand, children, so-called primitives, the mad and women; and on the other hand, civilised society and men. That is to say that we could construct two sets of binary oppositions such that one set went with the feminine and the other with the masculine.

If Dora is making such an implicit distinction, what then does that distinction mark? I think Freud is right to pick up the distinction and infer identifications with male and female discourse. But we must note that there is something special in this identification with the place of the male and of the female, something different from the identification which has so far been characterised. The identification with the female position does not imply an identification with the male position also and neither does a reverse identification hold. This is unlike the fluidity of the positions in a fantasy where masculine implies feminine and vice versa. We appear to be dealing with something that is not quite hysterical identification.

Utilising the 'cultural' hypothesis I have just outlined leads to the suggestion that there can be a point, a resting place, a temporary arrest of the oscillation of the drive made possible by identification with one term of a culturally given distinction. That is to say that we might speak of masculine and feminine positions but that these, in so far as they imply relatively stable positions, are the product of cultural distinctions. So what exactly is the influence on what constitutes masculine and feminine positions?

We can continue to use the oral/written distinction and we can start by looking at moments in which Freud constitutes himself as feminine, moments that he retrospectively describes from a position that he takes to be fully masculine. Here I am indebted to Hertz who, in the article on Dora referred to earlier (Hertz 1985), deftly makes the links on the one hand between a knowledge gained from oral sources and Freud's femininity, and on the other between the transcending of these oral sources of knowledge and a scientific, masculine Freud. You will also see how in establishing Freud's femininity Hertz speaks of the pair superordination/subordination.

So how does Hertz establish Freud's femininity? His argument is that Freud needs to make a separation between his knowledge and Dora's knowledge since they both derive from oral sources. And Hertz argues that pursuing this goal has consequences for the treatment of the case. But

24

what is relevant here is that as an analogy to what is happening in the Dora case, Hertz refers to some anecdotes from the beginning of *On the History of the Psychoanalytic Movement* (*SE* XIV). There Freud tells three stories about three men, Breuer, Charcot and Chrobak, who had all communicated a piece of knowledge, the knowledge that neurosis had a sexual aetiology, without really possessing that knowledge themselves. Hertz, while arguing that Freud is almost flaunting his femininity in these anecdotes, describes Freud's role in them as what he calls the Impressionable Junior Colleague.

In the second anecdote, Freud gives an account of overhearing a conversation in French between Charcot and Brouardel. Here Hertz makes a particularly telling analysis. Charcot is saying that it is always a sexual matter; Freud is almost paralysed by amazement but soon forgets the scene, being totally absorbed by the experimental induction of hysterical paralyses. Hertz links these two allusions to paralysis as part of his comment on this scene:

> Freud's distinctly marginal relation to this scene of professional knowingness, almost out of earshot, listening to two men talking – in French, of course – about suggestive matters, *secrets d'alcôve*, locates him close to the position of the woman in his analysis of obscene jokes, just as his being paralysed with amazement aligns him with the (mostly female) victims of hysterical paralysis. In his innocence, in his capacity to receive impressions, he is feminised.
>
> (Hertz 1985: 141)

In the third anecdote Chrobak takes Freud aside and tells him that the cause of a female patient's anxiety is her husband's impotence but that all a medical man could do was to shield the domestic misfortune with his own reputation. Hertz comments, and I continue to paraphrase, that Freud is glancing at the structure of complicity that keeps the sexual aetiology of the neuroses a well-kept smoking room secret. While he does not remain in the position of the hysteric taking in knowledge he does not know he has, he none the less remains outside the circle of collegiality. Freud can only put himself into the world of Oedipal rivalry by asserting his intention to be serious about this knowledge, bringing it into the light of conscious intention and doing so by using a distinction between a casual flirtation and a legal marriage. Hertz points out that then Freud can deploy this knowledge,

acquired after the manner in which the hysteric acquires *her* knowledge, as a proper *technique*.

What does this very suggestive analysis actually tell us? We start with the figure of Freud, the feminine, the junior colleague. In the end, he does succeed in overtaking his masculine seniors. That is to say that in the end he is victorious. The feminine is what is *before* taking possession of the field, before the victory. The feminine is the position of the junior colleague being beaten, the younger Freud being beaten by his older nephew John. But Freud the hysteric, the feminised, the beaten, is transformed into Freud victorious, in possession of the field.

You might well say, so there you are, the feminine can indeed be relinquished, transcended, and the masculine can indeed be put in place. But I have left out the *reason* why Freud is victorious. Freud is victorious because he establishes scientific knowledge; he is victorious *qua* masculine scientist. Note that the scientist is masculine by definition. What stabilises Freud's masculine position is his identification with a discourse which is culturally designated masculine. But as Hertz shows elsewhere in his article, for Freud the man, Dora's analyst, there remains a constant struggle to transcend the oral sources of knowledge which psychoanalytic practice necessarily involves, to avoid the feminine position, for there is no general sense in which he can have put himself beyond and outside it.

What this shows is that sexuality is not gender. Of course you do not need a psychoanalytic model to account for gender. But this is not to say that sexual positions are given socially. It is true that Freud's account of identification and object choice doesn't suffice. What then constitutes sexual difference? If sexual difference is to be defined, as in psychoanalysis, in relation to the phallus, how do we arrive at 'masculinity' and 'femininity', and do these exhaust the possibilities?

# 3

# Of female bondage

Social science students are often set essays which they dutifully deliver in terms of the naturalness of sex and the constructed nature of gender. The biological and the sociological present little difficulty for social science students; they know what's what. Sex can be thought of in biological terms; gender can be thought of in sociological terms. To introduce psychoanalytic theory is to complicate things because we have to make room for one more reality, this time psychical reality. If psychoanalysis is dealing with quite another reality, it is not surprising that psychoanalysis seems to have nothing to say about sex and gender. What psychoanalysis speaks about is sexuality. Sexuality can indeed be thought of in biological or sociological terms but in neither case does it coincide with Freud's concept. For Freud sexuality is a drive which inhabits and determines the space of a psychical reality. There is a chasm between this and the concept of sexuality either as instinct or as something determined by the environment.

Nevertheless, I want to make something quite clear: there *is* a sense, and this is important for the thesis of this chapter, in which Freud's theory of sexuality is inextricably bound up with both biological sex and sociological gender. It is important because I want to show later what a separation of sexuality and gender might look like. I am of course talking about genital sexuality. In Freudian theory while sexuality pervades infancy, infantile sexuality does not know sexual difference. It is genital sexuality, fundamentally altered by what comes before it, that is closely tied to sex and gender in Freudian theory. Sex, sexuality and gender form a knot from which sexuality cannot be easily extricated.

Now these knots that sex, sexuality and gender form: let us say that sometimes they are slip knots and that sometimes they are tie knots, and that they correspond to the knots that form women and the knots that form men. Of course these knots have their variations, but the generic difference remains. And while men may sometimes be said to be feminine, the knots remain tie knots; and while women may sometimes be said to be masculine, the knots remain slip knots.

In order to see the generic difference more clearly, consider the Oedipus complex, the moment of the differentiation into masculinity and femininity. The Oedipus complex and its resolution turn around the question of castration, a lack represented by the phallic signifier, a castration that presupposes the phallus as a reference point. Both the boy and the girl have to submit to castration to allow the emergence of desire, that investment of the object with erotic value which makes the object relation possible. To demonstrate the intrication of sexuality and gender it is crucial to make quite explicit how this works. The whole economy of desire is rooted in the phallus *and* this phallus is attributed to the father. Moustapha Safouan is quite clear on this when explaining the move from narcissistic choice to object choice:

> In fact, the function of the ideal, insofar as it penetrates the whole economy of desire, is rooted in the promotion of the *phallus* that is, precisely, of that whose insufficiency is discovered for the boy and its non-existence for the girl, at an early age in an attribute of the father.
>
> (Safouan 1990: 280)

So if desire is the investing of the object with erotic value, this investment is not made in relation to difference as such, but in relation to a gendered difference. The object's erotic value is dependent on the question of whether the man or the woman has the phallus. Desire is *engendered* by difference.

In practice the boy and the girl will have a different relation to the phallus because of the anatomical difference between the sexes. Now a gendered difference would not matter were it not for the fact that the girl's sex and gender work to obstruct her entry into desire. In the girl's case the Oedipus complex admits of no solution; everything that looks like a solution is secretly wrecked by the havoc of *Penisneid*.

Let us first see how the boy treads the path to desire. For the boy, the

28

Oedipus complex leads to the castration complex and, with the sword of Damocles hanging over his genitals, the boy has to make up his mind in a hurry. Usually he does so, giving up his love for his mother, indeed also giving up his love for his father and identifying with him instead; with the proviso that he recognises himself as *unlike* the father insofar as the essentials are concerned. The identification holds a promise for the future in lieu of symbolic castration.

For girls, the castration complex precedes the Oedipus complex. Once she is safely within the latter Freud gives her three options – retreat from sexuality, or femininity, or masculinity. It is Catherine Millot, a Lacanian analyst, who spells out what these options mean for the girl's entry into desire. In her article on the feminine super-ego she discusses these in a most telling way (Millot 1990). Fundamentally the choice is one of remaining within the Oedipus complex and not acceding to desire (retreat from sexuality, and penis envy which is one mode of the masculinity complex) or of an exit from the Oedipus complex which nonetheless remains marked by the desire for the paternal phallus, a problematic entry into desire (femininity and the masculinity complex).

To understand this layout of female sexualities we can imagine a group of post-castration-complex girls lounging about within that haven of refuge, the Oedipus complex. Actually, to be more precise, some of the girls aren't so comfortable; the castration has been a trauma, they know that they will never have a male genital again and they are utterly despondent (read: retreat from sexuality). Some distance away is the exit from the Oedipus complex, the gateway to desire. These girls are oblivious of its existence; they stare vacantly in another direction. Another group of girls face their fathers; they are not resigned to their loss and they noisily demand what they want (read: *Penisneid*). These girls also do not see the sign saying 'Exit from the Oedipus complex'. But there are some who do and they discover one of two ways out. Some see that a baby would be a good substitute for what they want (read: femininity) and some, realising that the father won't give them the male genital, decide to give up loving him and to give up demanding his love. They go for him in another way; they identify with him (read: masculinity complex). This means they yield up their demands and can exit. Of course they do emerge on the other side in the domain of desire – but with a paternal super-ego. Sure, these girls accede to desire, but

29

something is wrong. Each now enjoys the fantasy that she possesses the male organ, thanks to which she will now suffer from a castration anxiety of some magnitude. Joan Riviere's patient is the classic example (Riviere 1929). An example, as Catherine Millot puts it, of a woman who regards herself as a man, who passes for a woman. Whenever this woman successfully displayed her considerable intellectual gifts in public she was compelled to reverse this performance by ogling and coquetting with father figures who had witnessed it. This was a way of allaying the anxiety and fear of retaliation produced by the fantasy that she possessed the male organ.

Since the Oedipus complex has to do with the promotion of the paternal phallus it looks as though the girl is going to lose out. Her sexuality, feminine or masculine, is going to be out of line. For her there is no ideal exit from the Oedipus complex; the Oedipus complex neuroticises the girl. It is one thing to say that the Oedipus complex is the source of all neurosis; it is quite another to recognise that the Oedipus complex pathologises femininity and feminine sexuality.

Catherine Millot goes further: within the domain of the paternal function the woman does not exist – a good old Lacanian proposition that Millot understands as the impossibility of a post-Oedipal feminine identification. Woman does not exist because there is no ideal exit from the Oedipus complex for the girl. Neither can the woman come into existence by copying the man's entry into desire; it just doesn't work. In the effort not to let her evaporate altogether we are offered the notion of a feminine *jouissance*. In all the moves that women make Lacan sees a *jouissance* that tries to but of course cannot realise itself within the phallic domain and it is posited as a *jouissance* beyond the phallus.[1] But does this help?

Given a boy with a penis and a girl without, a father with the phallus and a mother most probably without, the stage is set for all the posturings of the characters, for their envies and anxieties, for the masquerade of woman-liness, for the faithlessness of manliness, for mutual deceit, and for all the boys who act as girls who dress up as boys.

All this does nothing but reproduce the social and familial order, the order in which the phallus coincides with the father, in which the links between sex, reproduction and gender find a material support. I do believe that Freudian psychoanalysis has discovered the human psyche – the necessity of a relation to the phallus and the necessity of unconscious representations

which articulate the space between drive and desire. The theoretical issue is this: could these unconscious representations be different? What relation could an unconscious representation have to reality? Does the unconscious simply borrow whatever is most appropriate and ready to hand, in which case the bits of reality which are appropriated in a representation are but possible and predictable materialisations of unconscious life? Or do aspects of reality press forward and make possible a change in the balance of unconscious life, in which case reality produces a possible but unpredictable materialisation of unconscious life?

To say that the unconscious representations could be different is to say that sexuality could be organised in a different relation to the phallus, that there could be new sexualities. Perhaps these new sexualities would be divorced from gender positions. In this chapter I want to show how new sexualities can be identified and explained using psychoanalytic concepts. I hope to contribute some new arguments to the debates on sexual politics by showing that psychoanalysis can theorise new phenomena without transforming itself into sociology or psychology.

## Disavowal, fetishism, masochism

What I have described so far are a set of sexual relations and their inherent difficulty, in particular a difficulty of the assumption of femininity, though masculinity is far from straightforward either. What is clear, however, is that the split between femininity and masculinity which is necessitated by the father's phallic attribute is quite different for the little girl than it is for the little boy. But what if the phallus is not attributed to the father? Then we are in the domain of the perversions, those sexual positions whose essence is fetishism. Now in the case of masochism, which is the subject of this chapter, Freud does not make this connection explicitly.

In his 1919 paper 'A Child Is Being Beaten' (SE XVII: 175–204) Freud defines the masochistic position through the grid of neurosis. The fantasy 'a child is being beaten' is analysed in standard Oedipal terms; it concerns a child, either male or female, with an incestuous desire for the father. Later writers, psychoanalysts and others, have recognised in masochism that element which is so crucial to the perversions, disavowal and the construction of the fetish. Of course it is Freud himself who gave us in two papers,

'Fetishism' (*SE* XXI) and 'The Splitting of the Ego in the Process of Defence' (*SE* XXIII) the definition of fetishism that is being used here. But he does not anywhere explain masochism in relation to disavowal and fetishism. However, it is just this that is stressed by three writers I will draw on, Gilles Deleuze, Joyce McDougall and Jean Clavreul, three quite distinct figures, philosopher, psychoanalyst of the International Psychoanalytic Association and Lacanian.[2]

So, what are the perversions, psychoanalytically speaking? Traditionally the perverse figures are the figures of the fetishist, the sadomasochist and the male homosexual. But the fetishism that produces the fetishist is also at the root of the other perversions. Fetishism is of the essence of the perversions. There, there is always fetishism, and fetishism always concerns disavowal. This disavowal is the refusal to recognise that the mother does not have a penis. He who refuses to recognise the absence of the mother's penis may then avow its material existence in some other part of the body or in some object. This material element that thus consecrates the disavowal is the fetish. Notice that the fetish is the means of denying that there is a sexual difference between the mother and the father.

In our earlier account of the Oedipus complex we did not have occasion to speak of disavowal precisely because the Oedipus complex is the means of sexual division. There may be problems, as we saw; nonetheless, the problems are organised in a particular way. Since it is the recognition of the mother's castration that necessitates sexual division, none of the girl's Oedipal difficulties concern disavowal. The Oedipal account of sexual difference concerns the 'normal' and the neurotic; the disavowal of sexual difference and the fetish concern the perverse.

The phallus is equally important both in the neuroses and in the perversions but it is used very differently. It shores up the familial and social order in the former, but it is the occasion of transgression in the latter. None of this is new; I have merely set out what I am referring to when I speak of different relations to the phallus. This difference is basically marked out by the neuroses on the one hand and the perversions on the other.

Of course the perversions are not a homogeneous field. Pure fetishism differs from (male) homosexuality and both are different from masochism. But I am not arguing that these differences constitute different relations to the phallus. It is more important for my argument that masochism itself is

not a homogeneous field. In my view the sexual formations of masochism have to be distinguished into at least three groups: that of the self-flagellating man of religion, that of the traditional sexual pervert, and that of contemporary lesbian sadomasochism. I doubt whether fetishism is of the essence of the first group but I will argue that it is crucial to the other two groups. Notwithstanding the disavowal in these cases, the mark of perversion as it were, I will argue that the reconstruction of sexual difference in the two cases differs in its significance and in its success.

In order to distinguish the three groups of masochists from a psychoanalytic point of view I have to start from the only group which has been studied both clinically and theoretically, the masochist as sexual pervert. The classic picture of masochism is to be found in Theodor Reik's *Masochism in Modern Man* (1941). Reik specifies four characteristics of the masochistic scene, two of which, fantasy and the factor of suspense, concern us. The first characteristic is of great importance since the preparatory fantasy is essential. Masochistic performances are the dramatised, ritualised acting out of these fantasies, their staging. The second characteristic, suspense, involves a delay, a waiting; it is a state with no definite end-point; it is an endless postponement of gratification. Actually being suspended, being hung, is the most transparent sign of this dimension.

Deleuze gives Reik full credit for isolating what he calls the formal characteristics of masochism. But he shows that they derive from disavowal. The disavowal of reality is transposed into fantasy and the disavowal also extends to sexual pleasure itself which is postponed through waiting and suspense. Since fetishism also derives from disavowal it takes little more to add fetishism to the list of characteristics. Masochism involves fetishism, fantasy and suspense. Deleuze describes a masochistic fantasy in which the elements of suspense and fetishism are quite clear:

> Consider the following masochistic fantasy; a woman in shorts is pedalling energetically on a stationary bicycle; the subject is lying under the bicycle, the whirring pedals almost brushing him, his palms pressed against the woman's calves. All the elements are conjoined in this image, from the fetishism of the woman's calf to the twofold waiting represented by the motion of the pedals and the immobility of the bicycle.
>
> (Deleuze 1971: 72)

Suspense then is the mark of disavowal within the masochistic scene. The qualities of suspense can be seen in the bicycle fantasy and also in the photograph-like scenes of Masoch's *Venus in Furs*: the woman torturer takes on the poses of a statue, a painting, a photograph – she breaks off and holds the gestures of bringing down a whip or taking off the furs or turning to look at herself in the mirror. The photograph and the painting capture the gesture mid-way and this is the moment of suspense. Now the fetish itself has the qualities of suspense, the frozen, arrested quality of a photograph, the something fixed to which the subject constantly returns 'to exorcise the dangerous consequences of movement'.

If we accept disavowal as central to masochism we have an explanation not only of fantasy and suspense, but also an explanation of how masochism constitutes transgression. Here I follow Jean Clavreul in his article, 'The Perverse Couple' (1980). Masochism is a transgression of the Law. Not in the sense that it offends against laws on the statute book, but in its setting aside of Oedipal Law. We have already seen how the Oedipus complex leads to the prohibition on incest through the reference to the paternal phallus. This whole operation depends on distinguishing between the father who has a penis and the mother who turns out to be without one. If there is disavowal this distinction is not made; the Oedipus complex is no longer the moment of sexual difference as is usual. Disavowal means that the child refuses to recognise that the mother he had always imagined to be endowed with the phallus is without it. Disavowal means that the child refuses to recognise the sexual difference of the parents. So the pervert has the puzzle of inventing sexual difference, a puzzle that he has to solve with his own wits. But he can construct and maintain a viable sexual difference only if someone colludes with his disavowal. This someone is the mother who remains blind to the disavowal; at first, it is the mother's look that lets itself be seduced and fascinated.

If we accompany Clavreul as far as this we can see what is transgressive about the pervert's sexuality. For insofar as the mother's look also refers to the father through whom the relationship to the Law is founded, the seduction of the mother's look challenges the social and familial order, indeed, we could say, perverts it. Think of the masochist in particular; though he may appear as victim he is in fact in charge. He is the stage manager in charge of the scenery, the costumes and the roles.

*

Putting together some writings on masochism has led to the disavowal at the heart of masochism, the disavowal which explains fantasy, suspense and the transgression of the Oedipal order. How does the first of our three groups of masochists compare with this masochist as sexual pervert? What can be said of the self-flagellation of the man of religion? It is Reik again who comments on this in a chapter on the martyr and the masochist. It must be made clear that Reik does not hold that religious martyrdom is a form of sexual masochism. 'Both do approximately the same thing', he writes, 'but it does not mean the same thing, as it is performed under different psychic suppositions. . . The thorn driven in the flesh has here the function of atonement, there the function to create excitement' (Reik 1941).

Nonetheless, while noting the differences in the 'more limited sexual sense' between martyr and masochist, Reik wishes to make a comparison between the two in a broader sense, comparing sexual masochism with what he calls social masochism. Here, he resorts to the three fundamental characteristics again: the special significance of fantasy, the suspense factor and the demonstrative feature. He finds these characteristics at the level of the organisation of martyrdom. There is a collective fantasy through which the individual identifies with the divine figure and longs for the pain of martyrdom in his name. The suspense factor is marked not only by the postponement of pleasure until the next world, but also in the way in which the suffering is detailed and drawn out. Finally, there is the demonstrative feature and what more apt than the figure of Simeon Stylites on his pillar to represent it?

Certainly the fundamental characteristics describe some aspects of the organisation of martyrdom. But why should we call this any kind of masochism? Reik saw very clearly that the similarities in behaviour were not equivalent; and he drew back from linking martyr and masochist at the narrow sexual level. But the narrow sexual level is the level which concerns disavowal, fetishism, and hence the relation to the phallus which defines the masochistic position. It seems, then, that the similarities at the broader level cannot have some common signification either. Even here the differences are more striking than the similarities. Reik (1941) quotes Cyprian: 'He conquers once who suffers once, but he who continues always battling with punishments and is not overcome with suffering is daily crowned',

and Flaubert's Saint Anthony: 'Martyrs who have been beheaded, pinched with tongs or burned, have perhaps less merits than I, because my life is an incessant martyrdom.' Clearly this competitive insistence on incessant suffering is not what the sexual pervert aims at. One can only heed Reik's own initial warning against holding martyrdom to be a form of sexual masochism: 'Both do approximately the same things, but it does not mean the same thing.'

There are two definitive points of contrast to be made at the narrow sexual level. (It should be obvious that there can be no comparison at a broader level which is not derived from the narrower one.) First, the disavowal of sexual difference is crucial to the masochist; the martyr, however, has heterosexual fantasies and temptations. Second, the disavowal of the masochist is also a disavowal of the father, an abolition of the father from the Symbolic, and the pervert attempts to pervert the course of the Law. Suffice it to ask how the martyr could be said to abolish the father from the Symbolic. This comparison should teach us to identify and avoid the temptations of behavioural similarity! The organisation of martyrdom enables the psychic production of martyrs; if the martyr occupied a different sexual position from others of his time then we could say that something of reality, the organisation of martyrdom, is essential to the establishing of a new sexuality. But we know nothing of this.

We do, however, know something about the fantasies and practices of our third group of masochists, the lesbian sadomasochists. These practices do indeed seem to be organised around disavowal and to be transgressive, but I will show that while they are indeed masochistic, nevertheless they constitute a new sexuality. Before this argument can be made, however, it is necessary to look more closely at what is involved in fetishism. The important question concerns the subject's relation to the phallus and the extent to which this reference point limits the pervert's success in placing himself within a different psychical order of sexual relations.

## There is disavowal and disavowal

What we have not noted so far and what Freud made abundantly clear is that fetishism is crucially about the splitting of the ego. Which is to say it concerns not only the disavowal of the absence of the penis in the

mother, but also, contradictorily, the recognition that the mother does not have the penis after all. Indeed, when the child disavows what he has seen he doesn't do this directly; he doesn't have the nerve to say that he has actually seen a penis. Instead, he avows the existence of the penis in some other part of the body or in some other object. Thus the fetish is a 'memorial' to castration; it is 'a token of triumph over the threat of castration and a protection against it' ('Fetishism', *SE* XXI). So two contradictory attitudes can coexist and Freud points out that there are fetishists with the same fear of castration as is found in non-fetishists.

The ratio between the two attitudes varies considerably so that in some cases a fetish does not preclude a considerable amount of normal sexual behaviour and Freud even speaks of the case where fetishism may be 'limited to a mere hint' (*An Outline of Psychoanalysis, SE* XXIII). It is worth noting that this is to say that sexual difference is simultaneously and contradictorily disavowed and avowed. This hint of fetishism suffices to bring about a splitting of the ego. But Freud also identifies a splitting of the ego in neurosis where there is no question of fetishism. The formation of a fetish is not necessary for splitting; all that is required is both a disavowal and at the same time an avowal of that which is disavowed. In his inimitable fashion Freud universalises disavowal.

We can see what this means by looking at Octave Mannoni's article 'Je sais bien . . . mais quand même' (1964). Mannoni analyses the workings of disavowal outside cases of fetishism. The two examples I use from this article show how disavowal can have consequences for the subject's relation to the paternal phallus. However, whether the paternal phallus is readily or reluctantly accepted, it is important to note that it remains the structuring principle.

The first example shows how the splitting occasioned by disavowal is actually used to put the phallus in place in the initiation ceremonies through which the Hopi child enters the familial and social order. By analysing part of Talayseva's *Sun Chief, the Autobiography of a Hopi Indian*, Mannoni looks at the way in which beliefs essential to Hopi religion are produced. The initiate's original belief is transformed into religious belief (in such a way that the original belief is also maintained). What Mannoni shows is that the adults are using the structure of the coexistence of contradictory beliefs to guide the initiate into the belief which is essential to Hopi religion.

Katcina are Hopi masks. The Hopi child has a firm belief that the Katcina are terrifying figures who are interested in eating children. They appear once a year and the mothers have to buy back their children with morsels of meat. The Katcina then give the children red maize *piki* to eat. When the Hopi child is ten years old initiation ceremonies directly evoking castration take place and now the belief in Katcina is rudely shattered. The 'fathers' and 'uncles' reveal themselves as the Katcina; the reality is that the Katcina are not spirits. Yet the child is initiated into a new belief in the Katcina. The child is told that the *real* Katcina once came to dance, but no longer come as of yore (*comme autrefois*); now they only come in an invisible form and inhabit the mask in a mystic manner. The Hopi can then say:

> I know full well ( *je sais bien)* that the Katcina are not spirits, they are my fathers and uncles, but all the same (*mais quand même*) the Katcina are there when my fathers and uncles dance with their masks on.
>
> (Mannoni 1964: 1269)

The splitting occasioned by castration is the prototype for *je sais bien . . . mais quand même*. Mannoni's example shows that the splitting is actually *required* for the normalising rites of initiation among the Hopi. They take advantage of the splitting of the ego to put the phallus in place.

The second example from Mannoni concerns a more troublesome dis-avowal which leads to a relation to the phallus that is both defiant and submissive. It concerns the play of disavowal in Casanova. He may believe that everyone including his mother has the phallus, yet he knows that he can lose his own organ. Here disavowal, still at the level of belief, not yet materialised in the fetish, is clearly linked to a system of protection against castration. Mannoni shows how the protective structure of Casanova's beliefs is easily threatened, leaving him at the mercy of the reality of the castration he wished to deny. Belief in the paternal phallus is not so easily abandoned.

Casanova cannot resist profiting from finding two dupes. The first possesses a knife which he believes is the one with which Saint Peter cut off Malchus's ear; the other is a peasant who imagines he has treasure in his cave. Casanova convinces them that with the knife for which he has provided a magical sheath, the gnomes will bring the treasure to the surface. The pleasure lies in one fool helping another to find treasure that doesn't exist. Casanova writes that he is longing to play the role of magician which he loves

to distraction. Mannoni glosses: I know full well that there is no treasure but all the same it is tremendous.

Now the peasant has a daughter, Javotte, and Casanova decides that conquering her will be part of his triumph as a magician. But for the moment he declares her virginity essential to the success of the undertaking. So Casanova makes himself some magic robes by making an enormous circle of paper with cabbalistic signs on it. And at night he dons this garment and goes outside. A storm breaks, the dupes fail to show up, and Casanova is in total panic. I knew the operation would fail, he says; to Mannoni this implies a '*mais quand même*'. Although he knows that the storm is natural ( *je sais bien*), he begins to be afraid (*mais quand même*). He persuades himself that the lightning won't strike him if he continues to stand in his paper circle; so he stands all night without moving. The circle is magical after all.

What has happened? Casanova had denied his belief in magic and it was firmly lodged with the dupes. When the storm breaks and the dupes stay away, their absence provokes a reversal in Casanova. Casanova had wanted to be a magician in their eyes; now he is the one who believes in magic.

This hero of 'anti-castration' is made impotent with the reversal. On returning he feels frightened of Javotte, who 'no longer appeared to be of a sex different from mine, because I no longer found mine different from hers' (ibid.: 1280). He has been magically castrated. For Casanova magic (a way of disavowing castration) took the place of the fetish when he offloaded belief onto the dupe. By doing this he possessed the phallus not through magic but through imposture. Of course the impostor is the magician *quand même*, and when the magician fails, when the impostor takes back on himself the belief in magic, he comes under the threat of magical castration.

In both of the examples discussed, though in very different ways, the disavowal of the lack of the maternal phallus and the splitting that ensues appear to be inextricably intertwined with the valorisation of the phallus, the paternal phallus. Does this remain true when an actual fetish is constructed? To answer this question we need to know something more about this construction of the fetish. Now Mannoni sees that Freud's account of the origin of the fetish object is an account of the construction of screen memories. But Mannoni himself can go no further than noting that while disavowal opens onto the field of belief, with an actual fetish in place it is no

longer a question of *belief*. The fetish no longer appears to relate to a belief in the phallus. Where does this leave the fetishist in relation to the phallus?

## There is fetishism and fetishism

The question of the fetishist's relation to the phallus is re-posed by Leo Bersani and Ulysse Dutoit (1985) as the question of whether the fetish is a phallic symbol at all. It is obvious that the fetish does not necessarily resemble the penis. But these writers claim that the success of the fetish actually depends on its being seen as authentically different from the missing penis. In his paper 'Fetishism' Freud had written: 'Yes, in his mind the woman *has* got a penis, in spite of everything; but this penis is no longer the same as it was before.' Bersani and Dutoit argue that the fetishist knows that the fetish is not a penis, doesn't want it to be that alone, and knows that there is a lack (to which he is resigned) which nothing can replace. They rely on Freud: 'The fetishist can see the woman as she is, without a penis, because he loves her with a penis somewhere else'('Fetishism'). This penis somewhere else, this fetish that he loves her with, is itself the sexual object and it is quite different both from the penis and from the maternal phallus. The fetish as sexual object is a displacement from one object onto another; it is not a replacement of an internalised absent object.

Bersani and Dutoit proceed to outline these two models of the sexual object. The first model has a founding object of desire (a model they characterise as 'fetishistic' because it repudiates the absence of the object). We have already seen that for the Freudian child everyone has a fantasy phallus. The sight of the anatomical difference between the sexes is crucial for sexual division in that this fantasy can be seen to be realised in relation to the father while at the same time the mother is seen as lacking in relation to it. This is the foundation for the dimension of illusion, the dimension in which the child will substitute an object for the absent phallus.

But Bersani and Dutoit's young fetishist relates to the anatomical distinction in a different way. We should note that the neurotic may well have the fantasy that the mother has the phallus. But the young fetishist does not do this either. One could say that the fetishist does not know whether the mother has the penis or not, or one could say that the fetishist knows that she does not have the real organ and can only ever have the 'penis [which] is

no longer the same as it was before'. This penis, no longer the same, is the fetish, that which the fetishist now desires. Since the mother has not got the penis which signifies the phallus she has nothing which links her with the fantasy phallus. Since the mediating substitute is missing, desire is 'cut off' from the phallus; henceforth anything can come to be the object of desire.

If indeed the gap between the first object and desire is recognised and accepted, fetishism implies a quite sufficient castration of an order different from the neurotic's. For the neurotic the penis continues to symbolise the phallus and desire remains tied to its first object. But the irreducible difference between the fetish and the first object demonstrates that desire itself might be cut off from its object and may therefore travel to other objects. Bersani and Dutoit conclude: 'Thus the very terror of castration can initiate us into those psychic severances which guarantee the diversification of desire.'

To speak of desire being detached from the phallus does not mean that the phallus ceases to have any function in the organisation of sexuality. Without its function as a third term there would be psychosis. The point is rather that the desire is detached from the paternal phallus; there is a phallus, but it is not the paternal one. We might say that the pervert recognises that no one has the phallus. He knows full well that the mother does not have it. Of course he disavows this but this disavowal merely puts her on a par with the father. Whatever it is that they both have or don't have won't suffice to symbolise the phallus. Which is to say that the pervert refuses to distinguish between them in so far as having the penis/phallus is concerned. So the difference necessary for sexuality and sanity has to be constructed on some other basis. The axis of this difference will come to be represented by all sorts of other differences. This is one way of coming to terms with the fact of the lack of the phallus. If we can continue to say that the phallus is the signifier of desire, albeit in a somewhat different sense, it is because it is not replaced by some other signifier which substitutes as a fixed point of reference for the construction of some fixed sexual difference. The entry into desire is necessarily through castration and it is in the perversions that we see the possibility that the form desire takes will be freed from the penile representation of the phallus and freed into a mobility of representations.

This is my understanding of Bersani and Dutoit's claim that desire can be detached from the phallus and thus be rendered mobile. Of course they are

aware that the claim for the mobility of desires contrasts oddly with the rigidity with which the clinical fetishist holds onto his fetish. He has not fully accepted his castration and detached himself from the phallus; he has not been freed into a mobility of desires. The clinical fetishist still believes in the paternal phallus. The disavowal of the lack of the maternal phallus is not necessarily followed by a disavowal of the paternal phallus. Logically it should be so, but when did psychical processes ever follow the dictates of logic? So, contrary to his own expectations, the pervert finds himself in the company of the paternal phallus, an unwelcome companion which reminds him that some people have penises and others do not; penises are disposable. Paradoxically, then, the pervert who has disavowed castration suffers at the same time from castration anxiety. The paternal phallus exacts its price. In spite of the construction of the fetish the pervert, like Casanova, has retained his fearful position in relation to the domination of the paternal phallus.

The castration anxiety of the fetishist had not escaped Freud's notice; nor was he the only one. Here, a quotation from McDougall on the forms of castration anxiety will suffice:

> the script of the sado-masochist with his concentration on pain . . . or the fetishist who reduces the game of castration to beaten buttocks and bodily constriction (the important bodily marks that symbolise castration but are so readily effaced) or the transvestite . . . or again the homosexual – in every instance the plot is the same; castration does not hurt and in fact is the very condition of erotic arousal and pleasure. When anxiety appears nonetheless (and it is rarely absent) it is in turn eroticised and becomes a new condition of sexual excitement.
>
> (McDougall 1980)

The clinical fetishist, then, is engaged in a constant struggle to avoid the reality of sexual difference. He is engaged in the continuous and repetitive task of maintaining the fabric of the illusion that sustains him. Clavreul talks of the tightrope act that the pervert must maintain, and McDougall writes that 'the pervert is facing a losing battle with reality. Like trying to repair a crumbling wall with scotch tape, it has to be redone every day' (ibid.).

Now if the fetishist succeeds in maintaining his illusion, this is achieved at the price of the mobility inherent in the structure of the fetish. The pervert's

objects and acts are marked by a rigidity, a repetition, a compulsion that cannot fail to bring to mind Casanova standing all night in the pouring rain with bolts of lightning around him. He subjects himself to constraints as a means of control, as a means of ensuring that he does not find himself in unexpected situations, situations in which the threat of castration might suddenly surprise him. One could say that the pervert is all right as long as things go according to plan. The trouble is that he finds his own plans compelling and has little ability to change them.

## There is masochism and masochism

Of course a certain rigidity, repetition and compulsion mark all sexual positions; there are always conditions of satisfaction. But a compulsive sexuality of the order just described, the lack of potency which is such a frequent theme in the clinical literature on masochism, together with the deviation from a genitally organised relation to the opposite sex, is marked off as the structure we call clinical masochism.

Here, there is a regression from genitality to anality which is evident enough in the beating of buttocks and in urination and defecation within the sexual scenario. Since the fact that the mother and the father copulated is disavowed, genital sex must be replaced and sexual pleasure must come about in these other ways. McDougall specifies this task as the reinvention of the primal scene (and she also suggests one way in which the regression to anality leads to a lack of potency: 'the primal scene, divested of its genital significance, becomes an anal-narcissistic struggle. Orgasm is then equivalent to a *loss of control*, and must frequently be retarded or even warded off altogether').

The clinical masochist seems to embody a deviation from a heterosexual genital relation in the sense that he has maintained a reference to the paternal norm at the same time as he partakes of the pleasures of perverse sexuality. As we saw, the clinical masochist has to deny actively and constantly the relation between the sexes which is constituted by Oedipal Law. The Oedipal order is a threat to him. Gender remains a threat to his sexuality.

I think this is clear when we look at what the heterosexuality of the clinical masochist means, for the traditional masochistic couple is indeed a

heterosexual pair. Freud had argued that the masochist escapes the homo-sexual position both by regression to the anal-sadistic and by retaining the opposition of the sexes in the beating fantasy. Whatever we may think of this general argument, the fact remains that others have also documented this avoidance of any taint of homosexuality on the masochist's part. McDougall writes of a patient who paid prostitutes to whip him and stamp on his genitals. This man became highly anxious when another client claimed some similarity with him because he, too, paid to be whipped on the genitals, though in his case he was whipped by boys. McDougall quotes the patient: 'but that man's crazy. We have absolutely nothing in common. Why, he's a homosexual!'

But of course the clinical masochist is no ordinary heterosexual. He is heterosexual insofar as he cannot afford to transgress the demarcations of gender even for the sake of his sexuality. His sexuality is constituted via the women who will distance him from the father and from men who can serve neither as objects of desire nor as objects of identification. His female partner colludes with him in denying the reality of the woman's castra-tion, and in seducing her he undermines the place of the woman in the Oedipal order. The invented primal scene has to have a woman in it and if the clinical masochist likes to be whipped it is clear that not just anybody can administer this whipping. When Severin, the hero of Sacher-Masoch's *Venus in Furs*, is whipped by the Greek, sexual reality breaks in. It is too much. Indeed this thorough thrashing cures Severin of his masochism. Once again we see how very precarious the perverse position is. And once again it is because the rejection of the sexual reality of the Oedipal order is so precarious.

The heterosexuality of the clinical masochist is itself an attempt to construct difference. This may seem a bizarre thing to say, but this hetero-sexuality is a *consequence* of deviation from a genitally organised relation to the opposite sex. There is a further paradox here; this heterosexuality is not heterosexuality because the clinical masochist *remains* on the edge of the Oedipal order.

The question then is whether all human sexuality is Oedipally organised or whether there are perversions which are not so organised which are dissociable in principle from clinical masochism. Which is to ask if the psychoanalytic model is correct in assuming that the disavowal of the truth

44

of sexual difference at the heart of all perversions always has the same consequences. I want to say that new sexualities exist. That is, it is not enough to say either that lesbian sadomasochism is a perversion or to say that it is not a perversion. It is necessary to insist that it partakes neither of the structure of heterosexuality nor of that of perversion as psychoanalysis describes them.

But we cannot settle the question of the homogeneity of the perversions without noting that in this formulation the idea of perversion is not sufficiently problematised. When is a perversion a perversion? We could speak of perversion when it is possible to identify processes stemming from disavowal and fetishism. But how are we to conceive of new sexualities which will not be the same entities that Freud investigated? If we can show that there are entities that are 'perverse' descriptively but that do not share the same structure, we will have demonstrated that psychical processes do not of themselves *determine* sexualities and their structure.[3] I asked at the beginning whether 'aspects of reality press forward and make possible a change in the balance of unconscious life' which would produce 'a possible but unpredictable materialisation of unconscious life'. I now ask whether lesbian sadomasochism is such a materialisation.

Can lesbian sadomasochism be considered a case of a predominantly perverse organization of sexuality and, if so, must it be considered in the same way as traditional masochism? I think the first attempt to answer this question must be at the factual level. While the lesbian sadomasochistic literature[4] describes practices that fit the descriptions of the masochistic scenarios I have outlined, there are important differences between the lesbian sadomasochist and the clinical masochist. These differences suggest that although we are dealing with perversion we are not dealing with the same structure.

What precisely are the similarities and the differences between the lesbian sadomasochistic woman and the traditional masochistic man? They can be summed up in a sentence: the similarities lie in the scenarios which involve fetishes, whipping, bondage, all that goes with the factor of fantasy and suspense; the differences are that lesbian sadomasochism appears not to be compulsive, can just as easily be genital as not, and is an affair of women.

What is similar is what flows from disavowal and leads to a degenitalisation of sexuality, and yet the lesbian sadomasochist has the capacity for

genital pleasure. We might ask whether if genital pleasure remains available we are dealing only with an unusual set of fore-pleasures. If that were the case, the absence of the compulsive element would be accounted for. But that is too simple. Fore-pleasures are foreshadowed by the satisfaction of pre-genital organizations of sexuality. The pleasure of kissing harks back to oral gratification. The fetish, the whip, the gag, suspense and delay do not bear the same relation to any pre-genital gratification. Where do they come from? Is it possible to treat these forms of satisfaction as mere behaviours, randomly put in place? Psychoanalytically speaking, all behaviours conducive to sexual satisfaction have a psychical significance; we are dealing with the marks of disavowal which signal perversion. Certainly there is the hint of the process of disavowal in all of us, but not everyone constructs a fetish. Mannoni's distinction between the domain of belief and the actual fetish means that we can distinguish between the disavowal of the neurotic who holds two contradictory beliefs and the disavowal of the pervert who actually constructs a fetish. Technically, when disavowal leads to fetishism and beyond that to sadomasochism, we *have* to speak of perversion. The sexual scenarios of lesbian sadomasochism have to be recognised as perverse scenarios.

If the similarities demonstrate perversions, what of the differences? The enigma of compulsion, a necessary heterosexuality and a disturbance of genitality are absent. Instead, there is choice and mobility, an experimentation with the sexual yield of consensual constraint; there is a construction of a sexuality between women; there is genital satisfaction as one among many pleasures of the body. I have shown how some features of clinical masochism fit into the traditional structure and it is just these features that are absent from lesbian sadomasochism.

If the clinical masochist failed to take advantage of the inherent possibilities of fetishism outlined by Bersani and Dutoit, it seems that the lesbian sadomasochist takes full advantage of these possibilities. For the clinical pervert things have to be just so. The fetishist is immobilised by his fetish, the masochist plays and replays the scene that is essential to him. The rigidity and repetition constitute the compulsion and the enigma of the masochist's sexuality. For the lesbian sadomasochist, on the other hand, there is an erotic plasticity and movement: she constructs fetishes and substitutes them, one for another; she multiplies fantasies and tries them

on like costumes. All this is done quite explicitly as an incitement of the senses, a proliferation of bodily pleasures, a transgressive excitement; a play with identity and a play with genitality. It is a perverse intensification of pleasure.

Now if this illustrates quite precisely what Bersani and Dutoit mean when they talk of a mobility of desires, can we assume the detachment from the phallus on which this mobility of desires was predicated? Has the lesbian sadomasochist succeeded in detaching herself from the paternal phallus without falling into a sickness? Here psychoanalysts are likely to be constrained by their presuppositions. For as usual it is the question of the paternal phallus as the North Pole of the compass of desire and the consequences of orienting oneself outside its magnetic field. Mannoni's text shows how the disavowal of the Hopi Indian is used for both his phallic and his cultural orientation. But it suggests a tinge of pathology in Casanova's case where the reference to the paternal phallus is accompanied by a more developed disavowal. I have shown that the clinical pervert also has retained this reference in spite of the disavowal of sexual difference and has perhaps done this at a price. Could we say that it is this contradiction that determines the presence of the traditional structure?

If so, its absence in the lesbian sadomasochist would suggest the absence of the contradiction; which is to say that she has succeeded in detaching herself from the phallic reference and in orienting her sexuality outside the phallic field; which in turn suggests that the question of sexuality has finally been divorced from the question of gender.

This takes us back to the beginning of this chapter. There I showed how the girl's sex and gender work to obstruct her entry into desire. This is her difficulty: that she recognises sexual difference. We could almost say that she *therefore* has difficulty with the question of her own sexuality and gender. Desire is a problem precisely because sexuality is linked to gender. We then saw that what happens in the perversions is very different. So what happens for the lesbian sadomasochist is very different.

What then does the homosexuality of the lesbian sadomasochist signify? It is crucial to recognise that it is a homosexuality which is quite differently organised from that of the lesbian who is not a pervert. (In the traditional account female homosexuality is not a perversion even though male homosexuality is.) The traditional homosexual woman is fundamentally similar to

the traditional heterosexual woman in that she also bears the burden of maintaining a reference point which cannot give her her bearings. For both these women the paternal phallus is the signifier of desire and nothing changes this. In the feminine heterosexual position the woman finds the signifier of her desire in the body of the man; within the masculinity complex the heterosexual woman who has made a virile identification with the father wants the man to recognise her virility and the homosexual woman is in the same way enabled to offer that which she does not have. But the woman is not simply a man; so we find Lacan talking of a specifically feminine *jouissance*. It seems that the problem of the entry into desire has to be understood as the attempt to realise a specifically feminine *jouissance*. This attempt is doomed to fail within the Oedipal drama. Hence the question of a feminine *jouissance* beyond the phallus.

But if the lesbian sadomasochist has solved the problem of her entry into desire it is not through the realisation of anything we could call feminine *jouissance*. She has refused the forms of womanly pathology organised within the phallic field; she does not find the signifier of her desire in the body of the man nor, since she makes no virile identification, does she offer that which she does not have. Since the lesbian sadomasochist has refused to operate within the space of masculine and feminine choices, it would be meaningless to call this a *feminine jouissance* beyond the phallus. The lesbian sadomasochist has separated sexuality from gender and is able to enact differences in the theatre where roles freely circulate.

This is a sexuality which is not centred on the paternal phallus and which thereby remains outside the social and familial order. But paradoxically such a transgressive sexuality can only accede to a psychical reality in a complex relation with some fledgling piece of external reality.

# 4

# Waiving the phallus

Why the phallus? For humans, the phallus sits as an answer to two riddles, one of having and one of being. Do I have the phallus or not? Am I the phallus? Of course no one has it; no one is it. It is a question which opens up the Imaginary, the space in which the subjective formulas include such characteristically odd registers as 'having' and 'being'. Humans 'are' not something, neither do they 'have' or 'lack' something, yet these are categories of experience within which humans represent themselves to themselves. This of course is the register through which sexual difference is experienced. Having and not having bring together the question of the phallus and castration. Castration and the threat of castration are the imaginary form of the experience of difference. Again, of course no one has the phallus and no one is the phallus, but the experience of 'having' it or 'being' it is a defence against castration.

The category of the phallus is the Gordian knot of the Imaginary, the Symbolic and the Real. It signifies difference, difference at the level of the Imaginary. It is the privileged term within the Symbolic order. And it is the signifier of the order of the Real. This latter dimension means that the signifier provides a series of substitutes which cover over the absence of the object, the lack. It can elucidate what is meant by being the phallus. Being the phallus is the consequence of an act of identification. Being the phallus signifies that I am identified with the phallus. Whether I have or I am the phallus indicates two modes of identification, which differentially cover over the lack of the object. From the point of view of psychoanalytic theory they both represent a defence. Only when the assumption of having or being the

phallus is relinquished can the subject make the separation from the object with which it has made an identification. For Lacan, it is only at this point that desire can emerge from the identifications which the subject made to defend itself from castration. 'Itself', for though the identifications may be differential as between the sexes, castration bears down upon both sexes within the registers of the Symbolic, the Imaginary and the Real.

This disrupts the usual account which is the one which many feminists find unacceptable – that an organ is arbitrarily privileged so that it is women who are castrated and therefore inferior. It is an account of psychoanalytic theory which turns it into a form of Aristotelian biology in which the woman is deformed and incomplete. It is perhaps this reading of psychoanalytic theory which has sought to rescue the woman by demonstrating that women lack nothing. Or perhaps that women possess an 'it' (breast, capacity for reproduction, etc.) which turns the tables in the war of the sexes and celebrates an 'organ' superiority. In my view, this position misses the point. The experience of 'having' or 'not having', just like the experience of 'being' or 'not being' in respect to an organ, exists at the level of identification, of the Imaginary. To experience 'having' it, whatever the organ might be – penis, breast or womb – is to experience phallic satisfaction. The irony then is that the counter-celebration of other candidate organs as the model of female completeness is itself an act of phallic identification, and is a defence against the emergence of desire. Both sexes defend against castration by the modes of defence which are offered by 'having' and 'being', their infinite permutations and their capacity to be phallically invested in any object. The urge to 'wholeness', far from demonstrating the lack of a lack, demonstrates the defence against a lack.

This 'rescue' of the woman in fact puts an obstacle in the path of the recognition of her desires, for that recognition comes not from the experience of 'wholeness' but from a separation. Insofar as we are subjects of the signifier our desire comes from the signifying order. Unless some distance is created, we enact a fluent identification with the order as if it were the expression of our innermost wishes. For Lacan this distance is the effect of separation, of separation from the object which exhausted the subject in her identifications.[1] The separation made, the subject has the space of desires. This separation involves the recognition of two lacks, lack in the subject and lack in the object. I don't have it; the analyst doesn't have it. What is

50

recognised here is that objects of identification themselves 'lack', or that objects are so many coverings of lack. Thus the phallus is the signifier of lack and so is the covering of lack *par excellence*. The phallus is in fact a veil. This deliberate contamination of metaphors frees the path to permit access to the view that separation from the ideal object is the condition for the expression of desires.

For after all the object of desire is not a possible object of satisfaction, of pleasure. The object is an object which lacks; it is a lost object. Desire for it is founded upon its loss; it cannot fulfil desire. The separation of the subject from this object is not a deprivation of the subject, for the object had sustained desire only through its constitutive loss. Separation involves the recognition of this loss and it involves a great change which can seem a small change, to which corresponds a public sense that psychoanalysis produces small changes, and a private sense that psychoanalysis produces vast changes. What is at stake is the asymmetry of measures of internal and external space. However small the external measure of change may be, the internal space may be freed to produce new things in the place of the objects of earlier fixed identifications and fantasies. Even in the most static cases where the same objects are retained, the relation to them would have changed, would have been renewed by a desire freed from the rigidity of fixed identifications.

I have argued that in Lacan's terms it makes no sense to construct the woman outside the phallic order, because the signifying order *is* the phallic order. Indeed the project of constructing The Woman leans easily upon the Imaginary, The Woman as the object of fixed identifications, of those ideal objects which fulfil the function of covering a lack – the Church, Nation, Motherhood, etc. Now of course the dissolution of fixed identifications can be substituted for by providing the subject with another set of ideal objects to supplant a previous generation of objects. These substitute objects may be judged, according to political calculation, to be 'better'. But the relation to these objects will not have changed, however estimable these objects are; in this case, however 'feminist' they may be, they remain on the side of the phallic, signifying identifications and not on the side of a desire which, however partially, has separated from such identifications. This point may illuminate a historical problem about the peculiar way in which groups, parties, etc. can radically change views, objectives, friends and enemies. Liberal political scientists often feel that this is a function of 'cynicism'; but

in fact it is a function of sincerity. The point is that it does not matter so much what the meaning of an object is; what matters is the relation to the object.

I would like to demonstrate this by considering two early papers by Hélène Deutsch, 'The Psychology of Women in Relation to the Functions of Reproduction' (1925) and 'The Significance of Masochism in the Mental Life of Women' (1930). She puts forward an atypical argument about the wholeness and satisfaction of The Woman which does not jettison the phallus but which draws all these themes together. Her solution to the problem of women's castration is to assert that the woman has it. If the usual feminist solution to the problem of lack is to deny both castration and the phallus, Deutsch intervenes to assert the phallus and deny castration. The Woman can exist, can be gratified, by becoming a Mother. Teleologically, one sex, women, achieves its identity by becoming The Mother, within whose aura the phallus is subsumed by an elaborated table of equivalences.[2] But this view of identity as destiny obscures the question Freud posed, 'What does a woman want?' by reducing it to the answer 'to be the Mother'. It is the question of the woman rather than that of the dynamics of motherhood that Freud addresses. The consequence of Deutsch's argument is that the mother 'has' it; the mother is the name for the woman who, when, where, she has it. The woman is either the embryonic mother or is outside womanhood. But the telos of womanhood, motherhood, is invested in the idea of completion, of the totality implied in the fully extended sexual act which for females ends with parturition. My objection here is not to any phallic reference, but to the insistence on originary, repetitious imaginary equivalences.

Nicole Kress Rosen, in an article on Deutsch in *Ornicar?* (1978), rudely says that 'the feminists' should be pleased with Deutsch. She herself attacks Deutsch's argument abruptly – while she notes that social norms are upheld, what is more important is the denial of castration. It is this latter that should please 'the feminists'. But of course Deutsch's argument that the woman lacks nothing is a paradoxical confirmation of the object of lack since the real woman is the mother plus baby. Perhaps this shows that as feminists we should beware theories that seem to placate the feminists 'too soon'. The assertion that we 'lack nothing' often points to an object that differentiates us. The reduction of women to mothers-to-be, a favourite device of the

virtuous father, is a savage regression from the question 'What do women want?'

Nicole Kress Rosen's article shows how the early work of Deutsch endows the woman with the phallus. Indeed it is the woman's lack of the penis that opens this possibility of endowing her with the phallus. The difference between the penis and the phallus is what makes possible this endowment. In Deutsch's account the whole sequence of coitus, pregnancy, childbirth and parturition all accumulate into the woman who lacks nothing, the woman as Mother. This is, as Kress Rosen insists, not a question of being socialised into the norm of motherhood. Deutsch's account is in effect an account of how the woman is shielded from castration by the fantasy and reality of motherhood. But in fact the mechanism of the latter may be in the service of the former. No one would oppose motherhood, but nonetheless its psychic experience may take the form of fulfilling a norm as a means of denying a lack, of identifying with Motherhood as a denial of castration. The aspect of triumph here is revealing. The satisfactions which flow from imaginary identifications may well be correctly described by Deutsch at a phenomenological level. But this does not show how these identifications work, either at the level of reinforcing social norms or in terms of blocking the subject's potential desire. Who knows? What we can see at the level of group psychology is the way in which the denial of castration lends social norms a powerful leverage over the subject's identifications. Obedience of the 'whole' person is all the more powerful for being represented as the uncontaminated outcome of wishes.

Deutsch allows no castration within the woman-as-mother. It is true that she refers to castration and she does touch upon identification with the father which sets up the ego ideal, but the force of this is dissipated in the endless multiplication of imaginary equivalences which displace the significance of the father and which are tantamount to an *overcoming* of castration, while maintaining the significance of the ego ideal. But the ego ideal is the very structure of master signifiers in Lacan's terms. Deutsch supposes that the master signifiers may be left undisturbed. Indeed she appears to consider these master signifiers as proper to the subject; that is, that a subject can be identified in the signifier. The circle has fully turned here, for what Deutsch is demonstrating is not, as she thinks, the woman's triumph over castration in motherhood, but the repetitious power of phallic identification. By

contrast, within the Lacanian approach to analysis these master signifiers are uncovered and this allows the subject to touch something of the Real, something of that *jouissance* that exceeds the Imaginary and the Symbolic, something of a woman's desire.

Deutsch produces an account of the lackless phallic Mother. She reigns over the woman's world of conception, pregnancy and parturition; a world turned into a self-enclosed realm of satisfaction without difference. Especially sexual difference. This world is possessed by *The Mother who does indeed exist*, where The Woman does not. She is in fact the phallus, she is the object that covers over lack. She is the object who will produce the daughter as phallus, through the relay of the signifying identification. By presenting herself as The Mother, the mother precludes the recognition of castration in the daughter. Desire in both generations can be short-circuited by the phallic identification. Maybe it is here that one can learn something of the difficulty of the separation of mother and daughter, an issue widely debated in analytic and feminist contexts. It is a question of the mother's complicity with The Mother as phallus, a complicity reinforced by the dominant social norms. This issue is actually obscurely recognised by Deutsch. She seems to sense the link between The Mother and the imposition upon *women* of dominant patriarchal norms:

> *Women would never have suffered themselves throughout the epochs of history to have been withheld by social ordinances on the one hand from possibilities of sublimation, and on the other from sexual gratifications, were it not that in the function of reproduction they have found magnificent satisfaction for both urges.*
>
> (Deutsch 1930: 60; her italics)

It is not a question of agreeing or disagreeing with this analysis. What is revealing is that it is put forward by Deutsch in a way that seems to uncover a function of her own discourse as a normative one. Motherhood is the value of womanhood but it is also here admitted as the 'price' of womanhood. The reassurance brought by the figure of The Mother untouched by castration is paid for by 'forgoing' sublimations of sexuality and direct sexual gratifications which might otherwise have been open to the woman. The Mother/Woman is so completely satisfied that desire lacks nothing for its fulfilment. Really? What has happened to Freud's dictum that something in the nature of sexuality resists satisfaction? How could this be reconciled with Lacan's

position that within sexuality there is an excess which is outside the grasp of the signifying chain?

For it is all too easy for the woman to find 'fulfilment', that untroubled consistency which is the product of idealising identifications which find her a place in the sun of the phallic order. What is of concern here is to understand how this process of identification so fluently puts her in her place, for a woman's place is in the signifying chain. What Lacan argues is that there is an order of the Real in respect to which 'existence' itself lacks. If the analysand comes to apprehend the lack around which we are all organised then a gap appears such that the phallic order is less than all. This gap may allow the analysand just enough scope to loosen the ties of identification and to achieve a certain freedom of movement. The analysand may find the room to breathe. In order to conceptualise this in Lacanian terms we have to leave behind the simple dichotomy of phallus/castration, the dichotomy of positive and negative. It becomes a question of *objet petit a*, the left-over of *jouissance*. Neither the phallus as signifier nor the *objet petit a* has a negative for they are outside dichotomy. Thus the phallus is also the signifier of *jouissance* and it points to a field beyond castration and the negation it implies. The concept of the phallus puts in play all three orders of the Imaginary, the Symbolic and the Real, and this is its complexity as a concept, a complexity rarely acknowledged.

The denial of castration which is the denial of difference brings satisfactions which impose high costs. The triumphant 'wholeness' leaves the woman at the mercy of the signifying chain. Within this her relation to norms will be to fulfil them and find fulfilment in them. This makes norms a double-edged weapon for feminists. Certainly there can be better and worse norms; certainly there can be feminist norms. There will always be a struggle over norms at a social level. But at a psychical level, the identification with norms produces the subject of the signifier and not the subject of desire. This leads to paradoxical results in the field of culture: whatever is 'politically correct' is automatically phallic. It matters not a whit that the *content* of the proposition is feminist, transgressive or whatever; once it is correct it is phallic. It is phallic in the sense of supporting the same mode of identification that supports all norms, phallic identification. Of course it is necessary that this goes on – the replacement of some norms with others. But it is important to see that the articulation of feminist norms does not

subvert the phallic order, for it is part of the phallic order. What does induce some freedom from that order, what permits the emergence of desire, lies at the opposite pole from norms. It is the separation of the subject from the objects of desire which have been set up through signifying identifications. This demands not norms, nor role models, nor definitions of the new Woman, but the work of separation. One understands why this path lacks – how should I put it? – a certain allure.

# 5

# The truth on assault

*With Mark Cousins*

A democratic society is not just a society which accommodates different groups and beliefs, although it may do. It is one in which members of society tolerate an *internal* discrepancy between different registers of society. A democratic society does not add up. It is a society of the discontinuous. This is why intellectuals with their regressed preference for consistency are frequently a threat to the necessarily strange and inconsistent nature of democracy. A pluralist society not only involves but requires a level of inconsistency between its institutions and forms of justification. What is argued within the constitution will not be that which is argued within art, or within the arts of getting by, or on the couch or on the street. Yet nor are these domains given boundaries – the different arguments cross, recross, regroup and seek to have effect. There is only one price to pay – the recognition of the place of difference. The space of communication and argument between different domains is a space of representation, the space in which one domain is represented, translated, for another. The 'freedom' or 'tyranny' of a society is in part to be measured by the capacity to tolerate or crush the difference between domains.

'Representation' does not rest upon the relation between a theory, a word or an image and a *thing*, but upon the equivocation between one word and image and another word and image. The intellectual and political attack upon this uneasy world takes its fundamentalist stand upon the assertion of a reality in which a true representation is the truth and is insignificant as a representation, or is a false representation and is therefore neither a representation nor a truth, but a crime. Perhaps in order to understand fundamentalism, instead

of regarding it as an alien fanaticism, we might consider it in terms of its domestic flowering. At the outset we would propose a hypothesis and an object of demonstration. *Contemporary fundamentalism seeks to abolish the difference between a representation and an event.* The object of our demonstration would be the text of Catherine MacKinnon, *Only Words* (1993).

This book is commonly taken as feminist outrage at pornography and as a constitutional proposal as to why pornography should not be able to seek refuge in the First Amendment. So it is, but the text's positions relate to a whole discourse concerning the relation between women, speech and sexual violence. This discourse presupposes a truly odd world. Our remarks here are not an attempt to assess her case in constitutional or political terms, but to characterise that world and to comment on its oddness. For the meaning of pornography for her lies within that discourse on women, speech and sexual violence rather than within her definition of pornography. When she takes the line that pornography be defined as 'graphic sexually explicit materials that subordinate women through pictures or words', this is not important for our purposes. It is a lawyer's draft, and the philosopher's objections to the definition would be met by the lawyer's reply that the courts would find a way to determine the meaning of the definition in the light of hard cases. The legislative proposal does nothing to elucidate the meaning of the term pornography in MacKinnon's world.

For her, pornography is not a term for a form of writing or a genre of images. It is the name for a vast machine, an industrial and emotional complex which circulates 'sex' through society in order to maximise and extend the abuse of women. This profits from a crucial feature of the word 'abuse' – its current ambiguity as between words and physical assault. For MacKinnon, abusive 'speech' is made up of words which are also sexual acts. Sex and words intersect at this point of 'abuse', and the term of abuse acts directly upon the body of the woman. To hurl abuse is always successful. It is a performative you cannot refuse. So, in this view, our filthy pictures and foul language reap a great harvest of victims whose bodies have been physically abused by these words and images. In an astonishing passage MacKinnon asserts:

> it has something to do with the positioning of sex words in sexual abuse,
> in abuse as sex, in sex as abuse, in sex. Words of sexual abuse are

integral to acts of sexual abuse from birth to after death. As incantations while sexual abuse is occurring, they carry that world with them such that to utter them is to let loose in the body the feeling of doing it, and sex is done largely for the purpose of creating that feeling.

(MacKinnon 1993: 58)

Let's get this clear. Sex now happens in order to recreate that same feeling as the feeling that was created by the use of words to recreate the feeling that *sexual abuse is happening now.*

Obviously the legal campaign against pornographic materials and the constitutional arguments designed to reduce the extension of the First Amendment is not conducted on the same basis as campaigns against pornography in the UK. Here, opposition usually takes a conservative form as a call to censor 'obscenity' based only sometimes on the conviction that pornography corrupts its users. Perhaps Catherine MacKinnon might be happy to endorse such opposition, but her own opposition is based, not upon the centrality of pornography, but upon the regime of sexual abuse whose agent pornography is. Images and words are elements in this great enterprise but they do not define it. It labours to produce and circulate abuse. But what exactly is abuse? Here again it is not a question of giving a definition; it is a question of the meaning and extension of this term in MacKinnon's 'world'. It is easier to say what it is not. Abuse is not exactly speech; it is not just an action. It is not only an assault; it is not quite the relation of men to women, nor is it exclusively a relation of some adults to the child. Yet it may involve any of the above. Actually it is abuse whenever a word, image, action or relation tends in the general direction of rape. Rape is the model of abuse and is the logic of abuse. Rape is the final state of abuse and so all the stations of abuse which approach it fall under the shadow of rape. Words, images, speech are all dimensions of the dress rehearsal of rape.

Pornography has a gospel to preach: 'the message of these materials, and there is one, as there is to all conscious activity, is "get her" (ibid.: 21). Unlike most campaigns this is not addressed to hearts or minds. 'This message is addressed directly to the penis, delivered through an erection and taken out on women in the real world' (ibid.: 21). The erect penis has a vital strategic role to play in this world. First of all it is the proof that pornography cannot claim to be just 'speech'. Sure it may have some ideas,

may spread around a 'mainstream misogyny', but ideas 'do not make men hard' (ibid.: 24). By inducing an erection pornography is a special type of action, the performance of pornography. The man becomes habituated to it, to the 'primitive conditioning, with pictures and words as sexual stimuli' (ibid.: 16). He belongs to the text as a relation of masturbation rather than a relation of 'reading' or 'looking'. The whole little scene – this man, this erect penis, this book, this image however apparently solitary – is in fact a 'sex act' with a woman as the victim even if she is not there. She may not be there, but for MacKinnon, she is not absent. She is present as the image which records the crime which has already been enacted upon her in producing the image. Violated, exploited and possibly murdered, the image is in his hand and the scene repeats the man's enjoyment of her torture. If that is the victim from the past, there is also the victim of the future. She is not absent either. She is the target in the future, unidentified as yet, yet already the object of this man's training. With his erect penis and his words and images he is preparing to

> live out the pornography further in three dimensions. Sooner or later, in one way or another, they do. *It* makes them want to; when they believe they can, when they feel they can get away with it, *they* do.
>
> (ibid.: 19)

They *all* do, or are waiting for the moment when they can, or remembering when they did it. Sooner or later, one way or another, they do. Of course in the social labour of abuse there must be a division of pornographic labour, just 'so they can continue to get hard from everyday life' (ibid.: 19). But as teachers, doctors, consumers, jury members, Senate Judiciary Committee members, editors, film directors, employers, fathers, husbands, clients of prostitutes, serial rapists, sex murderers . . . they will all find their opportunity to extend the empire of abuse.

If rape was the origin of abuse, the pornographic extension of abuse is transforming the technique. We are moving into a kind of Late Abuse, characterised by pornographic representations. Now naturally MacKinnon has no truck with 'concepts' of representation. They smack too much of leaking-pen liberals who defend the First Amendment. The term 'representation' (ibid.: 28) seems to irritate her almost as much as 'fantasy' (ibid.: 26). These terms must be used by intellectuals to anaesthetise the reality

which actually characterises pornography – that it is both the memorial to a victim in the past, and the training circuit whose victim is in the future. Representation and fantasy, indeed. Pornography is a sexual act and not a question of representation. Nonetheless, pornography is getting more wordy. On the one hand, pornography is a component of a sexual act which will end up with rape in 'reality'. On the other hand, 'pornography is often more sexually compelling than the realities it presents, more sexually real than reality' (ibid.: 24). The relation between pornography and the world is one where the world bends towards pornography. Speech and sex become a singular form of intercourse. 'What was words and pictures becomes through masturbation, sex itself' (ibid.: 24). The 'real' world disappears and becomes indistinct from the pornographic world. The words and pictures of pornography are acted out in the world as stereotypes, as feminine normality. Reality becomes a pornographic film into which all women are cast. In this alienated and inverted reality,

> force comes to define consent as pictures and words become the forms
> of possession and use through which women are actually possessed and
> used . . . . As sex becomes speech, speech becomes sex.
>
> (ibid.: 26)

This point serves to reinforce her objection to First Amendment defences of pornography as privileged speech. But it is also to insist that the world is poisoned by the marriage of language and sexual abuse. It has sired a monster, a ghastly hybrid thing – let us call it a *porneme* – a performing sign, a graphic organ, an erect penis which punctuates the experience of women. The erect penis is both the means of abuse and the *voice* of sex.

So the world is deafened by the organ speech of the man/penis. It finds its garrulous triumph in the absolute silence of women. It is not only that she is subject to the violent injunction 'Silence', but if she were to speak she finds herself traduced, betrayed and abandoned by language. For language has been polluted by the *porneme*. Words do not name things properly. Words are now pornography. 'Reality', the reality of abuse, is represented only in and by the mute suffering of women. Since things are upside-down, it follows that the defence of 'free speech' is not what it seems. 'Free speech' actually means 'sexual abuse' and pornography. 'You learn that speech is not what you say but what your abusers do to you' (ibid.: 6).

61

Not only has the language of abuse turned sex into sexual abuse, but sexual abuse has returned as the abuse of language. Nothing means what it says. If a woman tries to speak of what was said and done to her, she is transformed from accuser into the crime. The language will not work for her but it will continue to turn her into sex: 'It and you are treated as if you do not belong, as if you pulled down your pants and defecated in public' (ibid.: 66). The woman who speaks out finds herself adding to the world of pornography – 'testimony about sexual harassment is live oral pornography starring the victim' (ibid.: 67). Catherine MacKinnon quotes Andrea Dworkin that 'pornography is the law for women'. In this upside-down world the defence of the 'freedom of speech' is the call for sexual abuse to become a constitutional right.

This whole world is dedicated to the production and suppression of victims who are helpless, mute, damaged and alone. Fortunately the cure for this depraved world is simple: get rid of pornography and break the connection between sex and domination. Once there is real equality between citizens, linguistic abuse will be 'nonsense syllables' (ibid.: 109). Likewise, in the domain of sexuality, humans will find their proper partners. The world would be set to rights:

> Sex between people and things, human beings and pieces of paper, real men and unreal women, will be a turn off. Artifacts of these abuses will reside in a glass case next to the dinosaur skeletons in the Smithsonian.
>
> (ibid.: 110)

Given the current demand to see dinosaurs, given the circulation of their images, this sounds not so much like a scholarly burial of pornography as a curatorial proposal to extend it.

<div align="center">*</div>

We hope we have shown that there is a 'world' embedded in Catherine MacKinnon's book. It may not be the main figure of argument which is about the presumed constitutional conflict between equality and protected speech. But it is the ground on which those conflicts are figured. It is a 'world' in the sense that we are not treating it as a representation of *the* world, that is a representation which might be more or less true or more or less false. That would revolve around the issue of evidence. (This is just as well since she is

engagingly brisk with the figures: 38 per cent of women are sexually molested as children; 24 per cent raped in marriage; nearly 50 per cent are victims of rape or attempted rape; 85 per cent of women are sexually harassed at work.) Our problem is not whether her figures are right or wrong, but how to account for a world in which facts are so radiant with their own clarity, and so completely occluded by the system of that world. At one point MacKinnon remarks, 'Only for pornography are women killed to make a sex movie' (ibid.: 110). There is little point in contesting this as evidence; a tautology like this is a form of repetition which is also the conservation of a world.

We have attempted to chart the world of the text. Doubtless she would insist that what she has mapped *is* the world that there is. We certainly and completely reject this; nothing in the text persuades us that this is a plausible analysis of pornography. But we are no more concerned here to give reasons and evidence for this than Catherine MacKinnon is interested to give reasons and evidence for her view of pornography. We are concerned to interpret the world her text both creates and refers to. For it is a sadistic world, not just a contingently violent world, a world which has the pure consistency of sadism. Indeed, it is the exclusive centrality of this sadistic regime which prevents the text from giving an account of the ordinary economy of pornography or of quotidian sexual abuse and harassment. Ultimately this is because the insistence upon the sadistic regime prevents the text from ever admitting the issue of sexuality. Also we say the text is itself sadistic.

This claim may seem absurd to many, malicious to others and contemptibly predictable to some. It might be granted that several reviews and comments have been struck by the appearance of passages in the book which are 'pornographic':

> You grow up with your father holding you down and covering your mouth so another man can make a horrible searing pain between your legs. When you are older, your husband ties you to the bed and drips hot wax on your nipples and brings in other men to watch and makes you smile through it. Your doctor will not give you drugs he has addicted you to unless you suck his penis.
>
> (ibid.: 3)

But no one has suggested that the text is sadistic. We do.

The first reason for thinking this concerns the victim. This figure of the victim in the book is singular. It is 'the victim'. She is one figure who may have several moments and various guises but she remains singular, the victim/object of pain. Pain is central, pain which rains down on her as abuse. Now this pain is inflicted pain and in this world of pain it starts with a child. *A child is being raped*. At the end of the first essay which began with the invocation of paternal collusion at a marital rape we are left with 'a violated child alone on the bed – this one wondering if she is lucky to be alive' (ibid.: 41). Later on this figure appears again:

> The aggressor gets an erection; the victim screams and struggles and bleeds and blisters and becomes *five years old*.
>
> (ibid.: 58, our italics)

Someone five years old? What is she doing here? At one level the violated, abandoned, five-year-old, the value of whose existence may be in the balance, appears as a mark of the absolute horror of the pornographic regime. Sex on this planet owes everything to atrocity and nothing to desire or pleasure. But who is this child and who is the abuser? She is the incarnation of the victim and he is the father. If the book started with the scene of your husband raping you, he is only repeating what your father did to you. This rape is the origin and model for what men can do to you at any time. Harassment, abuse, pornography are all repetitions of the original scene of paternal rape. Her body is continuously violated. The first five pages name the victim as 'you', you the violated reader.[1] 'You' are violated not just by physical assault, but 'you' are also abused by the words of sex, which you read (here).

Two elements are important here. Firstly, the space and time of the victim. The victim is everywhere always. She, the victim, is the woman in essence, whose local assault does not detract from the interchangeability of all women as victims. This is even clearer in respect to time. Since all time is just the medium of repeating rape, all victims reflect and literally return to the time of the body of a five-year-old. This is not regression; it is literally the time of repetition. Secondly, the idea of a body lashed and assaulted by words – words and images which hurt and damage her body. This moment of a body writhing in pain under the lash of words and the blades of images is a crucial moment in the text's articulation of what might

seem at first an implausible claim. The world of MacKinnon's text requires *the indestructibility of the woman's body*. Obviously we understand that MacKinnon is manifestly protesting against the real damage done to women in rape and abuse. But given the way the text has cast the body of the victim in respect to time, space and language, the body is always ready to be abused again, unmarked as the body is by the physical damage caused by words. The text frames an unintended complicity with de Sade.

This rape, this childhood rape, is the primal scene of the book. It has nothing to do with the primal scene in Freud's Oedipal drama. Indeed it supplants the latter as the reconstruction of the victim's history. In terms of the text all women are raped as children, and as children, are raped again and again throughout their adult life. The lack of evidence of this fact must be attributed to the monstrous power of the pornographic regime which owns human speech and fixes the evidence. Probably for MacKinnon the Oedipus complex is part of the devilish propaganda put out by pornography to cover the tracks of rapists with alibis like 'fantasies' and 'representations'. Certainly it is vital to MacKinnon's whole enterprise that the figure of rape replace and annul the Oedipus complex in the sense that at a logical level, the conflict between an account based upon rape as against an account given in terms of the Oedipus complex is really a conflict between a 'real event' and a 'representation' or 'fantasy'. For this is a crucial moment of the collapse of *any* idea of representation whatsoever, the evacuation of a symbolic order, the denial of a zone of fantasy. This is indeed the hinge of the text's world. Once any idea of representation is abandoned then MacKinnon can deny the distinction between pornography and rape, between a fantasy and a crime. It also enables the text to evade the relation between loss and desire which the Oedipus complex seeks to understand. Instead, loss and desire must be kept in quarantine from each other. Loss is always the loss of an integrity, occasioned by abuse. Desire, to which the text never accords any positive weight, is always that which is at risk from its pornographic perversion and will not be able to exist as 'intimacy' until the evil empire of sex-as-words is vanquished.

The collapse of representation into the event is the decisive, discursive characteristic of the text. It exists at several levels. At a conceptual level, it is central to the argument that words and images may be considered as sexual acts, as abuse. At a referential level, it gives rise to strange, hybrid

objects such as the *porneme*, the organ of sexual speech/abuse. Speech becomes the highest form of abuse. At a rhetorical level, it produces a violent enactment of the conceptual argument through its construction of horrible little scenes and nasty stories of degradation. Finally, at an enunciative level, it seeks to bind the reader to the moral intention of her discourse while deriving all the secret pleasures of 'shocking' the reader that are the perverse prerogative of the moralist down the ages. This layered consistency of the collapse of representation and the event creates a self-contained world. As Barthes says of de Sade:

> Sade always chooses the discourse over the referent; he always sides with *semiosis* rather than *mimesis*: what he 'represents' is constantly being deformed by the meaning, and it is on the level of the meaning, not of the referent, that we should read him.
>
> (Barthes 1976: 37)

What is always being represented, over and over again, is the moment of the collapse of representation and event into each other, the moment that creates and recreates the world of the text.

Consider the following passage:

> In terms of what the men are doing sexually, an audience watching a gang rape in a movie is no different from an audience watching a gang rape that is re-enacting a gang rape from a movie, or an audience watching any gang rape.
>
> (MacKinnon 1993: 28)

Notice that it is not just a question of asserting that watching a gang rape is the same as watching a film of a gang rape, but of providing the means whereby the two can collapse into each other, that is 'an audience watching a gang rape that is re-enacting a gang rape from a movie'. Even someone in agreement with MacKinnon's proposals might grant that the above example lacks a certain empirical plausibility. That does not matter; it remains a crucial discursive and fantasmatic demonstration that representation and action *can* become each other. At a conceptual level it is the demonstration that representation and event are the same. At a referential level it shows that the perpetrators of gang rape, the audience of a gang rape and the audience of a film are the *same* in so far as they are an erect penis. For it is

66

the erect penis that destroys the usual distinction between a film critic and a rapist. At a rhetorical level the horrid little story of 'an audience watching a gang rape that is re-enacting a gang rape from a movie' marries rape and film in a story which is all in all a sadistic story rather than a story which is about sadism. The sheer consistency of the discourse which abolishes the distinction between representation and event at each level of the discourse suggests to us that we interpret the wish to deny a difference between representation and event as being characteristic of sadism.

Indeed, we might simplify this further: a function of sadism is to deny differences. In this example of the gang rape there are obviously socially and legally recognised differences between an audience at a film, witnesses at a crime and rapists. The text denies this difference. In doing so it commits what Barthes calls 'metonymic violence'. Speaking of de Sade he says that 'in the same syntagm he juxtaposes heterogeneous fragments belonging to spheres of language that are ordinarily kept separate by socio-legal taboos' (Barthes 1976: 33-4). In Sade's case this 'metonymic violence' is in the deliberate service of transgression, and the production of literary pleasure. Flouting every taboo is a conscious programme. But what is MacKinnon's relation to taboo, especially the incest taboo? At the heart of her argument is the fact that through paternal rape an incest is committed which contaminates existence. But the very idea of a taboo against incest situates the taboo on the side of prohibiting action while implicitly recognising a desire on the side of fantasy and representation. The incest taboo is therefore not a random injunction against a particular relation. It is the very moment of the inauguration of the difference between representation and event. Where does that leave this text, horrified by paternal rape but unable to comprehend the taboo? For it is those who deny the difference between representation and the event who have already begun to transgress the taboo.

The text tips in a highly consistent manner, from a discourse on sadism into a sadistic text. And there is one other level of the text which will bear this out. At a conceptual, referential and rhetorical level the account of rape and abuse is a sadistic account of rape and abuse. But this sadistic strain is also present in the enunciative level of the text. Obviously the question of speech has already been crucial at the other levels. The collapse of representation and event at the conceptual level turns speech at a referential level into an organ of abuse, just as it gives the erect penis a speaking part. At this

level the noise of abuse is mirrored by this 'thousand years of silence', the Reich of abuse which women have borne. The male ownership of speech parallels Barthes's comments upon de Sade, that while the acts involved in a scene may be performed by anyone, the sadist alone retains the right of speech. But Barthes is not alone in linking sadist and speech. Lacan (1968–9) makes a similar connection when he says that the sadistic voice completes the Other. This flawless completion in which we no longer have to bear and endure a gap is central to Lacan's account of perversion. We are more familiar with a form of this account in terms of the gaze as that object through which the voyeur and the exhibitionist *complete* the Other.[2] But in the case of sadism and masochism it is the *voice* and its way of completing the Other that matters. How can one characterise the voice of the text, the enunciative level?

A voice is speaking, speaking out, against, and on behalf of; the combative voice battling against the powers of abuse/speech on behalf of those abused and speechless victims. It is certainly a voice. For denunciation requires the sound of a voice. That is why the super-ego is always associated with the voice. The voice in the text addresses 'you' the victim, as it denounces the world. The voice as an 'object' always underpins the morality of denunciation, but it always enjoys veering away, exceeding and indeed contradicting the dictates of that morality. At a certain point of divergence, one can always ask what the voice wants for itself, as opposed to or in addition to the injunctions issued in the name of the voice. What is the perverse enjoyment of this voice?

This split within the enunciative level is a function of the split character of the super-ego. Such a split is always a problem for those who issue injunctions. How can one publish injunctions without an enjoyment which exceeds them and betrays a yield of sadistic satisfaction which undercuts the reasoned and disinterested act of judgement? Denying the problem always exacerbates it. The split in the super-ego, as Freud recognised, was more like a contradiction. The super-ego itself makes an injunction which distinguishes, which can be divided between the moral law and the pleasure of punishment, between the representation and the event. This entails, for want of a better term, the difference between a wish and an act, a fantasy and a crime, in short the acceptance of castration. But at the very same time the dread voice of the super-ego (signifier) can also exist as an object (the

voice) which works in a diametrically opposite way; it fills in the gap opened up by that castration. It is here where the voice utterly obliterates the gap, that judges really begin to enjoy their job.

The danger contained within the enunciative level of MacKinnon's text is clear. It lies there where the voice of the super-ego is installed. Since the single issue which is to be found at every level of the text's discourse is the collapse of representation and the event into each other, this is where the voice finds itself. As an object the voice finds its triumphant space just *where there should be a gap*. As an enunciation this will have the effect of creating, out of what was manifestly an attempt to indict the sadism of the pornographic complex, an instance of a sadistic performance as a text. Apart from anything else this is why the text is creepy.

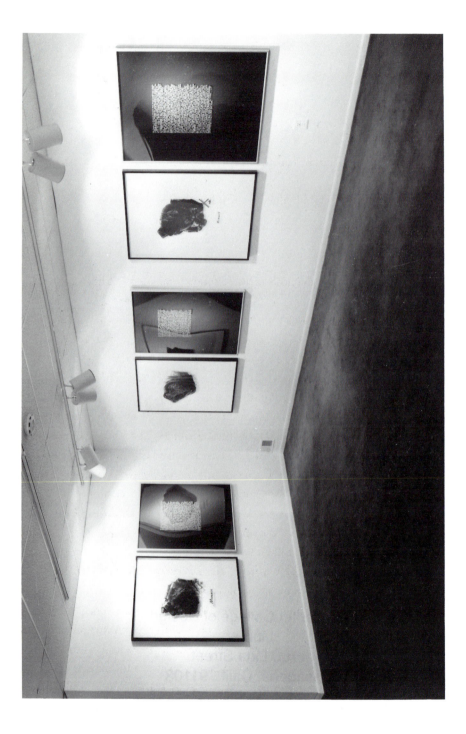

# 6

# The art of analysis: Mary Kelly's *Interim* and the discourse of the analyst

Mary Kelly makes an exhibition of us. Though who we are I have less and less idea. What was showing at the New Museum[1] is that which is called Mary Kelly's *Interim*. I want to try to think about what it is through psychoanalysis, through the question of love and identity, that is through the category of transference. Now Mary Kelly's work has always displayed the question of psychoanalysis. There it is, in *Post-Partum Document*,[2] in question and algorithm, making theoretical production and the infant's productions different moments of a representation. In *Interim*, the psycho-analytic glosses are minimal. But my argument is that the fundamental situation of *Interim*, that of the series, the spectator, the art work and the fantasy of whatever goes under the name of Mary Kelly finds its analogue in the analytic situation. I am suggesting that going to the exhibition is like going to analysis. But of course one is not a substitute for the other; I am not suggesting that you choose between going to analysis and going to see *Interim*. I do think that the relation of transference helps to clarify what is going on in *Interim*, especially where the exhibition confronts that most delicate of issues, that of ways of going on.

Let me start with the famous question 'What do women want?' As will become clear I have nothing to add by way of an answer. I am not concerned with the answer, but with the question, the question which itself needs to be questioned. Indeed what is a question? Who questions? Who answers? What

---

*Plate 1* Mary Kelly, *Interim Part I, Corpus* (1984–5). Detail: Installation, thirty panels, 36" × 48" each.

kind of answer is demanded by what type of question? What does the question want with us? Who does the question want us to be? How does the question want us to answer? What relation to truth does the question demand of us? For we can imagine the question, 'What do women want?', to be involved in radically *different* situations. There isn't one world in which the question is posed. We cannot even think about the question and its meaning until we think about the scene in which the question is posed.

I feel helped here by Lacan's notion of discourses (Lacan 1991) as a way of thinking how even the same question can mean and imply such fundamentally different situations. For discourses describe the structures of different social bonds. Discourse is a fundamental apparatus which is prior to and which determines the whole relation of subjects to subjects and subjects to objects as they appear within that apparatus. Lacan develops this conviction by constructing four different discursive apparatuses to demonstrate how much hangs upon the situation of a discourse and how little on the semantics of a situation. They are the discourses of the Master, the University, the Hysteric and the Analyst. Each of these is a possible apparatus which has entirely different effects upon the subject. When you are inserted into the apparatus in these different scenes you are a person quite differently in each. For example, to be within the discourse of the Master is to be within a fundamental structure. You can get a new master, you can change him for a mistress. It might be better, but you remain within the same structure. A change of sex doesn't undermine the place of the master, for that place is prior to gender. A structured change only occurs at the level of the discourse. Later I will suggest that what was on show at the New Museum was not the setting for the discourse of the Master, or the University, or the Hysteric. I will suggest that it was the setting for the discourse of the Analyst, a discourse which structures the conditions under which questions and answers circulate.

But first we must follow Lacan's position in more detail. For him there are a number of elements that define a discourse, that is, the apparatus. There is the point from which speech is enunciated, the space of the *agent*. There is the point to which the speech is addressed, the *other*. When the agent acts upon the other, it sets up a third, the space of *production*. Lastly, any discourse has a dimension of *truth*. This space is necessitated by the psychoanalytic discovery that one does not know what one is saying. For a discourse

to function in its own particular way, there is always something at the place of truth that remains masked. What counts as truth for the discourse itself is another matter. The four elements define the discursive machine in which the product is always separated from truth.

The person who speaks has to be fitted into this machine and there is more than one way this can be done. We cannot talk of the person who speaks as a unity; we have to disengage three terms that mark the person who speaks – $\mathcal{S}$, $S_1$ and $a$. Let us start with a full subject S, and see how speech produces the subject as barred, for the subject is barred inasmuch as he speaks. Now, what is the Lacanian subject? It is a signifier. A signifier is a subject for another signifier. Let us call the first signifier $S_1$ and the second $S_2$. Although the signifier only exists through difference, $S_1$ is a single signifier. It is a signifier without signification; it is outside the chain of signifiers. This is the master signifier in the name of which the agent speaks. (Some of you will know Laplanche and Leclaire's paper 'The Unconscious: A Psychoanalytical Study', in which they locate the originary signifier, the $S_1$, in the signifier *li-corne*, the bit of unconscious non-sense to which the analysand Philippe is subjected.) Now if the originary signifier *is* the subject for another signifier, it is the second signifier that engages the signifying chain. This is $S_2$, the signifying other. It is the place from where one speaks and it is also the place of knowledge. $S_2$ is the knowledge that $S_1$ activates. The subject, then, is represented in the relation of $S_1$ and $S_2$.

What has happened to the full subject S we started with? What has happened to the living body? In Lacanian theory language deprives the body of *jouissance* which finds refuge only in the limited zones of the body that Freud called the erotogenic zones. The entry into language produces the barred subject by depriving the body of *jouissance*. It is thus the origin of the

73

Lacanian *manque-à-être*, the lack-in-being. Now, what comes to take the place of this lack is the object, which Lacan designates *objet petit a*. In place of the original full subject we now have ⑤ and *objet petit a*, the complement of being of the subject. We have the order of the signifier and another which is heterogeneous to it. Which is to say that there is no signifier of *objet petit a*, the left-over of *jouissance*. There is a hole in the signifying network. Analysis is of course the talking cure. Yet this object without a signifier has a key role in analysis. And I will show that it has a key role in *Interim*.

The four terms ⑤, $S_1$, $S_2$ and *a* which I have just described fit the four places the apparatus provides to give us the discourse of the Master, where $S_1$ is at the place of the agent, $S_2$ in the place of the other and *a* is in the place of production. You can think of ⑤ as the repressed term in the place of truth.

Now, in the discourse of the Master the relation of speech introduces the

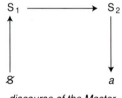

*discourse of the Master*

social bond as mastery. But a great deal depends on how you distribute the terms across the four places which remain constant. If you rotate the terms anti-clockwise through the four places you get in succession what Lacan calls the discourse of the University, the discourse of the Analyst and the discourse of the Hysteric. And being located in one discourse rather than another has radical consequences for speaking and being.

Let us see how these diagrams might be read. Take the discourse of the

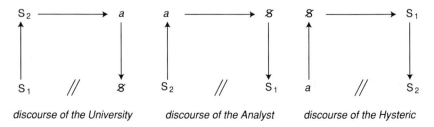

*discourse of the University*     *discourse of the Analyst*     *discourse of the Hysteric*

hysteric. In the hysteric the gap between subject and object is most visible and she raises the question of the object which resists interpellation in demanding to know what her desire is. She addresses this demand to the man; typically, in the nineteenth century, to the medical man. You can see from the fact that the $S_1$ is in the place of the other that she addresses her demand to the master. The result is $S_2$, a knowledge about the hysteric. But the barrier between production and truth is here precisely the barrier between knowledge and *objet petit a*. The medical man can never succeed in telling her who she is; the hysteric forever taunts him and forever remains unmastered.

Now take the discourse of the analyst. Lacan often says that the discourse of the analyst hystericises the analysand. The two discourses are only a quarter turn away from each other. You can see that where the hysteric was the barred subject at the place of the agent, the analysand is the barred subject at the place of the other. If we start with $\mathcal{S}$, the terms follow in the same order, but it makes a great difference that they have changed their place. Although the subject of analysis is hystericised, the impasse between medical man and hysteric is not repeated. Moreover, if the medical man was master, the analyst is not; notice that he appears in the form of *objet petit a*. Finally, what does it mean that $S_1$ appears in the place of production? That analysis brings to light the originary signifier of the subject is clear; the question whether this is a new kind of master signifier remains open.

Let me finish this brief account of the four discourses by performing an experiment. Let us take a sentence and run the same sentence through each of the discourses as a way of demonstrating the power of the structure of the discourses to determine the situations we find ourselves in. Let us take a famous sentence, 'I am that I am', and let it be the sentence enunciated by the agent in each of the discourses. To begin at the beginning with the Master, for that is where he always begins. God says 'I am that I am.' Well, where does that leave us? He is announcing that He is the prime mover, not just as a fact but as a structure; or rather, the fact includes the fact that we are His subjects. He is the Way and therefore He is the Truth. Now let us move to the University. The professor lectures us with the example 'I am that I am.' The professor is teaching us the logic that if $p$ then not $q$. He is teaching us about propositions and their relation to Truth. Logic obeys the Truth as *knowledge*; although the situation does not avoid the $S_1$ of the master stalking the lecture hall. In the discourse of the analyst the situation is a good

deal more sticky. Actually the analyst doesn't say 'I am that I am', but this doesn't prevent the patient from hearing it. And what the patient has heard finds an echo in his longing. 'If only I could say that', muses the patient. Yet this is not what actually comes to pass, for the patient may come to hear something different at the end of the analysis; may, if he is lucky, hear the analyst's version of 'I am that I am' as 'I am only what I am'. He realises that the analyst does not have what he wanted and at last he can make his lack his own. In the discourse of the hysteric that assertion 'I am that I am' is of course a question, 'Who am I?', a question put in a thousand exasperating ways which unman the master who is supposed to tell her.

Our experiment demonstrates that the sentence 'I am that I am' can run all the way from revelation to question. We see that what comes to the place of the agent need be no master at all, and what is more, that elsewhere the master does not always have mastery. But we have not finished with our sentence. What happens if we shift the emphasis from the 'I' of 'I am that I am' to the 'am'? 'I' is about speaking; 'am' is about being. What about the object in all this? In the discourse of the Master *objet petit a* is the remainder, the left-over of meaning; in the discourse of the University the object is acted upon and yields to meaning, the discourse produces the barred subject; in the discourse of the hysteric the object resists meaning, you cannot succeed in telling her who she is; only in the discourse of the Analyst is the object asserted at the same time as meaning.

It is important to my argument that the analyst is not the Master. What enables him to abdicate that position is this fact that the object is asserted at the same time as meaning. In the discourse of the Analyst *objet petit a* and the barred subject occupy the places of agent and other. By virtue of this, the relation of the subject to the object can be worked on directly and be modified, because there, between agent and other, is where the action is. What appears at these two places is crucial in the organization of a discourse and if the discourse of *Interim* is like that of the analyst, we should be able to locate the spectator as barred subject and the artist as object in those places.

But first we must ask about what goes on in analysis to make the analyst appear as *objet petit a* and the analysand appear as the barred subject. I will call what goes on in analysis the textuality of the analyst on the one hand, and the silence of the analyst on the other. By speaking of the textuality of the analyst I refer to the fact that he interprets and that interpretation works

on the analysand as the subject of the signifier. To the extent that it does this interpretation does not, of course, produce the analyst as *objet petit a*. If interpretation were his only job, the analyst would remain the master, the subject supposed to know, that the analysand takes him to be at the start. Interpretation *per se* does not make the subject any less subject to the signifier and this is why the subject would be no less subject to the analyst who embodies the Other of language. The analyst's interpretation draws out the signifiers of the subject's past history and puts them in a dominant place in the discourse. What was repressed yields to signification.[3] So when the analyst detaches the subject's signifiers in this way, he reinforces their symbolic weight. In or out of the analytic situation the signifier offers shelter to humans. Signifiers supplied by social apparatuses yield humans the relief of an identity. The signifiers detached by the analyst are no exception.

The textuality of the analyst cannot be the whole picture. So let us look at a phenomenon of analysis that cannot be interpreted but that is crucial to the analytic relation, the phenomenon that brings the object into play – transference love. The analyst does not interpret transference love. But neither does he respond in the role of love object. Instead, he takes the form of *objet petit a* by responding with the silence of the analyst.

Let us start with the relation between subject and object that is found in transference love. We know from Freud that in love the overestimation of the love object is the same thing as narcissism. The loved object yields the subject a narcissistic satisfaction. Now to say that the loved object is overestimated is to say that it is put in the place of the ego ideal, that place where the subject is mapped in an ideal signifier. This ego ideal is necessarily involved in narcissism because the ego ideal is the point from which the subject feels himself to be satisfactory and loved. In other words, a symbolic identification with the place of the ego ideal precedes narcissistic identification. Lacan explains this when he speaks of

> the sight in the mirror of the ego ideal, of that being that he first saw appearing in the form of the parent holding him up before the mirror. By clinging to the reference point of him who looks at him in the mirror, the subject sees appearing, not his ego ideal, but his ideal ego, that point at which he desires to gratify himself in himself.
>
> (Lacan 1977a: 257)

The story that follows puts the point very simply: 'Not so long ago, a little girl said to me sweetly that it was about time somebody began to look after her so that she might seem lovable to herself' (ibid.: 257).

In transference love it is the analyst who is put at the place of the ego ideal; it is the analyst who is called to embody the capital I of identification of the ego ideal. It is from the place of the analyst that the analysand wants to see himself as satisfactory and loved. What this does is to make the analyst the Master and analysis suggestion. It is what Jacques-Alain Miller mentions as the problem of clones – all the analysands who end up looking like each other by virtue of sharing an analyst.

How could that change? Put simply, the object has to be detached from the ego ideal. Because the object doesn't belong there. Let me explain why. We know that the analysand as barred subject lacks the object. What we have just seen is that he fills out this lack with the object that the Other, the analyst, is supposed to have. But this is to confuse the I of identification and *objet petit a*, cause of desire. You will remember that the lost object *qua* breast founds the Freudian wish. Lacan's formulation of this is that the lost object causes desire – *objet petit a*, cause of desire. The object comes *before* desire. Desire, which is always the desire of the Other, misrecognises the object because when it pursues the object, it fails to recognise that the object is not in front of desire, but before it.

Desire is in the field of the Other and transference love merely increases the subject's alienation in the Other. Something has to happen to break the grip of the signifier. This something is what Lacan calls separation. The difference in the two operations of alienation and separation is given very precisely in Jacques-Alain Miller's diagrams.[4]

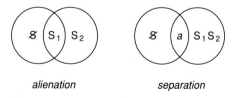

alienation                    separation

The diagram for alienation concerns the subject and the field of significa-tion; *objet petit a* does not figure in it. In the diagram for separation the *a*

appears in the intersection of the fields of the subject and the Other. But note that the *a* is quite outside the S$_1$ and the S$_2$ which constitute signification. What this diagram shows is that the Other is also lacking, that the object is separated from the Other, that the Other does not have a final answer. Here is the opening for the analysand: by identifying his own lack with the lack in the Other he can avoid total alienation in the signifier.

But for this to happen the analyst must fall from idealisation and become the support of *objet petit a*; the analyst must embody the function of lack. It is notoriously difficult to pin down what Lacan meant by the desire of the analyst, but it is certainly something of this order, that the analyst be seen as desiring in the sense that the analyst also lacks. The analyst doesn't have it.

But how does the analyst show that he doesn't have it? By his silence. I borrow this answer from Michel Silvestre's paper on the transference where he describes this silence. I quote:

> Certainly not conventional silence, for it is indeed necessary to be silent in order to hear the other who speaks, but the refusal to respond there where the analyst would have something to say, but the leaden silence which comes to redouble that of the analysand, but again the mute question, anguished echo of the limit of the Other's knowledge. The being of the analyst is silent, through which he makes himself massive and enigmatic presence.
>
> (Silvestre 1987: 76)

It is only when the analysand realises that the analyst doesn't have the object that he can live a life in which he is no longer completely locked into the desire of the Other but has a little bit of leeway.

My argument about *Interim* is that there also something of textuality and something of silence engage the spectator so that the relation to the signifier and the relation to the object are both in play. And that there also the place of the master is left vacant.

I linked the textuality of the analyst with the activity of interpretation that he engages in. But you mustn't think that interpretations work on some unorganised raw material. They work on a textuality of the analysand which is itself a texture of interpretations. You can see this in the dream that the analysand takes to the analyst. Even when it seems nonsensical, his very telling of it already involves what Freud called secondary revision. It is in this

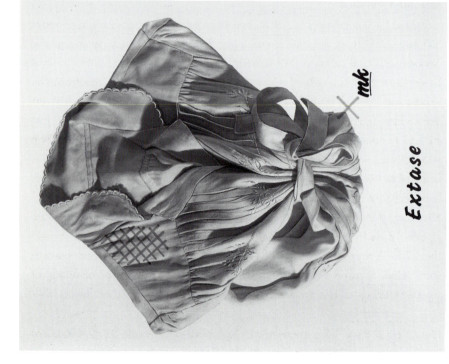

sense that textuality and interpretation are inextricably bound. There is no recounting of a dream which is not also an interpretation; there is no interpretation which doesn't represent a text. Even if we wish to retain the separation of text and interpretation as different functions, in practice they always come together.

Now pictures are certainly texts, and they come impregnated with interpretation, as if the truth of the painting is also there in the painting, the truth which is stated by the artist supposed to know. We all know the errors of referring to the meaning of the picture as contained within the authorial intention to mean. But what interests me is that knowing this argument doesn't stop our fantasies about the artist, not so much as a person but as a function, the vanishing point at which the picture and its truth would intersect as the source of the picture's correct interpretation. We may call this fantasy of the artist the ego ideal of the spectator, the place from which the spectator's interpretations may be felt to be validated. At this point, when it works, we do indeed think we are looking at a masterpiece. For the spectator, then, pictures are certainly texts that come impregnated with interpretation.

Before I speak of interpretation and transference love in *Interim*, I would like you to think of Aeneas. Perhaps you have forgotten that in one of the episodes of Virgil's *Aeneid*, Aeneas is a spectator before a picture, for he finds before him, on the walls of a temple in Dido's Carthage, scenes from the Trojan war. He is a special kind of spectator, one whose own past is laid out before him. The picture has an effect; Aeneas weeps. Does the picture just stir sad memories? Or is it that his story is being told? Is being told by one who knows, who exhibits the order of signifiers of arms and the man? In front of the picture Aeneas says, 'Great valour has due honour; they weep here/For how the world goes, and our life that passes/Touches their hearts.' His story is understood; he sees it as it is seen. Aeneas as subject of the signifier finds his past before him. There is a subject supposed to know and there is interpretation. Aeneas says, 'Throw off your fear. This fame ensures some kind of refuge.' Is it too far-fetched to say that this ordering of signifiers brings a certain peace of mind? Is it too far-fetched to say that

---

*Plates 2 and 3* Mary Kelly, *Interim Part I, Corpus* (1984–5). Details: *Extase*. Laminated photo positives on plexiglass, 36" × 48".

this is the trust in the subject supposed to know that Lacan speaks of? Finally, is it too far-fetched to say that it is Dido, queen of Carthage, who is the point on which these effects converge?

For where there is a subject supposed to know there is transference and transference love. Of course in Virgil we are told at length about how Dido's passion for Aeneas is kindled by the boy god of love. Aeneas' passion for Dido is left unexplained. It is ascribed neither to her powerful position nor to her beauty. There is room to suggest that Aeneas' love is transference love. Transference love, we know, is real.

If there is an analogy here with the signifying side of analysis, it is clear that the ingredients on the side of the object, so important for an analysis, are missing. Dido is no analyst. Far from letting Aeneas liquidate the transference, she tries her utmost to keep him trapped in it. Dido demands love. So for Aeneas the object continues to coincide with the ego ideal and he tears himself away from Dido only when Jove himself intervenes to ensure that Aeneas sail away to fulfil his destiny in Italy.

Remember, we have been talking about the effects of a picture.

Now Aeneas is in trouble when he arrives in Carthage. Many of his ships and his men have been lost in a storm at sea and he wants to know what he can expect in this strange land. The picture gives him his answer. And when you go to an analyst you also want to be told what things mean. Isn't there something of this when you go to see a picture in an exhibition? Of course the interpretation has to engage you before you set up a subject supposed to know and before there can be anything that can be called transference love. But then you do expect to be told about yourself.

*

This is what happens in *Interim*. I will speak of the inscribed stories of the *Corpus* section, stories which have been worked up from hours of conversation with feminist friends. The spectator can identify with the point of view from which these conversations have occurred. The spectator watches, if not her own history, then a history which she can identify herself from. The elements come from something like her history, from something in respect of which she has a history. The stories are not so much quotations as a selection of signifiers, where selection is always an interpretation. But the selection is not a collusion or a simple sharing. For an interpretation always

82

involves discomfort, the recognition that something else is at stake, some-
thing other than what we thought we said. Indeed, sometimes the most
devastating interpretation *can* take the form of quotation. Indeed, how can
we more efficiently persecute others than by reminding them of what they
have said? Not that *Interim* persecutes us; but we probably don't feel
comfortable. I am saying that the spectator recognises as her own the
reference to worry – a worry over fat legs, unflattering lighting and so
on. She may not like it, but she recognises her subjection to these signifiers.

Now the grimace and the grin testify not just to the reference to getting
older but also to something that lies behind this; what the signifiers
represent is not just the wrinkles in reality but something absent behind
the wrinkles. The signifiers hollow out spaces and intensify absences. The
spectator realises that signifiers are wanting; there is something that is not
yet signified. In this sense *Interim* points to the absence behind identity.

Perhaps you go to analysis for a fresh identity; perhaps you go to a
feminist exhibition to find positive images. Perhaps you go knowing that
your identity is fictional and hoping for a new one. You make the same point
as the philosophical critique of the fiction of identity, where fiction means
error. But the psychoanalytic critique of the fiction of identity makes a
different point. Psychoanalysis does not tell you that while your present
identity is not really you, matters can be rectified by clothing you in more
fitting attire. You pay your couturier for that original number that will
express your identity, to run up something that is absolutely *you*. You don't
pay the analyst for that. You pay the analyst for the dubious pleasure of the
knowledge of the conditions under which that special outfit which we long to
make our own has become the object of our desire. And that has to do with
producing the place of the object as empty.

After all, what would happen if we demanded positive images? What is a
positive image? It would be as if some images are in deficit of what we want
to identify with as adequate representations. If that were so we would want
to escape from an order of signifiers which we could call a male order, we
would want to free ourselves from imaginary capture by this order and
construct, in accordance with a demand which might be called feminist, a
feminine order of signifiers. This would be to place on *Interim* the demand
that we be captured by a feminine Imaginary, the demand for a feminine gaze
in which we might bask. Perhaps, indeed, what *Interim* does is to whet your

appetite for a feminine ego ideal, for a point of view from which we can feel satisfactory and loved.

But if I am right in drawing together the discourse of the analyst and the space of production of *Interim*, then this promise won't be made good. Certainly the analyst talks, and this artist makes images. But at the limit of the analyst's speech there is silence, and at the limit of this artist's images there is emptiness. They both function to refuse the imaginary capture by a positive world in which identity is *prêt-à-porter*. They both seek to undo the confusion between the object and the ego ideal.

We have gone beyond interpretation and transference love. If interpretation were the goal of analysis, the analyst would simply be the master and I wouldn't be trying to argue that the art practice of Mary Kelly was like the discourse of the analyst. But the analyst vacates the place of the master and becomes the support of the separating *a*. Where is the *objet petit a* in *Interim*? How can a picture interrogate the object of desire and interrupt the movement of desire in its misrecognition of the object? How does *Interim* move from the signifier to something which is radically heterogeneous to it?

Well, there are pictures which give us images as the objects of desire and there are pictures which work at the limit of the image. *Interim* gives us the place of the *objet petit a* at the limit of the image. Which is to say, at the limit of the Symbolic. You might well ask how you are to think of this limit and I will answer by saying that you think the limit through the notion of an apparition. An apparition is both sublime and horrible; an apparition is silent, being outside signification. I think Lacan draws a picture of an apparition in speaking about the *toi* that comes to our lips in an attempt to find the signifier of the remainder, that which cannot be signified. The *toi* is a reference to the Other of *jouissance*, a primal Other, a pre-symbolic Other – a very different Other from the Other of language referred to throughout this chapter. Now this Other of *jouissance* is precisely a reference to *objet petit a*, the lack in the Other of language, the object which must figure in *Interim*. The picture Lacan draws might serve as a model for us:

How can we represent the utterance, the articulation, the surging forth out of our self of this '*toi*' which can come to our lips in a moment of disarray, distress, of surprise in the presence of something that I will not too hastily call death but certainly another singling us out, around whom

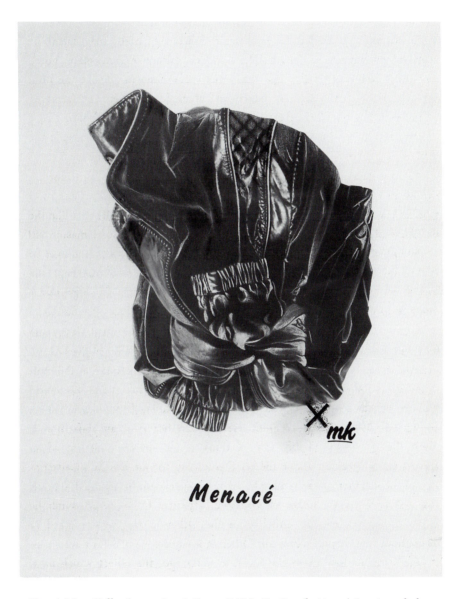

Plate 4 Mary Kelly, *Interim Part I, Corpus* (1984–5). Detail: *Menacé*. Laminated photo positive on plexiglass, 36" × 48".

our major preoccupations turn and who troubles us nonetheless? I do not think that this 'toi' is simple. I think that in it there is the temptation to win over the Other, the prehistoric Other, the unforgettable Other who ventures to surprise us all of a sudden, and to throw us from the heights of his appearing. 'Toi' contains I know not what defence and I will say that at the moment when it is pronounced it is entirely in this 'toi' and not elsewhere that that which I have presented to you in *Das Ding* resides.

(Lacan 1986: 69, my translation)

I think this pictures an apparition. The Other of *jouissance* is awesome, silent and threatening. He troubles us from 'the heights of his apppearing'. His silence is the silence of the pre-symbolic, the silence of the Thing in itself.

Now let me tell you that when Slavoj Zizek, the Slovenian Lacanian, saw one of the leather jacket frames of *Corpus* in my house he let out a yell of terror. Did I expect him to calmly inhabit a room with that Thing in it? It takes an apparition to perturb loyal subjects of the signifier.

How then does *Corpus* produce its effect? Take the images of the leather jacket folded in three different ways. This section called the Body hasn't a body in sight. The body of fashion, the body of medicine, the body of romantic fiction are all absent. Not a fashion model, not a dissected organ, no pair of ethereal lovers. If these images of the leather jacket, these looming presences, yield a body, it is the real body, the awesome, silent *jouissance* of the body. I am saying that the images of *Corpus* take the form of the apparition. When *Corpus* was first exhibited in England the catalogue carried an image from Gray's *Anatomy* which shows the throat in section. Next to it was the second folding of the dress. The juxtaposition is startling. There is a decided resemblance between the folds of the dress and the muscles of the neck but this play between the two is disturbing. The dress is not something that might clothe the neck. Nor is the dress a representation of the throat for all the similarity of lines and wrinkles. When we look at the image of the dress we see neither a wrinkled dress nor a wrinkled throat. What we see are folds, wrinkles, hollowings, marks on the perspex which take on a life of their own, a silent life, precisely outside any signifying network. This is the apparition at the limit of the Symbolic. The field of the signifier is penetrated by something other.

Marks without meaning. We find them again in *Pecunia*. What is going on

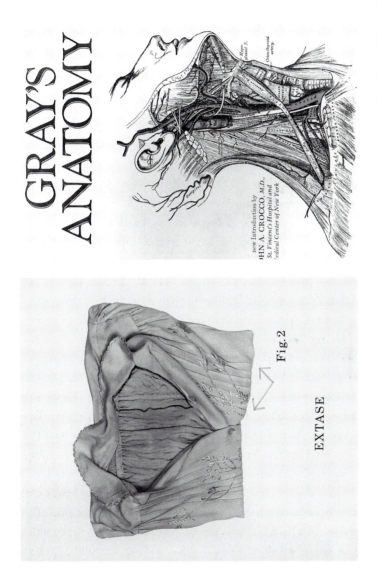

Fig. 2

EXTASE

GRAY'S
ANATOMY

new Introduction by
HN A. CROCCO, M.D.
St. Vincent's Hospital and
edical Center of New York

Plate 5 Mary Kelly, *Interim Part I, Corpus* (1984–5). Detail: *Extase*. Laminated photo positive on plexiglass, 36" × 48".
Plate 6 Mary Kelly, *Interim Part I, Corpus* (1984–5). Detail: *Gray's Anatomy*. Laminated photo positive on plexiglass, 36" × 48".

when we see a word like SOROR punctuating the space of the gallery wall? From SISTER to SOROR to the string of letters S O R O R. From meaning to the letter. From meaning to the dimension of the lost object. For the letter is a signifier emptied of signification; it is the signifier as a mark. We have here a signifier which is not articulated to a system but has the value of a distinguishing mark, a badge. You can also call it a signature, an X. It is like a hieroglyph. It is at the origin of the signifier though it is outside signification; but on its other side it is the mark of the loss of *jouissance*, the mark the subject makes to mark the loss of the object.

Since I have mentioned the signature I cannot resist the temptation to comment on the MK which is found under each of the images of the third set of foldings in *Corpus*, those which make reference to the discourse of romantic fiction. I found this most puzzling. Does the artist's signature endorse something about romantic fiction? Do the knots of the images tell us that Mary has it all sewn up? The MK troubled me – as perhaps it did you. Now I am clearer – the signature has the function of the letter which marks the loss of the object. But nonetheless why do the letters happen to be MK? And why does the signature MK appear in *Corpus* at the point where there is a reference to masochism? For in the set of third foldings there is always a tying – the arms of the jacket tied around itself, the laces of the boots tying one to the other, the sash of the dress knotted around its waist, and so on. I do not think these motifs of masochism lend the images a masochistic appeal. This is *not* a positive image waiting to confound my argument. Masochism can be no more or less of an answer to the question 'What does a woman want?' than any other answer. In masochism the marks of flagellation *do* have an affinity with the *jouissance* of the body. But the masochist offers himself as an object of *jouissance* for the Other; he seeks to complete the Other. The knottings and tyings in these images from *Corpus* do not function in this way; they have the quality of the apparition that puts the image at the limit of signification. These images draw out the inconsistency between the object and the Other by emptying out the place of the object. Mary Kelly's signature endorses the apparition and the lack of the object in the artist herself. The MK in the subject supposed to image.

The artist does not have the object any more than the analyst has it. *Interim* does not provide a perspective from which the spectator can see herself as satisfactory and lovable. Without that perspective what do we see in the mirror? In *Corpus*, the nearest thing to a mirror is the reflecting plane

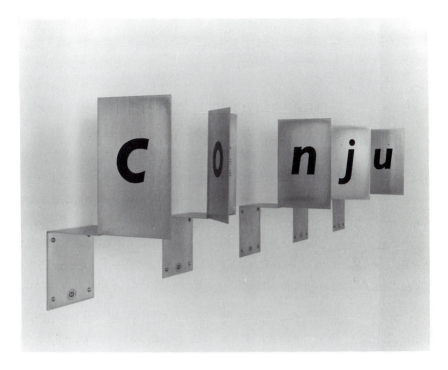

*Plate* 7 Mary Kelly, *Interim Part II, Pecunia* (1988–9). Detail: *Conju*. Screenprint on steel, five units, 16.75" × 16.25" × 11.25" each.

of perspex on which are the laminated photo positives, screen prints and painting. Of course you may see yourself shadowed in the perspex; but what is vivid is the image in which you cannot see yourself reflected, the image pushed to its limit and the empty place of the object given at that limit. The mirror no longer reflects satisfactorily; it produces as apparition the object that cannot be reflected in the mirror. A moment of blindness – the artist's analogue to the moment of the analyst's silence in the talking cure.

These moments allow desire to emerge in the subject. The empty place of the object will come to be occupied by new things among which may be the work of art itself.

'Father, can't you see I'm filming?'

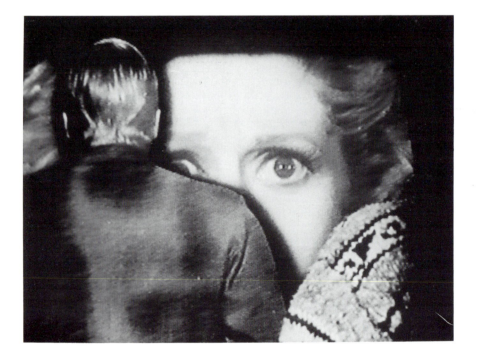

*Plate 8    Peeping Tom*, I.

# 7

# 'Father, can't you see I'm filming?'

What is it to watch a film about perversion? Does such a scenario invariably call up the scopophilia of the spectator? Indeed, does a perverse scene have an advantage over others in achieving this? Clearly much cinema thinks so and plays with a repertoire of incitement not just to look, but to look at a perversion. It is in general a supplementary feature of any perversion to incite a spectator, as if the aura of the perversion is made up of a consumption of vision that demands that a spectator restore the visual energy which is exhausted in the scene. 'Look at me', says any representation of perversion in a structure of fascination. One's eye does not fall on such a representation; it is seized by the representation. It is clear how our horror and enjoyment go together. If we turn away because it is 'too much', we have to ask 'too much of what?'

This has led to the thought that the enjoyment of the film spectator is perverse in so far as it obeys a regime of scopophilia. And even to the thought that perversion is enjoyable in so far as it can be compared with the pleasure of the spectator. But it seems to me that this precisely fails to distinguish between a pleasure and the question of *jouissance*. In order to try to sustain these distinctions I will speak about just one film – Michael Powell's *Peeping Tom* (1960). It concerns a young man, Mark Lewis, who films women as he kills them. At the time the film constituted something of a scandal; one reviewer suggested that it should be flushed down the sewer. But since then it has acquired a certain critical status. Linda Williams (1984) has called it a 'progressive' horror movie, insofar as the woman is permitted a look. And indeed the regime and the economy of 'looking' within the film

and for the spectator is a central issue which I want to address. How are we incorporated into the structure of looking that constitutes the story of the hero?

I want to situate the question of looking within the question of perversion and its relation to *jouissance*. The real title of the film should be 'Father, Can't You See I'm Filming?' For I shall argue that the deadly filming of Mark Lewis is both a defence against and a fulfilment of the *jouissance* of the Other. The film which starts by including us within the perverse scenario gradually creates a separation between us and that scenario by representing the sight and looks of two women. Yet this very representation of the women which separates us from the perversion merely hastens Mark Lewis into the enactment and culmination of its logic.

I have already referred to the Lacanian category of *jouissance*. *Jouissance* of course is not something that exists, or rather it exists as that which is not there, is lost and gone for ever. It is the Real, that which Lacan famously announced is impossible. But that doesn't mean it is irrelevant. It irrupts and disturbs the life of the symbolic order. That which comes to the Symbolic from the Real, Lacan calls *objet petit a*. It functions as a hole and as the cover for a hole; to describe it is to chart the vicissitudes of the lost object. The lost object is the connection between the Symbolic and the Real, and its stake is *jouissance*. The Symbolic and the Real are two heterogeneous orders and yet the Real appears in the Symbolic; this means that though there is no direct, different relation to *jouissance*, we have to deal with the object which is the left-over of *jouissance*. I will add that that *jouissance* isn't very nice, and unlike Mark Lewis, your mother should have warned you against it.

Now *objet petit a* can be misrecognised and can be sought for in different ways. You can hanker after the object, thinking you can have it, in which case you fail to know that the object comes *before* desire, that it is the cause of desire. Or you can hanker after the object thinking that the Other has it, which can be seen in the analysand's expectations in the analytic situation. Or the relation to the object can be one of identification as in the perversions where it is most clearly exemplified in masochism where the masochist becomes or rather therefore *is* the object which ensures the *jouissance* of the Other; you are, in other words, that which ensures that the Other has the object. This is where analysis comes in – you can recognise, as at the end of analysis, the lack of the object in the Other, in other words, that the Other is

incomplete and does not have the object either. En route there, you can identify with the fall of the object as in the *passage à l'acte*, as did the young homosexual patient of Freud's when she jumped onto the railway cutting. Or by contrast, in acting out, you can seek direct access to the object and to *jouissance*, seeking to have the object in reality. This differs from merely hankering after the object in reality because it partakes of that strangeness that made Lacan identify the presence of the Real in the Symbolic.

This shows that the subject is partially determined by these relations to the object. Hopefully, analysis undoes many relations to the object and permits a separation from the object. Perversions such as that which the film unfolds would resist any such separation, so the spectator of such a film may well be placed in an interesting relation to the object.

First, let me tell you something about the film. *Peeping Tom* is the story of a young man, Mark Lewis, who films and who works in a studio as a focus puller. His own cine-camera from which he is never separated is a special object. With it he can film the scenes that he cannot put into words. In these scenes the camera films a murder and is a murder weapon. For one of the tripod legs has a concealed blade at its tip. A victim is filmed as the blade approaches her, the subject being a study in terror. The expression of terror is amplified by the addition to the camera of a reflector, a concave mirror in which the victim watches her own terrified, distorted image which fixes a look upon her face, that as the detective remarks far surpasses the terror normally found on the victim's face. Yet this act never quite works; a *something* is not captured which would mark his own assumption of the role of director. Such a triumphant documentary eludes him; 'the lights always fade too soon'.

This partial and schematic story will readily support your worst fears about the kind of film *Peeping Tom* is. Is it, as Mary Ann Doane asked a decade ago, the kind of film in which, to the detriment of women, 'the dominant cinema repetitively inscribes scenarios of voyeurism, internalising or narra-tivising the film-spectator relationship'? In this argument the man looks and the woman isn't allowed to. Presumably the man looks at the woman and presumably he finds a satisfaction in the target. But Mark Lewis is looking for a *look* which will satisfy his looking and yet it will not give him this satisfaction. Certainly his looking is inscribed in scenes of voyeurism and exhibitionism but there are other inscribed scenarios of looking that are

narratively constitutive of the film. In these it is the woman's look that counts. Or rather, the woman's relation to the look. For the look is the object look and it is the vicissitudes of this object that I want to follow through the film.

The title of the film, *Peeping Tom*, and the appearance of a psychiatrist who speaks of scopophilia are both necessary and misleading. If anything, at the beginning, the film peeps; we peep. But Mark Lewis is primarily an exhibitionist. This is partly to do with his murdering camera with its phallic blade. But it is also because of what he aims to do, which is to produce and to steal a look. For what is the terror he produces? What does it do? It effects the division of the Other to show that the Other has the object. That is to say, that the scene ensures the *jouissance* of the Other, which is the aim in all perversion. Now in exhibitionism and voyeurism the object at stake is the look. When a peeping Tom looks the circuit of the drive only closes when, by a rustle or a movement, he finds himself surprised as pure look. By contrast, the exhibitionist forces the look in the other, through the division of the other. In the end, in the Lacanian doctrine the exhibitionist, too, identifies with the object. But its mechanism allows us to make sense of the distorting mirror in Mark Lewis's scenario and of two crucial scenes later in the film.

It is important, whether it concerns exhibitionism or voyeurism, that the pervert's partner has an eye which is complicit, a fascinated eye. Which reminds us of a story of a failed exhibitionist act told by Theodore Reik (1941) in which the woman exclaims, 'My good man! Won't you catch cold?' She looks and refuses. But what happens when the look is captured? For in seeking to divide the Other the pervert is mounting a challenge to castration. The lack that would appear in the Other will be filled with the object. The exhibitionist's partner with the fascinated eye is complicit with this denial of castration; the look completes the Other, it secures the *jouissance* of the Other. However, it doesn't work with the woman in Reik's story and as we shall see it doesn't work with one woman in the story of *Peeping Tom*.

So Mark Lewis, in his exhibitionist murder scenarios, attempts to experience *jouissance* directly, and in this the film invites our participation. As he stalks his first two victims we are enclosed within his camera's point of view. At this point we are one with a thousand horror films relishing the

threat to the victim at the very moment we identify with her. Then the film veers away from his documentary; it cuts before the murder and it repeats his documentary as an act of repetition and projection in his darkroom. But he does not capture what he had hoped to capture. The film shows us that, as indeed in sadomasochism, what is at stake is something quite different from pain, painful though it is. His aim is to document what Lacan calls the *angoisse* of the Other, that anxiety that touches the Real and puts it in relation with the barred subject. Which is what puts this film at the level of the problem of *jouissance* rather than the imaginary system of pleasure and unpleasure. We as spectators are implicated in this as we are put in the position of wanting to see what it is that Mark Lewis wants to see, though we do not know what he wants to do. Not only do we see through his viewfinder in the first two murder scenes, but at times we share with him his re-viewing the scene in his darkroom. Usually we see his broad back first and the part of his body gives way to the content of the documentary that he has made and this sets up an explicit relay of looks – in which we are looking together at our shared victim. However, the screen is sometimes dominated by his back at the end of his documentary, at the moment when he recognises that he has not captured the ultimate look he wants. Then his body functions to block off the prior scene of perverse anticipation; it operates as the block on perverse seeing. In the replay of the second murder there is an additional figure who acts as a second block. She has this effect for another reason as we will see – she is blind.

The film provides part of the unfinished documentary as another related documentary. Old footage shows Mark Lewis as a boy filmed by his father who also made documentaries. Strong lights wake the boy who is deprived of sleep and privacy by being filmed in states of fear. For his father is represented as a scientist whose study of fear has led him to film his child awakening to find a lizard in his bedclothes, his child at his mother's deathbed, his child watching a courting couple. The footage ends with this happy monster leaving home with a second wife, leaving the boy with a gift – a camera. Obviously the camera can only shoot his father's film, and the son sets off to document a scene which essentially repeats the scene his father documented. The scene which Mark Lewis tries to film, his own primordial *mise-en-scène*, has not to do with the usual senses of primal scene but with intolerable *jouissance*. The promise is that this production will free

him once he has captured it on film. But each murder can only be a rehearsal, for the lights always fade too soon.

In effect Mark Lewis wants to make a documentary which will free him from the torment of his own life. If he can capture something on film he will free himself. It would document the look of terror which someone about to be murdered would exhibit if not only facing death, the victim faced her own face at the *momento mori*. In this scenario we can see the promise of looking and its impossibility. It rests upon the idea of the *completion* of terror in which the subject and the Other, killing and being killed, seeing and being seen, are incarnated in a single object, in a single impossible moment. His murders rest upon the hypothesis that by killing a victim he will have enacted a sufficient sacrifice. But this is impossible and the documentary is only a simulacrum of the documentary that awaits *him* as its completion. The attempt to mimic the Other in order to flee the Other returns him to the place of victim in these sacrifices to the Other. It is a scene that can only be completed when it is correctly cast, when he himself finally takes the lead.

*

The drama concerns the fulfilment of this logic. Two figures, a daughter and her blind mother, live in the flat below him and his darkroom. They precipitate a crisis in the drama and in the spectator's relation to the object look. The daughter (insofar as she mobilises a romantic wish which is split off from his primordial scene) produces the wish in him *not* to make a victim of her, he must not see her frightened or her fate would be sealed. It is this which highlights the inescapability of his perversion and it makes us finally look differently. Meanwhile, his encounter with the mother propels him into his suicide scenario and allows a break in the relay of looks the perverse scenario sets up. I will talk about the daughter first and her first meeting with Mark Lewis which produces this something new that means that he does not want to make a victim of her, this something that finally simply highlights the inescapability of his perverse desire. The film is not explicit about how this situation comes about and I will try to elucidate it.

So the first meeting. We find ourselves looking at a birthday party in full swing and at Mark Lewis looking in through the window at it. The daughter Helen, whose twenty-first birthday party it is, rushes ingenuously into the hall to invite him in but he pleads work and goes upstairs. We see him

watching part of his unfinished documentary (the film of the first murder we have already seen) when there is a knock at the door. It is Helen with a piece of cake for him. She comes in, accepts milk to drink and precipitously asks to see the films he's been watching – as a birthday present. They go into his darkroom and there she learns more than she bargains for from this stranger. Not only that he is the landlord of the house, but that it was his father's house and that this father was a scientist who studied the development of fear in the child. In fact, in his child, in Mark Lewis, and Helen is shown black and white documentation of this. She sees the scene with the lizard. She is frightened and demands to know what the father was trying to do. Finally a party guest comes to take her back, leaving Mark staring at the slice of cake on the table.

Something has happened, of which this description gives no idea. Visually, the scene set in his darkroom and projection room is quite remarkable. It is dimly lit, with high contrast between shadowy, blurred spaces and the sudden violence of spotlights, with deep reds and yellows, a certain grainy quality predominating. Our eyes stumble around it just as Helen does in the dimness and we, too, react to the lights Mark Lewis focuses on her with sudden violence. The scene plays upon the machinery of lighting and filming, the elements producing an echo of his scenario and a faint threat.

This is far from his intent. He sits her down in the very director's chair with his name on it – Mark Lewis – to watch the films of his childhood. Something makes it hard for her to be his victim; something that this scene itself produces. Despite the threatening echo it is something other that is happening. A mutation, in among the partial outlines, shapes, dim spaces and volumes. A mutation to do with what's happening to Mark Lewis which we register through what is happening to us. As in a dream, our position is, as Lacan says, 'profoundly that of someone who doesn't see'. Which is to say that we merge with this scene just as Mark Lewis merges with Helen within it. We could say that this identification founds Mark Lewis's ego and saves Helen from his scenario.[1]

Helen is also associated with a matrix of things to do with his mother. There are clues scattered about – the milk which figures again, the know-ledge that Helen's room was his mother's – but they only fall into place when we take other things into account which are less obviously about the mother, things which refer to what we might call the time of the mother, a

time of the reflection in the mirror, before triangulation, a time of a nascent relation to others and its promise of tenderness. Let us call it the promise of the humanisation of this monster, Mark Lewis.

These scattered clues include Mark Lewis looking in through the ground-floor window of his own house, looking in at the party – what is so familiar to all and so desperately foreign to him – looking in at chatter, laughter, gaiety. He is looking into his childhood home. He finds Helen in his childhood home. Helen is literally and symbolically in the place of his childhood. But more explicit still is the gesture with which Mark Lewis, caught up in the scene in front of him, seems suspended in a response from the past. It occurs twice: once in the second meeting when he makes her his very first twenty-first birthday gift, a dragonfly brooch, and again on their way to dinner when he stands transfixed before a kissing couple in the street. It is a strange gesture where he slowly and tentatively touches his chest almost without knowing it, caught up in another world. In the first scene the gesture occurs as a mirroring of Helen's movements when she holds the brooch up in one place and then another to see where it should go (and it is in the middle of this scene that he strangely asks the question, 'More milk?'). It is a gesture that includes the breast, feeling, and some fledgling relation to others, a gesture that gives us the little there is of Mark Lewis outside his compulsive and near psychotic perversion.

So Helen has a special place. He risks killing her if he photographs her and it is a risk he cannot take. It is not just that she is linked to the faint recollections of his mother; it is that these have been incorporated into something new. The romantic wish does not emerge in a direct way from these links but from an identification with Helen, an identification which founds Mark Lewis's ego. This is the type of identification that is made with someone who has the same problem of desire as oneself. This is true here insofar as the Other is absent in both cases. Helen and her mother, two women and the absence of the father, on the one hand, and on the other, Mark Lewis and his father, two men without the mother.

The way the film conveys something of this founding identification of the ego is by situating Helen at the point of intersection of the Imaginary and the Symbolic. Helen functions as the place of demand, first for a present, then for an explanation of his childhood films and also for help with photographs for the children's book she has written. She is curious and

full of questions about him. An appropriate place where the Imaginary and the Symbolic might intersect. It is a place where Mark Lewis might try to tell his story, dividing himself between his ego ideal, which is the place of the camera, and this alternative place in which his nascent ego might flourish.

In this way Helen stands for the normality, the release from the constant repetition of his scenario, the peace for which Mark Lewis longs. He risks killing her if he photographs her. Which we can now see would also be to lose that little of himself that he has built for himself through her, alongside the perverse structure. Despite this, the project of making the documentary is not displaced. Rather, the effect of the encounter with Helen adds an urgent necessity to the task of finishing the documentary. It remains the only way Mark Lewis can conceive of finding his way to peace. So we must note that Helen is not the place of Mark Lewis's desire. His desire remains elsewhere; it remains coordinated with the camera and with fear, his master signifiers. Helen kisses him goodnight after dinner; he stands there and slowly raises his camera till the lens touches his lips and his eyes close. Helen kisses Mark; Mark Lewis kisses the camera.

What of the spectator in all this? These scenes with Helen work in a quite different way to capture the spectator in a play of perverse looking. They include Helen watching the films of Mark his father made and this time it is Helen's voyeuristic pleasure and her own recoil from it that implicate the spectator. Reynold Humphries has pointed out that when we see the father handing his son a camera:

> The child immediately starts filming those who are filming him, i.e., he points the camera at their camera and, by extension, at the camera of the *énonciation*: at Helen, at us. For her it is too much and she asks Mark to stop the film. Her voyeuristic status is even more clearly revealed to her than at the point where he started to set up his camera to film her. Now the screen is doing what it is not meant to do: it is looking back at her/ us, returning her/our look. . .
>
> (Humphries 1980: 198)

Which is to say that the object look falls. The mechanism which produces this is just one of the number of ways in which Michael Powell harasses us into a certain spectatorial vigilance, a harassment which extends throughout

the film. While this vigilance concerns the separation from the object, a final intervention in the relay of perverse looks is necessary and it is Helen who will figure narratively in the film's definitive intervention.

If Helen is the motive to hasten the complete documentary, her blind mother is the one who is the determination of its suicide form. This mother could be herself quite frightening; certainly, she produces panic in Mark Lewis and there are two uncanny scenes that I want to comment on. The first is her first meeting with Mark Lewis as he calls to collect Helen for dinner. I say 'uncanny' because in dwelling upon it, we dwell upon Mark Lewis's dwelling, from which he is estranged and yet in which he dwells. It is the uncanny of the maternal presence re-presented within his mad-house. It is worth dwelling on the opening moments of the scene which Powell has organised with great care. We see Mark Lewis's face in the hall and we are almost aware next that a veil in front of the camera is being lifted off towards the top righthand side of the screen, first revealing the mother in focus on the sofa on the bottom left of the screen and then Mark Lewis standing on the right. Watching the scene in slow motion reveals something very interesting – what we see through the veil is the face of Mark Lewis in the hall and superimposed within that the image of the mother seated on the sofa in the living room. It is astonishing; it's there and you can hardly see it in real time. There follows a handshake and paced heartbeats on the soundtrack as she holds on to his hand and the beats continue even after she releases it. Again, before leaving, he looks at the back of her head knowing that she knows that he is looking at her. She troubles him deeply, but we've seen nothing yet.

In his projection room, Mark Lewis is watching the film of the second murder, that of Viv; he hears a sound and he switches on the spotlight to reveal the blind mother tripoded against the wall with her stick. This provocative presence in his inner sanctum is threatening. Mark Lewis panics in front of this woman castrated by her blindness but armed with her weapon with its pointed tip. This much is fairly obvious. But what can we say of the look? It is too simple to say that the blind cannot look. What makes the mother a terrifying figure is that she also stands for the object look. For it is not the look the pervert seeks. The aim of the pervert is to make vision and the look coincide; here, we have instead the blind woman as the look, the

look when vision has been subtracted. The look is not locked into the Other; the look falls there. This, of course, is the Lacanian idea of separation.

Now the spectator does not remain unaffected by this woman who stands for castration and the fall of the look. She interrupts our desire to see what Mark Lewis wants to see, by threatening us just as she threatens him. In or out of the perverse structure, we, too, are threatened by castration and the non-coincidence of vision and look. Usually, as Lacan remarks in Seminar XI (Lacan 1977a), the look is the object which most completely eludes castration. Here, the separation of the look unveils castration.

This woman knows and 'sees'. She has 'seen' the darkroom through the nightly visits as she lies in her room below and Mark Lewis remarks that she would know immediately if he were lying. Her 'seeing' is the screen of knowledge that he must pierce through in order to attain his *jouissance*. When she taunts him about what it is he watches all the time, he switches on the film of Viv's murder that her abrupt entry had interrupted. Following the injunction 'take me to your cinema' he leads this blind woman towards the screen. Perhaps this is a test: will she see his secret or will the murder documentary bring reassurance of the truth of *jouissance* and the lie of castration? The test fails him. For the documentary reveals the failure of another 'opportunity' and he moans that the lights always fade too soon.

But this test also fails the spectator, though not for the same reasons. Remember, we have just seen Mark Lewis take the blind woman to his 'cinema'. We are there as before, looking at him looking at the screen. Usually, his broad back gives way to the documentary scene he is replaying, but in this scene this does not happen and he does not open up the space of perverse seeing and share his victim with the spectator. His unseeing back continues to occupy a large part of the screen and the usual relay of looks is interrupted. Moreover, this time there is one more spectator – we are in fact also looking at the blind woman's back as she faces the image of the second victim at the point of death on Mark Lewis's screen (Plate 8). So what do we see? On the upper part of our screen is the upper part of the victim's face with its staring eyes, on the lower left Mark Lewis's back and on the lower right the large coarsely patterned cardigan and hair of the blind mother. It is with this image that the object falls. Paradoxically, we are too much in Mark Lewis's place – the victim is looking straight out at us, identifying us as the place where the camera originally was. Yet he himself is no longer in that

place, since we continue to see him on the screen. Moreover, we see the woman who cannot see, yet with her head turned inevitably to the documentary screen. The circuit of the look then is doubly disturbed. We do not occupy the place from which Mark Lewis now seeks to see what he wants to see and the blind woman *cannot* occupy that space either. While being in the place from which the film was shot, we find the perverse loop of seeing intercepted. The look falls and releases us from perverse looking by disrupting any identification with the two viewers on the screen. They become the blind spots in our wish to see. *The position of the object affects the nature of our desire.*

I cannot but develop my example from Lacan's notion of the fall of the look which he famously illustrates in his account of Holbein's *The Ambassadors* (Seminar XI, Lacan 1977a). Lacan does this through considering the anamorphic moment that allows a glimpse of the reality beyond the illusion of the painting. At the moment of turning away from this painting of worldly success, the strange shape in the foreground suddenly takes on the aspect of a skull, a reminder of mortality. The painting is shown to be merely a signifier; for a moment it fails to elude castration. Now for Lacan, anamorphosis always concerns a certain stretching and distortion but I have argued elsewhere that Lacan's idea of anamorphosis is governed by a phallic metaphor which unnecessarily restricts the conditions under which the reality beyond the signifier is indicated.[2] Here there is no question of a perspectival distortion of any kind, but nonetheless the look falls, the separation of the look unveils castration for us.

But what we learn is not for Mark Lewis. Having failed once more to document the murder scenario he panics and grabs the available opportunity to film, which is of course the mother. He starts and unsheathes the blade, but it won't work. He cannot put this woman into his exhibitionist scenario; her blindness refuses inclusion in the documentary that he continually seeks to complete. In her case the lights have always already failed. Yes, she is frightened, but he cannot get a blind woman to *see* her own terror. How can he escalate the terror and produce the ultimate division without a response to his distorting reflector? She will always be the incomplete Other who is not invested with the object. This marks the moment when he registers that all future opportunities will end in failure. One could say that he realises that the object will not be realised, that the *jouissance* of the Other cannot be

guaranteed. On leaving, the mother talks of 'instinct' and she notes drily that it is a pity that *it* can't be photographed. Here is an other who gives him a consultation and says that 'all this filming isn't healthy' and that he will have to get help, will have to talk to someone.

What is the consequence of all this? Mark Lewis tried to film and kill the mother – 'it's for Helen', as he says to her – in order to finish his documentary. But the encounter with the mother alters only one detail. It is still urgent to finish the documentary, but this encounter determines him to put into operation something he had known he would have to do for a long time, namely to include himself in it as the victim. I have not mentioned the strand of the narrative which introduces detectives into the plot, following on the murder of the stand-in in the studios. But it is clear, psychically as well as in support of the narrative, that he commits suicide not because the police are closing in on him, but rather that he ensures they close in on him because he has decided to commit suicide. They are to be included in the final documentary.

*

The mother and daughter have interrupted the logic of looks that prevailed for us through the murders and have served the narrative function of hastening the final suicide scene. So what about Mark Lewis? Is his last act different from the preceding ones? Does he not stop the chain of murders, the endless series of failed 'opportunities' by sacrificing himself? Is he not bravely turning the cameras and the bladepoint on himself to face what he has hitherto avoided, his own division? Isn't there here some psychical shift, some ethical step?

Let me state my thesis: there is no drama of separation from the object here, only the movement of acting out which by itself changes nothing but which in fact completes it. Mark Lewis does not extricate himself from his dilemma by giving up the hope of the one more time and it will work. He just makes sure the one more time will be the last time; the last time *as* the one more time which works. Now in acting out as it is understood in analysis there is a particular relation to the object. It is at one and the same time an acting *out*, outside, the scene of analysis and an acting for the Other, that is the analyst. Something in the analyst's discourse propels the analysand into acting out. When there is a break in the analyst's discourse, he is no longer

103

there as analyst and we get what Lacan, in his seminar 'L'Angoisse' (1962–3), calls wild transference. Acting out is transference without an analyst; when there is no one to speak to, there is only the Other to act in front of. When the analyst *qua* object leaves the analytic scene, the analysand looks for the object in the real.

Lacan elaborates the concept around a man who thinks he is a plagiarist, a patient of Ernst Kris. Kris reads his book and assures him he is not, but the patient goes straight out to eat cold brains and returns to tell the analyst about it. It is a piece of acting out directed at the Other, which takes place in the Real and is only secondarily put into language. The only point I want to emphasise here is that Lacan reads this as the patient's comment to the effect that everything Kris is saying is true but beside the point, for what concerns him, the patient, is cold brains, the remainder, the *objet petit a*. Acting out could take the form of smelling your analyst. Lacan alludes to smell (*l'odeur*) as object. What is happening if you smell your analyst is an acting out, for the Other doesn't smell.

The question of whether Mark Lewis is acting out or not in the suicide scene is a complex one. One could argue that all perverse scenarios arc actings out and that Mark Lewis's last scenario is not essentially different from all the others. Certainly acting out in analysis can produce innumerable transitory perversions. Acting out is to a large extent like perversion not only in relation to the object but also in relation to knowledge. J.-A. Miller, in his unpublished seminar 'Extimité' (1985–6), talks of acting out as the short-circuiting of the discourse of the analyst. You will recall the diagram for this discourse with its four places of agent, other, production and truth occupied respectively by the analyst as the object, the barred subject, $S_1$ the master signifier and $S_2$ unconscious knowledge (see p.74). The discourse is short-circuited when the analysand tries to obtain the object directly, in reality, without any reference to knowledge ($S_1$ and $S_2$). So acting out is by definition acting outside knowledge and it involves a real object. The difference with analysis is that though it too involves an object as real, it also concerns knowledge, so the object has a relation to knowledge. This difference means that in analysis there is the loss of the object and in acting out there is a solidification of the *bouchon*, for the object in Lacanian theory is both the hole and that which stops it up.

The pervert has also pierced the screen of knowledge and in a more

constant way. For the disavowal that is at the heart of all perversion, as Freud showed, is not just a disavowal of the fact that the mother does not have the penis. It is also a disavowal of the lack of knowledge that preceded the sight of that absence. Jean Clavreul has elaborated this with care in his article, 'The Perverse Couple' (1980). He argues that a lack of knowledge causes the child to look in the first place; the lack of knowledge as the cause of the scopophilic drive. What is disavowed is that the child did not know and wanted to know. Which in turn means that the father is not recognised as having the knowledge before the child. This is how the pervert occupies the position of one who will never again be deprived of knowledge, particularly knowledge about eroticism. Then, as Clavreul says, 'This knowledge about eroticism feels assured of obtaining the other's *jouissance* under any circumstances' (ibid.: 224).

We saw earlier that what the pervert seeks is an eye that is complicit with him, that will turn a blind eye to what is happening, that will remain fascinated and seduced. It is made possible precisely by the short-circuiting of the dimension of knowledge that is co-ordinated with the Other.

So in a sense the pervert is already, always in the place of the analysand who acts out outside the Other and yet for the Other. The last scenario is not distinguished from the others by virtue of being a piece of acting out. Mark Lewis remains a pervert to his deadly end. If anything marks the final scenes, then, it must be its *difference* from acting out. Now if the suicide scene is pure acting out, the scene with Helen which immediately precedes it is quite different. It is the revelation of the distorting mirror, not just to Helen, but for the first time to us. Helen has changed something in Mark Lewis concerning what he desires his relation to knowledge to be. Mark Lewis is doomed, yet there was something in his life he managed to preserve outside this. It is in this scene that Mark Lewis, at the limit of temptation, even while utilising the very instruments of his enjoyment, does not seek complicity from Helen. Hers is an eye that he wishes *not* to fascinate and seduce. He tells his pervert's secret and he knows she will not turn a blind eye. There is no threat to Helen in this scene where he holds the blade at her throat. It is his telling his story in the only way he can – fitfully and in large part in images and actions; but it is a telling all the same, a telling the blind mother had bade him do. So in addition to the documentary he is about to complete, he leaves a story behind. The pity of it is that it in no way

diminishes his own disavowal of knowledge. His acting out remains a one-way ticket with no way back to the Symbolic. Perhaps, if Mark Lewis now knows something new it is that his documentary can never be his return ticket to the Symbolic. The intervention of the women represents the fact that his act, killing, is only a postponement of his destiny. So he goes to meet his solution, his death, and thus to meet his Maker, his father. As the screen darkens, a small voice says, 'Goodnight daddy; hold my hand.'

These are the last words in the film; mine, however, must be about Helen and her part in the scene where she is told the story and confronted with her own distorted reflection in the mirror. Clearly, she survives castration. The mirror is like the Medusa's head and though Helen has to look at it, she then turns her head away. The fascination of the image fails; Helen is not petrified. She is not stiff either with terror or with enjoyment. She fails to be the pervert's partner; she effects a separation from the perverse scenario. The way in which this is achieved also means that we, as spectators, are freed from Mark Lewis's scenario. Once again it is through the fall of the object. Helen awaits Mark in his darkroom and, curious as she is, turns on the projector. We realise what she is looking at as her face registers first disbelief, then dawning horror and finally a choking fear. Mark Lewis enters and fiercely demands that he not see her fear. He agitatedly turns on a whole bank of sound tapes to satisfy her curiosity with his cries and screams when he was five, seven . . . This is the first time that the sound which complements his father's documentary footage has been referred to. And he further tells Helen that all the rooms in the house were and still are wired for sound. Then, on her insistence, he shows her the secret of his scenario – not just the blade, but the concave mirror in which we clearly see Helen's grotesquely distorted image. And simultaneously we hear a dreadful cry such as his first victim had emitted. But Helen is mute and the cry resounds as his own childhood terror in his father's 'scientific' scenarios. It is in the gap between her terror and his, between her grotesque reflection and his bloodcurdling cry, that the object falls. A space bursts open in the seamless scenario which is too close, too present, too full. Our drama is over. Mark Lewis no longer threatens Helen or the spectator. What is left is his enactment of the remnants of the perverse scenario, starring an old Mark Lewis.

'Father, can't you see I'm filming?'

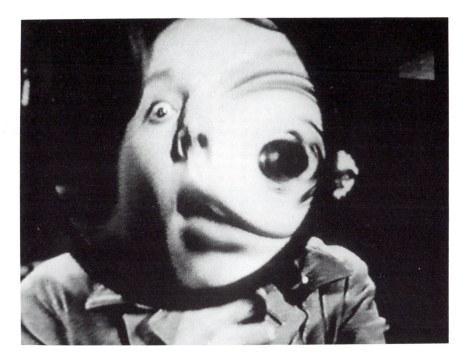

*Plate 9  Peeping Tom*, II.

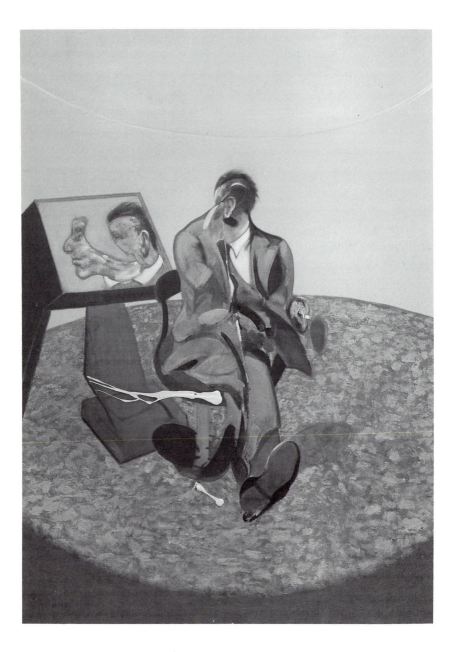

*Plate 10* Francis Bacon, *Portrait of George Dyer in a Mirror* (1967), oil on canvas, 198 cm × 147.5 cm.

# 8

# The violence of paint

In the conversations between Francis Bacon and David Sylvester published under the title *The Brutality of Fact* (Sylvester 1987) Bacon makes several statements about what he thinks art is and about his own ways of making paintings. He rejects illustration and narration and seeks to replace them with what he calls 'matters of fact'. These turn out to be nothing less than sensations that act directly on the nervous system. This allows him to compare the violence of reality in his paintings with the violence of everyday life:

> Isn't it that one wants a thing to be as factual as possible and at the same time as deeply suggestive or deeply unlocking of areas of sensation other than simple illustration of the object that you set out to do? Isn't that what all art is about?
>
> (Sylvester 1987: 56)

> As an artist you have to, in a sense, set a trap by which you hope to trap this living fact alive. How well can you set the trap? . . . I think the texture of a painting seems to be more immediate than the texture of a photograph, because the texture of a photograph seems to go through an illustrational process onto the nervous system, whereas the texture of a painting seems to come immediately onto the nervous system.
>
> (ibid.: 57–8)

Clearly something quite other than representation is at stake. For Bacon, what is important in his own method is the use of what he calls the 'accident'. But this does not diminish his belief in order:

I think that great art is deeply ordered. Even if within the order there may be enormously instinctive and accidental things, nevertheless I think that they come out of a desire for ordering and for returning fact onto the nervous system in a more violent way.

(ibid.: 59)

Indeed the 'accident' is precisely what allows this 'deep' order.

To me, the mystery of painting today is how can appearance be made. I know it can be illustrated, I know it can be photographed. But how can this thing be made so that you catch the mystery of appearance within the mystery of the making? . . . one hopes one will be able to suddenly make the thing there in a totally illogical way but that it will be totally real and, in the case of a portrait, recognisable as the person.

(ibid.: 105)

Bacon's contrived accidents – squeezing paint into his hand and throwing it at the canvas, the use of sponges, the rubbing in of studio dust and so on – allow him to pursue an alternative practice of painting to that of representation. They permit the possibility not so much of the transformation of his figures, but of their *deformation*. This becomes clear in his remarks about Picasso and the cubists.

DS   In the early analytical-cubist pictures it's fairly clear what is happening: you can more or less analyse the dislocations and the relationship of the forms to reality. But when you get to the very late analytical-cubist works, there's a totally mysterious relationship to reality which you can't begin to analyse, and you sense that the artist didn't know what he was doing . . . somehow he was working beyond reason.

(ibid.: 100)

FB   As you say, with early analytical cubism you can just literally see the town on a hill and all that kind of thing – they've just been cubed up. But perhaps in the later ones Picasso knew what he wanted to do but didn't know how to bring it about. I don't know about that. I know that, in my case, I know what I want to do but don't know how to bring it about. And that's what I'm hoping

accidents or chance or whatever you like to call it will bring about for me.

<div align="right">(ibid.: 102)</div>

<div align="center">*</div>

This article puts forward a psychoanalytic hypothesis about the psychical effects of the paintings, starting from Lacan's insistence on the fact that perception is not just an issue of vision, but an issue of desire. The question of perception must take up the problem of what I want to see, and the way in which it structures the gaze which captures me. Instead of thinking of perception as just a visual field, it must be thought of as the field that is structured by the relations and forces of objects and desires. Lacan puts it like this:

> If one does not stress the dialectic of desire one does not understand why the gaze of others should disorganise the field of perception. It is because the subject in question is not that of the reflexive consciousness, but that of desire. One thinks it is a question of the geometral eye-point, whereas it is a question of a quite different eye – that which flies in the foreground of The Ambassadors.
>
> <div align="right">(Lacan 1977a: 89)</div>

The Holbein picture is a masterpiece of theatrical, illusionistic space. It feels as though our vision and pleasure are at one. I enjoy what I see and I see what I enjoy. But it is well known that there is something else. There at the bottom of the picture is something scroll-like. As I move away it comes into perspective as a skull. This phenomenon of anamorphosis involves a projection which is distorted from the point of view of the subject who is perceiving the rest of the picture. Only from another angle can the projection be deciphered. This distortion in fact unhinges the whole point of view. In Holbein's terms, death unhinges worldly pleasures. In Lacan's terms, castration undoes the certainty and given character of visual space. Lacan identifies the oblique form as the annihilation of the subject 'in the form that is . . . the imaged embodiment of . . . castration' (ibid.: 88–9). Usually, I am transfixed by the fascination of the picture. It feels as though I am looking there where I desire to look. But at the anamorphic moment I become aware of something else, that seeing and the gaze within which I am

<div align="center">111</div>

caught are different. The gaze and the picture have become detached in the skull, which stands as the castration of perspective.

For Lacan then the gaze is not an action. It has more the quality of an object. This gaze as object, this gaze detached from the issue of vision, is added by Lacan (along with the voice) to the inventory of fundamental psychoanalytic objects – the breast, faeces, phallus – which are objects in the particular sense that they all materialise fundamental relations of possession and loss. Holbein has detached the gaze from the painting in order to warn against worldly pleasure. Above all, the effect of anamorphosis is to subvert the certainties which are induced by illusionistic space – that is that *this* space is all-inclusive, that this is what there is. Anamorphosis reveals that the condition of this illusion is that there is something hidden *behind* space:

> At issue, in an analogic or anamorphic form, is the effort to point once again to the fact that what we seek in the illusion is something in which the illusion as such in some way transcends itself, destroys itself, by demonstrating that it is only there as signifier.
>
> (Lacan 1992: 136)

In effect the experience of anamorphosis in general is to discover that what we take as 'reality' is based upon a trick, a trick of light. One experiences a momentary headiness, a sudden capacity to think. In going beyond the signifier the subject gains a certain leeway.[1]

Now this idea of the detachment of the gaze is important for my understanding of Bacon, although in my view Lacan's terms need some modification.[2] Both the issue and the modification can be dealt with by considering an issue raised by Ernst van Alphen in his recent book on Bacon (van Alphen 1992). He ends the book by asking to what extent Bacon's paintings might be said to undermine contemporary concepts of masculinity. In particular this concerns the way in which in order for the phallic power of the symbolic order to reign, it is vital that the father's genitals must not be seen. Why? Why not display them? Because they must remain at the level of the signifier. The only way to ensure this is to prohibit the sight of these genitals, for otherwise they might become signifieds. The child might see the flaccid penis of his father and identify with that, with a penis and not with the phallus. This reminds me of something Lacan says about anamorphosis. He suggests

an experiment for his audience: they are to imagine first, a tattoo etched onto a flaccid penis and then the perspective picture that would unfold as it took on its tumescent form. Following the schema suggested by Lacan, we could say that the detumescent penis is connected with the reality beyond the illusion of the signifier. A collapsed detumescent form threatens the filled-out perspectival space and the phallic position. And isn't that just as though the child saw the detumescent penis of the father?

The problem with van Alphen and indeed Lacan's account of perspective, the phallus and the detached gaze is that it remains phallic itself. (This is not van Alphen's intention, but any point-by-point refutation of a theory remains caught in its logic.) In a way they legitimate the phallic by seeing the phallus behind it. In the one case, both masculinity and the undermining of masculinity remain tied to a phallic model, just as in the other case, a certain going beyond the symbolic/phallic order is explained in terms of the rise and fall of the penis. When Bacon and Sylvester agree on the distinction between the early and late analytical-cubist work their thoughts move beyond the phallic metaphor. For the early 'cubed up' works precisely obey a topological transformation that Bacon refuses. When the idea of cubing up fails, so too does the phallic metaphor for anamorphosis. Deformations are not to be measured by phallic transformations. My argument is that nevertheless the detachment of the gaze remains crucial here. If we want to talk about how a *psychical* detumescence is to be achieved, something more than the phallic metaphor is required.

Bacon puts something of this into words through the notion of an appearance which is made to appear by being 'remade out of other shapes':

DS   And the otherness of those shapes is crucial.

FB   It is. Because if the thing seems to come off at all, it comes off because of a kind of darkness which the otherness of the shape which isn't known, as it were, conveys to it.

(Sylvester 1987: 105–6)

It is the image in all its materiality that throws out this darkness, that marks itself by darkness; it is not the other way round, it is not that the darkness gets reflected in the image. In other words, the otherness is that which has remained outside the signifying chain, desired and only dimly seen by the artist and acceded to only with the help of 'accidents' and 'chance' inter-

ventions. All this has to do with the reality behind the illusion of the signifier but it can no longer be explained with a phallic metaphor.

*

To understand the force of Bacon's images we have to understand the way in which they undercut the regime of representation. Now this regime is described by the fact that it ties together my wish to see and what is presented to me, a unity of the scopic field and the spectator. But when the gaze as an object becomes detached from this scene, a dislocation occurs. A gap opens up – the circuit is broken. The illusion of wholeness has been as it were castrated. In fact we can treat Bacon's images as just that – castration erupting within our wish to see, within the scopic field.

To the extent that pictures are narratives, and it must be remembered that Bacon specifically and repeatedly refuses narrative, they depend on the fascination of the spectator, they act as traps for the gaze. But we have seen that it is possible to detach the gaze. Let us now look at an example of this that is not perspectival. A clear and simple example is a 1989 installation by Geneviève Cadieux titled *Hear Me With Your Eyes*.[3] It consists of three very large photographs: the first is a black and white photograph of the head and shoulders of a woman with eyes shut and slightly parted lips; opposite it is a colour photograph of the same woman but there is a greater tension in the lips and the head is represented simultaneously both full-face and in three-quarter profile; finally, on the third wall, forming a U-shape is a third black and white photograph, this time a hugely enlarged pair of slightly parted lips. The spectator feels self-conscious and conscious of being a seeing subject. Why? Because the spectator's relation to the images of the woman is always interrupted by that other spectator, the pair of lips. But they, of course, are *in* the picture. In fact they function as the eye that flies in the foreground of Holbein's *Ambassadors*. The lips serve the function of detaching the gaze so that the spectator's relation to the image is disturbed. This detachment constitutes the object as object of loss, a loss that it is the very function of representation to deny.

Obviously this suggests Bacon's images of screaming heads; I have *Head VI* (1949) in mind. It is a particularly successful version of the paintings of heads with open mouths, teeth/mouths and no eyes really, just a dark hint of sockets. This head neither sees nor sees us. If we were to say that we see *it*,

we would fail to mark the difference of this image. For while we use our eyes, we *hear* the head with them. The scream effects what Deleuze (1984) calls 'the confusion of the scene'. It is the heard scream (which is nevertheless 'seen') which marks the detachment of the gaze. It seems that one of the features of the anamorphic moment is that the confidence in how we sense is shaken and a synaesthetic mobility is introduced. Above all, the day-to-day fluency of the world and our place in it is radically overthrown.

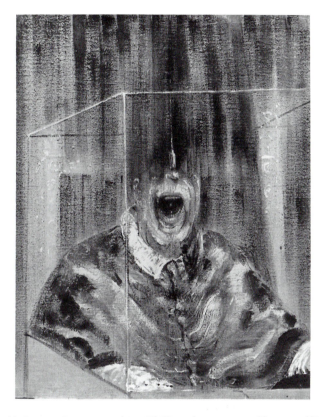

*Plate 11* Francis Bacon, *Head VI* (1949), oil on canvas, 93 cm × 77 cm.

There are of course other ways in which Bacon opens up that gap. The 'mirrors' in his painting, as one might expect, do anything but reflect. They work in the opposite direction of the narcissistic circuit. They recast the mirror as the tain, as the backing of the mirror, as the *surface* of the mirror which is repressed by the operation of reflection, the creation of

space. Van Alphen takes this for granted when he writes of *Figure in Movement* (1978):

> our gaze at the figure is repeated, not mirrored in the mirror. Looking itself, not the object in front of the mirror, is reflected.
>
> (van Alphen 1992: 63)[4]

What is this if not the detachment of the object; the loss of the object; castration? The same theme appears again in *Portrait of Georges Dyer in a Mirror* (1967–8, Plate 10). Van Alphen translates and quotes René Major from an interview on Bacon:

> This negative hallucination is an early experience, for it may also be held responsible for the cry of the infant at the moment he does not perceive the presence of his mother, while at that very moment she is at his side (*alors même qu'elle est à ses côtés*).
>
> (van Alphen 1992: 64)

So *Portrait of Georges Dyer in a Mirror* is also about looking. But instead of a doubling, an addition as in the 1978 painting, here we have the detachment of the object gaze by a subtraction, a vertiginous absence. The gaze detaches itself from the image and detaches *us* from the image.

\*

There are other, more complex ways in which Bacon effects his 'violence of sensation' and his 'matters of fact'. While he is interested in the 'violence of sensation', it is not at all the case that the more violent paintings are the more successful ones. Deleuze (1984) suggests that these violent paintings are the ones that still contain narratives and he instances the two versions of *Study for Bullfight* (both 1969) to make his point. Yet of course, the violence of sensation can also be very powerful and the question of the violence of sensations in Bacon's work is an important point to which we will return. In the two versions of the bullfight studies we have the detachment of the gaze; or rather, we can see the process by which this is brought about in the gap between the two paintings. In the first version there are spectators and hence a story; in the second version the spectators' stand is empty and blank. Of course this immediately puts us as spectators in a different place. Our expectations of a spectacle are disrupted. The emptiness of the stand is

like the unseeing white of an eye. It is this unseeingness that allows the gaze to detach itself from vision.

This stand can be compared to the mirrors that reflect nothing. Indeed the striking ubiquitous black rectangles behind many figures in Bacon may be added in as backings of the mirror. This aspect of the mirror, the black surface, is somehow just beyond the limit of, but is also the condition of, reflection. It is the moment, the point at which the gaze is detached.

This account may seem to overlook the question of the violence of sensation. But in fact this route allows us to form a view about the violence Bacon creates, as opposed to the violence of the world. Nothing could be

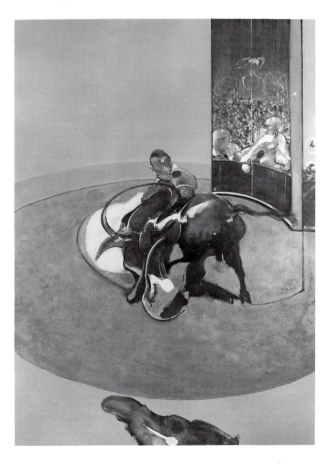

*Plate 12* Francis Bacon, *Study for Bullfight No. 1* (1969), oil on canvas, 198 cm × 147.5 cm.

more bland and obtuse than to use Bacon's work as a narrative about the lamentable violences of the age. The violence which Bacon creates concerns a certain experience of the body and something to do with the horror of a too close presence. This violence can indeed be usefully treated through the question of the detachment of the gaze. It will be that which enables us to distinguish in Bacon's paintings between a violence of painting and the painting of violence. If the violence at stake were a violence against the subject, a masochism, it would only be so by enabling us, even forcing us, to identify, to put ourselves in the place of the object in the same way as the masochist does. But in fact the detachment of the object gaze is the very antithesis of any identification with the object. We can see this in *Triptych* (August 1972) where the artificially produced violence of sensations is almost at a maximum.

In what follows my debt to Deleuze's extraordinarily detailed and perspicacious observations on Bacon is obvious.[5] Here is the passage in which he writes that in Bacon's images the body escapes through the orifices:

> The body endeavours, precisely, or expects precisely to escape. It is not me who tries to escape my body, it is the body which tries to escape itself through . . . In short, a spasm: the body as plexus, and its endeavour or its expectation of a spasm. The whole series of spasms in Bacon is of this type, love, vomit, excrement, always the body trying to escape *through* one of its organs in order to rejoin the flat tinted area, the material structure. Bacon has often said that the shadow has as much presence as the body: but the shadow only acquires this presence because it escapes the body, it is the body which has escaped through one or other point localised in the contour. And the scream (*le cri*), Bacon's scream, is the operation through which the entire body escapes through the mouth.
>
> (Deleuze 1984: 16–17; my translation)

I would put it differently. I would say that what escapes through the orifices is *libido*. The body squeezes itself out, empties itself out. What oozes out is the lamella, the organ of the drive.

Whenever the membranes of the egg in which the foetus emerges on its way to becoming a new-born are broken, imagine for a moment that

118

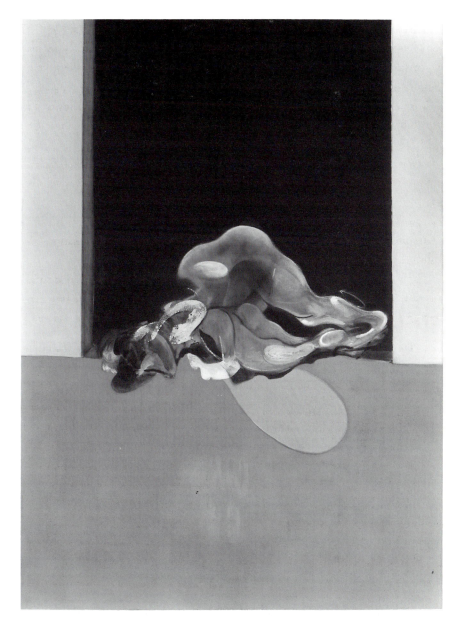

*Plate 13* Francis Bacon, *Triptych* (August 1972), centre panel.

something flies off, and that one can do it with an egg as easily as with a man, namely the *hommelette*, or the lamella.

The lamella is something extra flat . . . it survives any division, any scissiparous intervention.

(Lacan 1977a: 197–8)[6]

I am saying that it is the lamella that is the outcome of Bacon's efforts to avoid narrative and representation and to act directly on the nervous system. Bacon's 'matter of fact' turns out to be the lamella. And I mean you to take this quite literally. Within Bacon's paintings there are, attached to bodies, flat bounded shapes. Usually they are called shadows by commentators. I want to think of them as lamellae. You can see it clearly in many canvases including the *Triptych*. Not all the shadows are 'extra flat' but we can easily take the pink and mauve oozing matter to be the lamella. There is no dearth of flat shadows in other paintings.

What can we say of the lamella and its relation to the gaze? If Cadieux appeals to us to hear with our eyes, what is Bacon asking of us? The answer is that we are being invited to enjoy (*jouir*) with our eyes. In the Holbein a quite different eye (the image of the skull) flies across the foreground at that point in time when one turns away; in the Cadieux there are eyes (the pair of lips) in the space behind you that are directed at the back of your head; in Bacon it is not a question of this time or space, there is a void, an abyss (the lamella).

The void comes about through the body's endeavour to evacuate itself as Deleuze says. What do we have in the triptych? On the one hand, a heavy flux of contorted movement, a mass of wounding colours and jagged edges of the body, and on the other hand, the lamella, smooth, flat colour without volume. Is this not the substance of the living body, now no longer zoned into the senses and criss-crossed by castration? If what is readily available for speech is the violence of these bodies (the violence of sensation), the lamella marks the completion of another process, *dissipation*. Deleuze is right:

there is immobility beyond movement; beyond standing, there is sitting and beyond sitting, lying down, in order finally, to be dissipated.

(Deleuze 1984: 30)

That is to see nothing, *jouir*. One no longer has vision, but the eye lives on. The function of vision has been subtracted from the eye. The violence of

sensation has squeezed out a literal essence of being, the lamella, a puddle of being. To claim that the lamella appears in Bacon's work is to claim that he has taken the detachment of the gaze to its limit. The paintings are as far as possible withdrawn from the painting of everyday life, while yet capturing the 'appearance' of a human being. The violence of the painting is the correlate of the violence of appearing. What is at stake is not violence but paint.

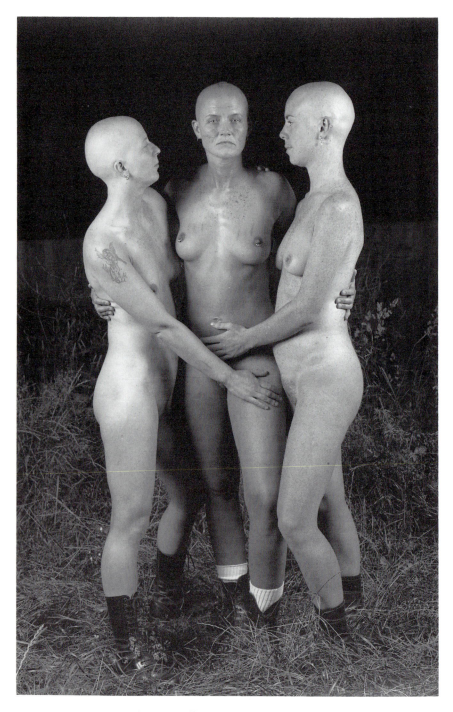

*Plate 14* Della Grace, *The Three Graces.*

# 9

# The three (dis)graces

These women are beyond recognition. For it is within the space of recognition that the representation of women is played out. Even the iconography of the Three Graces is referred to as a classical norm only to mask their own thoroughly uncivilised character. Grace has nothing to do with it.

The women are – what? Unclothed? Naked? What is the word for their condition? What is the name of their bald state? Have they lost adornment with their hair? How do we describe their relation to their tattoos and their boots? Where are they? It is true there is dry grass underfoot. But this is not the ideal landscape and fruitful setting of the Graces. It is out of inky blackness that they loom, tattooed, scarified, pierced. I have the experience of looking at strangers who provoke at the same time a sense of obscure affinity. It is an extraordinary and arresting image.

I want to argue that in fact this photograph can be thought of as at least disturbing the usual ways in which the representation of women operates. The system of this photograph breaks with the meaning of the Woman, the meaning which feminism denounces and disclaims in its destiny of being-object-for-the-male-look. This photograph permits me to think out something of the female subject of the look. If this sounds like a naive conjuring of objects into subjects, so be it. In fact my argument is psychoanalytic, and there is a particular sense of the woman as subject and object. I will argue that in the photograph there is a move away from the woman as object. This allows a female subject of the look, a woman of satisfaction, a woman spectator, and a woman who *makes*.

Della Grace describes this process for herself in phallic terms. Once she

123

photographed dildos, but no longer needs to because she 'has the phallus'. I think something else is going on. I have argued earlier, in 'Waiving the Phallus' (this volume, pp. 49–56), that the phallus is a crucial category for psychoanalytic thought. Its scope covers both male and female psychic life. But that is not because the difference between male and female coincides with the distinction possession/non-possession. Rather, the phallus is the central reference point because *no one* possesses the phallus. Perhaps the reason Della Grace simply *assumes* the phallic character of creation is because that is how creative power is traditionally spoken of. Indeed my problem in this chapter is that precisely those two Lacanian categories which I think help to elucidate the photograph, anamorphosis and sublimation, are themselves caught up in the extension of the phallic metaphor. I hope to show both how these categories are relevant, and at the same time that it is possible to go beyond the phallic metaphor within which they are embedded.

Lacanian theory begins to help me understand the power of Della Grace's image, but at the same time *The Three (Dis)Graces* resist the phallic metaphor. Here is an object that lays down a successful challenge and it is Lacan's conception of art that has difficulty staying aloft. The object interrogates the theory. Far from being explained by the theory, the object points out that the theory has some explaining to do. The object will not be dissected along the lines of the theoretical divisions. It is the difference of the object from the theory that can then be used to theorise anew the newly produced objects of a politics of representation. This is the relation of theory and the object of my chapter.

To understand the relation of women's relation to making and desiring and therefore to changes in this field, we must in fact go back to the psychoanalytic concepts of 'drive' and 'object'. Freud insisted that the drive could only be known through its representations. Beyond that space of representation, the space of primal repression is something beyond sense. For Lacan, beyond the Symbolic is the space of *Das Ding, La Chose, The Thing*; the space that yields the drives.

Now within the domain of representation the way in which drives may be satisfied takes the dream as its model. The dream is the fulfilment of disguised wishes. Of course this implies a series of substitutions, just as the symptom does. But the drive has another model of satisfaction which Lacan calls, though differently from Freud, *sublimation*. The satisfaction of

the drive through sublimation is simultaneously more direct and less direct than that through the substitutions opened by repression. The model for this satisfaction is supplied in *The Four Fundamental Concepts of Psychoanalysis* (Lacan 1977a) when Lacan draws the line of the drive tracing a loop around *objet a* and returning to the erogenous zone. The satisfaction is not purely auto-erotic, yet it is not the biological aim of the drive either. I quote from *The Ethics of Psychoanalysis*:

> The sublimation that provides the *Trieb* [drive] with a satisfaction different from its aim – an aim that is still defined as its natural aim – is precisely that which reveals the true nature of the *Trieb* in so far as it is not simply instinct but has a relationship to *Das Ding* as such, to the Thing in so far as it is distinct from the object.
>
> (Lacan 1992: 111)

Drive is not instinct precisely because the drive relates not only to the object but to that which lies beyond the object. In Lacanian theory the object is both the hole in the Real and the cover for the hole. But it is sublimation that connects the object and the Thing. Lacan conceives of the operation of sublimation as that in which the object itself is raised to the dignity of the Thing.

Now obviously this discussion of sublimation is of relevance to the thought of how women's desire is linked to making objects, of how to think of female creation. But the problem is that as soon as Lacan begins to discuss sublimation his example is of courtly love, a move of sublimation within which the object which is raised to the dignity of the Thing is Woman herself. Lacan, of course, is speaking not of the Woman but of the Lady. Nevertheless, we can ask what Lacan was referring to when he said we still live with the effects of the sublimation of the feminine object. The Woman inherits something from the Lady. She carries within her the effects of courtly love, effects which put her at the place of the object. Before women are allowed to think how they relate to making objects, they are kicked upstairs to the upper case, Woman, to the very place of the object. Before we know it, we are returned to the philosophical tropes in which woman is passive as object or skewed in her sex by being the subject of desire from the point of view of the man.

If sublimation raises the object to the dignity of the Thing, sublimation

becomes a model for art and the Woman becomes the metaphor for art. The Lady was fashioned by the troubadours as an operation of sublimation, as the feminine object. She is adored in her unattainability; like the Thing she is inaccessible; like the drives she is unknowable. Now from the man's point of view this is quite convenient. When the female object becomes the sublimated object, the man can find a relation of both desire and satisfaction in respect to the woman. Because for the man, the drive's trajectory loops around the sublimated object in the movement of satisfaction of the drive and that object *is the woman*. But what can the woman do? Created and sublimated, could *she* create and sublimate? Given her position, the question is not so much Freud's, '*what* does she want?', but '*how* can she want?' She is the object become the Thing. Let us be clear that what is at stake here is the experience of sexual difference, the way subjectivity is propped upon the experience of objects, exemplary among which is Woman as object. Without imagining that we live in continuity with doctrines of courtly love, we may imagine it as an obstacle to an exploration of sexual differences. We still live with the effects of the sublimations of the feminine object.

But we are looking at a photograph. What relation does looking, the scopic drive, have to what has been said so far? The troubadour places the woman there where the object and the Thing intersect. It is not so much that he looks but that the Lady, the object *par excellence*, is what captivates the troubadour. She is the object around which the scopic drive traces its trajectory. Paradoxically, there is satisfaction even there, where the impossibility of the sexual relation is marked. Another way of putting it is to say that there is recognition, a recognition which we deny to woman in Della Grace's photograph. Lacan develops this scopic aspect in Seminar XI (Lacan 1977a) where he speaks of the look as being literally an object, one that takes its place with the breast, faeces, phallus and voice as objects which sustain modes of experience. Looking, here, is not so much a relation or faculty as an object itself. The object look serves to complete the fantasy of unity through which the man completes himself.

What is at stake here is a complicated set of shifts. For me, the question of the representation of the woman is not just her role as the object, but her relation to the object look. For the crucial question is about the way in which the object look might 'fall'. That is, the way in which the object look might be separated from signification, the conditions under which the gap of

the Real opens. The 'fall of the look' is, I argue, crucial for thinking out the possibility of transforming the representation of the woman. What are the ways in which the representation of the woman can be detached or dislocated from the object and its functions? What I am here calling the 'fall of the look' must be distinguished from sublimation, first of all in its economy. I think it falls within the economic situation which is in fact a third form of satisfaction of the drive, Lacan's model for what happens at the end of analysis. Obviously we are not concerned here with that, but I have already argued in respect of the work of Mary Kelly[1] how this situation is rich in suggestions for considering aesthetic experience. Its importance for the politics of the representation of women lies in the way that this fall of the object, the third mode of satisfaction, could allow us to think how the representation of women can be detached from its task of being the object. It is a mode which figures 'the impossible junction of enjoyment with the signifier' (Zizek 1989: 123), where the signifier is itself penetrated with *jouissance*.

To justify these remarks we must return to the stage of courtly love, a scene which Lacan insists we still witness today. Central to his account of courtly love is the mechanism of *anamorphosis*. Why is this idea of anamorphosis, of a distorted projection, relevant? Lacan argues that anamorphosis, as a technique in painting, becomes significant precisely at the moment when the representation of space is mastered. Anamorphosis works in the opposite direction towards the designation of something hidden behind the illusion of space:

> Thus, as I say, the interest of anamorphosis is described as a turning point when the artist completely reverses the use of that illusion of space, when he forces it to enter into the original goal, that is to transform it into the support of the hidden reality – it being understood that, to a certain extent, a work of art always involves encircling the Thing.
>
> (Lacan 1992: 141)

Anamorphosis performs the trick of differentiating the creation of emptiness from the illusion of space. Lacan's own examples include *The Ambassadors* by Holbein and an instrument which Lacan appears to have demonstrated to his audience:

It is formed of a polished cylinder that has the function of a mirror, and around it you put a bib or flat surface on which there are also indecipherable lines. When you stand at a certain angle, you see the image concerned emerge in the cylindrical mirror; in this case it is a beautiful anamorphosis of a painting of a crucifixion copied from Rubens.

(ibid.: 135)

Out of a jumble of unintelligible lines emerges, at a certain point, the Rubens copy. Lacan argues that what is at stake is both the triumph and negation of representation:

At issue, in an analogic or anamorphic form, is the effort to point once again to the fact that what we seek in the illusion is something in which the illusion as such in some way transcends itself, destroys itself, by demonstrating that it is only there as signifier.

(ibid.: 136)

Thus anamorphosis disturbs our relation to the object. What then is the relation of anamorphosis and the object, in terms of its representation? By expanding the category of anamorphosis and in speaking of Cézanne's apples, Lacan argues that the aim of anamorphosis is always to project a reality which is different from the reality (illusion) of the object represented. Objects, these apples, are continuously defamiliarised and seen out of place. In a sense, Lacan is offering up the category of anamorphosis as a support for the modernist project of disturbing the illusions of perspectively organised pictorial space. A gap opens up between the register of the object and the register of the Real. This is relatively clear till we think of the sublimated woman object. Perhaps there is a case to argue that the female nude has always functioned anamorphically, in which the nude endlessly distracts us to see her anew. In which case the woman is being used as the support of a hidden reality behind the illusionistic space. Now it may well be acceptable to the apple to be used in this way. The apple gets to be purified and raised in its dignity. But, and not for the first time, putting the apple and the woman together does cause trouble. In particular, the purification and elevation of the woman puts her at a real disadvantage. The 'achievement' of courtly love was to use woman as the figure which projects another reality

beyond representation. Indeed this 'achievement' of civilisation is one of the things women are up against.

What is the relation between sublimation and anamorphosis? Speaking of the apparatus whose anamorphic projection produces from a certain point of view the Rubens crucifixion Lacan writes:

> yet how can one not be touched or even moved when faced with this thing in which the image takes a rising and descending form? When faced with this sort of syringe which, if I really let myself go, would seem to me to be a kind of apparatus for taking a blood sample, a blood sample of the Grail. But don't forget that the blood of the Grail is precisely what is lacking.
>
> (Lacan 1992: 142)

And towards the end of the same chapter Lacan asserts the connection with sublimation:

> I would like to make my boldest assertion today at this point in affirming that courtly love was created more or less as you see the fantasm emerge from the syringe that was evoked just now.
>
> (ibid.: 153)

So the rising and descending form of the image is evoked in relation to courtly love. This suggests that the fantasm of courtly love emerges from the *transformation* of discourses on love. Lacan points to one formula from Ovid's discourse on love which could be said to have been taken over and transformed in the practice of the troubadours: 'Love must be ruled by Art'. Guess who gets to personify Art.

Having sketched out the mechanism of anamorphosis and noted the collapse of the concept of sublimation onto that of anamorphosis, let us look at the way Lacan conceives of his examples. We find that all his investigations of perspective positions are related to 'phallic erection'. Speaking of anamorphosis in Seminar XI, Lacan says 'I will dwell, as on some delicious game, on this method that makes anything appear at will in a particular stretching' (1977a: 87). And a little further:

> How is it that nobody has ever thought of connecting this with . . . the effect of an erection? Imagine a tattoo traced on the sexual organ *ad hoc*

in the state of repose and assuming its, if I may so, developed form in
another state.

<div align="right">(ibid.: 87–8)</div>

Anamorphic projection seems linked to the rise and fall of the penis. Before
we are tempted to dismiss this phallic metaphor within Lacan's concept of
anamorphosis, we should see if it can't be exploited to good effect.

Remember that Della Grace photographs dildos. What is a dildo? Is it a
substitute for a penis? Is it a representation of the phallus? Prosthesis or
signifier? Why is it difficult to answer? Perhaps because the dildo *is*
anamorphic. Perhaps by not being a version of the penis or phallus, it
shows anamorphically that there is a gap, a gap there, where penis and
phallus are not the same at all. If that were so, then there is something else:
the dildo as phallic signifier is in fact put in the place of the object of
feminine desire. Here we have a representation of feminine desire which *does*
involve going round the phallus as object. Note that the object here is the
phallus rather than the penis, since the anamorphic effect of the dildo is
precisely to sever the connection between the two. The woman as object is
now off the hook. The phallus is hoist by its own petard. Through the good
offices of the dildo, the second mode of satisfaction, sublimation, is open to
the woman. The phallus is now the object where the woman had been. It
inherits that relation of courtly love which puts the sexual relation in
question. Perhaps the phallus properly finds its place here as the last
signifying cover over the gap in the Real. To some it may seem ludicrous
to promote a dildo (but what is a dildo?) to such a philosophical destiny. In
fact there are always consequences of putting any object forward to the place
of satisfaction. To some it will seem too perverse that it is a dildo that frees
the woman as object, by changing places. But why? The dildo did not free
the woman by being a knight errant in the castle of representation.

My argument is that the same displacement of the feminine object is
effected by Della Grace in *The Three (Dis)Graces*. Here we can think of the
anamorphic effect as appearing in the play of looks of the figures. Within
traditional representations the figures look in a line which either circulates
endlessly or where the line of the look travels out of the circle and out to
one side of the frame. In this photograph the figure in the centre seems to
look at us before we register her look. At the same time she remains rooted

<div align="center">130</div>

in her circle. Our eyes have been misled. We can look, but there is no invitation. Rather, our look is seen. This look that sees seems to break the traditional circle around the feminine object. It disrupts the smooth circuit of the scopophilic drive. The path of sublimation is disrupted.

In the case of anamorphosis a break occurs – the scene is divided, the picture is experienced between the world of objects in illusionistic space and the 'reality' behind, which momentarily empties that space. Thus the picture returns to itself to complete us. But with the photograph, the anamorphosis is not a momentary break but a discontinuous object. The look to which we are subjected is made possible by the fact that the women in the photograph figure what Zizek (1989) calls 'the impossible junction of enjoyment and the signifier'. At this point the phallic metaphors for anamorphosis fail – the central figure in the photograph is *not* looking at us. She is the object look whose appearance breaks the normal workings of our scopic drive. She is the object look and as such she is the blind spot in our wish to see. The tables of the Law have turned upon us. Perhaps this explains the hard sense of the archaic in this photograph. In this representation *before* representation there is no need for the woman and the object. In this representation *after* representation the woman and the object have been separated, separated by the detachment of the object look.

Certainly there are signs in this photograph, signs of a graphic life. But like markings found in the desert we do not know what they mean or what order of meaning we would find. Let them stand for the access to *jouissance* that the reduction of the signifier to the letter yields. Of course these archaic suggestions, these letterings upon the body, these are also elements of narrative which could decorate the image. But my point in this chapter is not to fill the image with commentary, but to notice its great work of emptying. *It empties the place of the object.*

This emptying is a work. The image that is produced is not exemplary; it should not become the mark of a representation of the new woman. That would be a phallic move in itself, and the cult of the image would have to repeat the whole story of the object one more time. Freud said that the object was only soldered to the drive. It is difficult to remember it, and to keep the place of the object as open as we can tolerate. Only within that tolerance can new objects emerge.

# 10

# The bald truth

A psychoanalytic account of new sexualities cannot avoid a theory of sexual difference. Any account of the plasticity of sexual behaviour and identities, their transformations over time and social space, can only provide an inventory of sexual possibilities. Now this might serve as a polemical history lesson to the guardians of normality, but it cannot provide a framework for understanding the unconscious significance of sexuality in relation to the sexes.

This was the promise of psychoanalytic theory; yet the promise has been redeemed in so many contradictory ways that it reveals a symptom within theory rather than a theory of the symptom. Is it really the case that the woman is the symptom of the man?[1] Or is woman the name of the symptom within theory? From the beginning of psychoanalysis the theory of sexuality and sexual difference has started out coherently and briskly and remained so as long as it is concerned with the male side of difference. When it moves to the female side of difference the theories themselves act out in extraordinary ways, pursue their own thoughts, start undoing the theory – in sum, seem to have some essential instability. One might ask 'what do theories want?'

Freud's model of sexual difference is the first to account for the difference between boys and girls as a consequence of a differentiation occasioned by the Oedipus complex and the relation to castration. It stresses the original sameness, and it stresses the role of the subject's relation to the phallus. And this account doesn't work. By the time of his last writings on femininity Freud ponders the consequences of the girl's intense, unbroken and ambivalent relation to her mother. In considering what a woman's relation to a man

might be, the 'Femininity' paper (*SE* XXII: 112–35) realises it may be a continuation of the relation to the mother. Such an account is obviously at variance with the phallic model as an account of both sexuality and sexual difference. Post-Freudian thought has had to start from this legacy.

Lacan's own response reflected the ambiguity of the theoretical situation; he produces two accounts of difference in succession.[2] In the first model, rather as in Freud, the woman is different from the man. In the second, the woman is different from *herself*. The excess, the difference within herself which makes herself, is itself conceived as beyond the reach of the phallus and therefore of speech and beyond interpretation. Now it is not a question of choosing between Lacan's two accounts but rather of showing that they are both attempts to answer a question which may need to be reformulated.

In fact the differences between Lacan's two positions are not as great as they seem at first. Nor is his first position nearly as 'Freudian' as it seems. Rather than following the Freudian path from bisexuality to differentiation, Lacan postulates an initial masculinity and femininity which stand in an asymmetrical relation to each other. One way of demonstrating this is that while for Freud castration is equally decisive for both sexes, for Lacan castration does not really concern the woman in herself, beyond the general order of symbolic castration.

The fact is that neither Freud nor Lacan was able to produce a 'phallic' model of female sexuality which is the equal and opposite case of the phallic model of male sexuality. In considering the relation of the woman to the man, Freud says that behind him is the mother. Lacan posits the idea of an 'ideal incubus', a figure in which is combined the 'dead man' and the 'castrated lover'. The figure, quite separate from the man as object, is the figure the woman relates to and in doing so makes the 'appearance' of sexuality possible. By contrast, the man's relation to his object *can* be accounted for in phallic terms. Of course the man does not relate to the woman as woman; rather he relates to the girl-phalluses that lie behind the figure of the female partner. But the man does find the signifier of his desire in the body of the woman. The woman does not; her desire for the man is merely the effect of a *jouissance* she finds elsewhere. The important point, at this stage, is not to assert the truth or falsity of this account, but to underline the failure of a phallic model of female sexuality and hence of the phallic model as such in providing an account of sexual difference. This

demonstrates the radical insufficiency of the well-known distinction between 'having' and 'being' the phallus. If the man 'has' the phallus, does it mean that woman *is* the phallus? Yes, but only from the man's point of view. For her it is a question already of a *jouissance* beyond the phallus, which is what the incubus idea suggests.

The concept of *jouissance* is called upon to play a decisive theoretical role. But clearly there are different kinds of *jouissance*. The phallic *jouissance* of the man, what Lacan calls the *jouissance* of the idiot, is obviously quite different from the woman's *jouissance*. To these differences Lacan adds one more – the Other *jouissance*, a *jouissance* beyond the phallus.

This Other *jouissance* dates from the second of Lacan's models of difference and is given expression in his *Encore* seminar in 1972 (Lacan 1975). It appears at first to be a supplement to the 1958 account. To the extent that the woman is not exhausted by the definition of the phallic, there remains to her a supplementary *jouissance* outside the scope of the phallic. This *jouissance*, which is not phallic, has a relation to the barred Other. This is not the Other that comes as desire, the alterity of desire that relays itself as language and which is sustained by the phallic order. On the contrary, the barred Other is signified by a signifier which does not link to another signifier and which therefore marks a lack, not only in the signifying chain, but in the object itself. She relates to the hole in things that is no longer concealed by language. This *jouissance* is by definition beyond the relation of language and the phallic function.

Is this satisfactory? Let us look at the way in which Geneviève Morel understands the Lacanian position on women. In an article entitled 'Conditions féminines de jouissance' (1993) she gives an account of a woman who enjoyed the *jouissance* of the hysterical symptom, sexual *jouissance* with her husband, and an ecstatic *jouissance*. The woman enjoyed in all three modes. It appears that this may exhaust the possibilities and so explain the woman. Certainly Geneviève Morel has no problem with the doubling of the woman in relation to the phallus on the one hand and the barred Other on the other. Certainly 'difference' is accounted for, but it is a model of difference *as* the woman.

This point can be exemplified by pursuing the Lacanian account of female homosexuality. According to Colette Solers (1993) Lacan argued that female homosexuality should be understood as a heterosexuality. This radical

suggestion is based on an idea that homosexuality and heterosexuality refer *not* to the relational question of the sameness or otherness of the object choice, but to the absolute question of the direction – man or woman. Man is the direction of homosexuality; woman is the direction of heterosexuality. When a woman is desired there is heterosexuality; when a man is desired there is homosexuality. The man is always on the side of the Same; the woman is always on the side of duplicity and doubling. The logical term which permits this whole apparatus of categories to be deployed is the Other *jouissance*, for it is this which is at the heart of the asymmetry of Lacan's second model. It is a testimony to the theoretical failure of the category of the phallus to constitute difference. In the wake of that failure it is always left to women to make the difference.

The paradox in all this is that the fundamental Freudian thrust to produce a theory of difference which was a theory of differentiation rather than the postulation of always already constituted differences, always seems to end up by requiring a feminine supplement. In the rest of this chapter I will argue that indeed difference must be conceived on a phallic model since this was the original non-essentialist promise of Freud. But I will also argue that a reformulation of the concept of the phallus is required if this objective is to be secured. In particular, I shall introduce the category of the dildo as a theoretical object to mark out the polemical direction of my argument. The dildo should clarify the phallus and should insist on its logical priority as *the signifier of the lack in the Other*, without the air of masquerading potency that the phallus still attracts to itself. The category of the dildo briskly frees itself from the reach of penis envy and the grasp of mysticism. Its logical status can be argued to be a non-original source of difference, phallic but non-essential. It exemplifies a certain theoretical situation and I will organise my remarks about this in relation to an image – *The Three Graces* by Della Grace.

These women are beyond recognition. For it is within the space of recognition that the representation of women is played out. Even the iconography of the Three Graces is referred to as a classical norm only to mask their own thoroughly uncivilised character. Grace has nothing to do with it.

These women are – what? Unclothed? Naked? What is the word for their condition? What is the name of their bald state? Have they lost

adornment with their hair? How do we describe their relation to their tattoos and their boots? Where are they? It is true there is dry grass underfoot. But this is not the ideal landscape and fruitful setting of the Graces. It is out of inky blackness that they loom, tattooed, scarified, pierced. I have the experience of looking at strangers who provoke at the same time a sense of obscure affinity. It is an extraordinary and arresting image.

(this volume, p. 123)

I had not quite grasped the state of baldness when I first wrote about this image. What is there about baldness that has to do with castration and what is there that doesn't?

In a paper on the unconscious significance of hair Charles Berg (1936) wrote, 'It is as if the hair were the only phallus we were permitted to *reveal*.' This is one of those propositions which it is easier to see that it is true than it is to see what it means. There are several questions wrapped around each other here. First, there is the question of what may stand in for the phallus. Second, why is it that the phallus reveals itself only through its substitutes? Third, what would it be to reveal the phallus 'as such'? The direction of all these questions tends towards the impossible figure, 'the phallus as such'. The definition 'as such' or 'in itself' immediately destroys the power of the phallus when it is still concealed behind its signification. The 'as such', cut off from any further signification, is in fact the moment when 'the phallus as such' equals castration.

This is less paradoxical than it may seem. Psychoanalysis has long approached the question of symbolisation with an insistence on the ambivalence of symbols that has always irritated others. *X* is allowed to symbolise something and its opposite. Perhaps indeed, the closer one gets to the issue of phallic symbolisation the more strictly this becomes true. Now if matters were simple and hair revealed the phallus, baldness ought to symbolise castration. But the ratio between hair and baldness is complex. Shaving may stand in for the act of castration, but baldness need not. Berg relates the dream of a patient in which, on a second haircut, the barber shaved the scalp into 1" x 4" strips with single hair lines in between. The shaved sections reminded the patient of penises and it was necessary, precisely, to brush flat the single hairs in order to cover the bald patches – for decency's sake (?).

There is a hair's breadth between the hair's exuberant exhibitionism and its function of covering over something in modesty. Likewise for baldness. Baldness exposes the scalp. Is it the phallus that's showing? So there is no visible difference between the emergence of the phallus and the site of castration.

Let us now return to the photographic image. Perhaps the naked bodies and the bald heads suggest a quotation from the erect penis with its prepuce. Now this is not to rush to the frequent interpretation of the female body as a phallus. For this would be to negate the ambivalence of the shaven head. What is at stake is not whether the image is phallic – it is – but what *moment* of the phallus it represents. My argument is that the image corresponds to the moment which in respect of the phallus is, equally, revelation and castration. From the point of view of that which must always be shrouded, it is the moment of turning the light on. This would be a logic of phallic representation which at the same time represents castration. And it is this logic that I want to mark by introducing the category of the dildo. The dildo does not cover over castration but reminds us of it. We will see that the dildo makes a difference to the theory of sexual difference.

With reference to Cindy Sherman's work, Laura Mulvey (1991) speaks of a postmodern 'oscillation' which exposes the fetish while using it. She argues that the spectator oscillates between being captivated by the image and 'seeing through it', recognising the 'set-up'. This seems helpful but it needs to be elaborated psychically. Perhaps there is no need to consider the process as an oscillation; perhaps both terms occur simultaneously. This simultaneous expression of phallic representation and castration is analogous to the signifying equivocation of the Lacanian interpretation. But how could one establish a relation between a photographic image and an interpretation?

The normal sense of interpretation is that it determines the meaning of something less determined. But psychoanalytic interpretation does not concern the narrowing of the scope of meaning. Rather, it is concerned to bring to light the simultaneous equivocation of a signifier. While this produces a maximum identification with the signifier, it also allows, fleetingly, the emergence of the subject's desire.[3] In the same way the photograph operates as an equivocating signifier, with psychical effects.

Iconographically, it plays on the figure of the Three Graces while refuting it. And as we have seen, the simultaneity of this effect is part of a larger simultaneity – that of representations that are simultaneously phallic and castrated – for the women are both phallic and castrated. It is this which puts them beyond recognition.

There is a fierce sense of the *jouissance* of these women but it is a *jouissance* which is not that of the hysteric, or that of the woman with the man, or that of the mystic. Is it then the *jouissance* of the female pervert who is supposed not to exist? I do not think so. The pervading sense of perversion is an effect of the collapse of heterosexuality in this image.[4] For the question of recognition is the question of our desire.

Recognition is a process that may be looked at from two sides. Women who are recognised as such are recognised by a rigorous template of definition. If we do not recognise, in this photograph, these women as women, it is not because they are recognised as something else. It is rather because the structure of recognition has been suspended. We have invoked the category of the dildo to characterise a certain moment in the logic of the phallus, the moment at which the phallic and the castrated combine simultaneously. When this moment is ascendant, although there will be difference the difference in question cannot be controlled as 'having' and 'being'. These terms require the phallus to be deployed as a pure positive term. The 'logic' of the dildo destroys the mutually exclusive either/or. Beyond the recognition of the phallus, the photographic image takes its bearings neither from the schemas of man and woman nor from those of heterosexuality or homosexuality. The image is no longer projected by a lens of gender. It is a dildoic image.

This reformulates the original problem. As we saw, in respect to the phallic model the woman always poses the problem of excess – that which belongs to woman but which escapes the old logic of the phallus. That unmapped excess of the woman (the dark continent) always returns the woman to a principle of a differentiated essence. But this answer was always predicated on what we might call a phallic view of the phallus. What was covered up by covering over the phallus was that it signified lack, a lack

caught by the dildo in a logic and appearance of something which is the phallus as such, that is, castrated. It is not the human who may be castrated, it is the phallus. Who knows what the consequences of this might be for the fetish, for sexual difference and for representation?

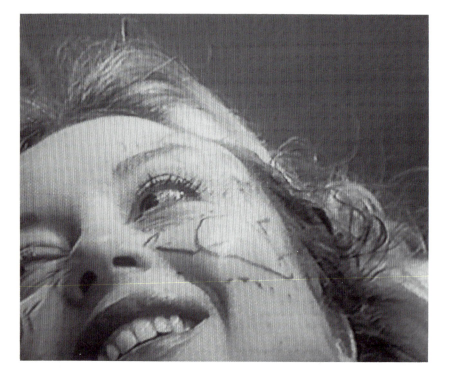

*Plate 15* Orlan, *Omnipresence* I.

# 11

# Operation Orlan

In his seminars on *Ethics* and *The Four Fundamental Concepts of Psychoanalysis* Lacan (1977a, 1992) considers the issue of anamorphosis and its relation to art. The emergence into focus of a distorted image is important because it demonstrates that there are two moments of viewing, not one as it might seem in everyday life. It shows up a gap between those two moments. In Holbein's *The Ambassadors* we see a blur or a skull depending on our point of view. When we see a blur we want to see the painting as a treasure-house of worldly objects. But once we have seen the skull, a gap opens up between it and the blur, which makes the picture incomplete. An object is missing insofar as the Other is now incomplete. This is not simply a moment of deprivation; it is the moment which reveals the structure of the illusion of the image and the subject's wishes in respect to it.

I shall argue that the work of the artist Orlan and her 'pictures' have to do with anamorphosis. I shall also argue that this anamorphosis bears upon sexual difference. But the anamorphosis I have in mind is not of the pictorial and perspectival kind to be found in the Holbein though perhaps this latter falls within what can be identified more centrally as an anamorphosis of space. The usual regime of spatial relations is guaranteed by one crucial condition: that the registers of inside and outside *fit*. This is both a logical and a topological point. Logically, inside and outside must be considered as mutually exclusive and jointly exhaustive. The topological correlate of this is that the inside and the outside *coincide* in an unproblematic form; they are completely isomorphic.[1] Now this isomorphism applies not only to the spatial categories of inside and outside but also to all those infamous pairs

of occidental thinking habits – mind/body, essence/appearance, subject/object, male/female. I shall want to add the pair phallic/castrated. To subject any of these pairs to an anamorphotic process is to reveal the extent to which each term of the pair is *not* in contradiction to the other term and the extent to which the relations between them, far from conforming to a clean-cut isomorphism, are strewn with strange thresholds and hybrid forms. I shall argue that something of this work of anamorphosis is carried out by Orlan.

It is difficult to identify the moment of the 'work' in Orlan's art. There is her body and the records of its transformation through surgery. Her body and the spectacle of its consumption create a kind of *corpus*. Her operations are networked live by satellite and reach a world-wide audience. The operations, in addition to being televised, are directed by Orlan in the aptly named 'operating theatre'. She directs under local anaesthetic to stage a general pain. To give a clearer idea of this I will describe two videotapes – one an operation for liposuction and the other, *Omnipresence*, a facial operation which involved cutting away sections of skin and the installation of implants, not to mention the multiple and gruelling injections. Both tapes involve an almost comic attempt to turn the theatre into a theatre. In the first we read a slogan which oversees the operation 'jamais film aussi abject n'avait sonné aussi pur'. We stare at the theatre gowns designed by Paco Rabanne. There are bowls draped with green and black grapes. And Orlan – Orlan has a model of a crayfish on her left breast and behind her is a large image of a woman. Black and white crosses, a picture of a bare-breasted St Orlan, and paramedics doubling as camera men complete the scene. The drama culminates in the moment of liposuction – the thick tube eases into her flank to the sound of the motor and Orlan's reading aloud from Lemoine-Luccioni's *La Robe*. In fact the only effective dramatic moment is when the doctor's rough movements jolt her, he expresses his concern, she confesses to a little disturbance and she goes on reading aloud.

*Omnipresence* makes a spectacle of her as well, though it is more disturbing and more successful. It is carefully staged, though it is sometimes artlessly propositional. Near the beginning we see lime green masks and red sheets. The supporting cast look strange – a young man in a black mask looks like a wizard but has something to do with television, a translator to translate into English, another who sports a tall lime green hat, is there to sign for the

deaf. But the audience is to be wider than this – not only is the operation to be locally relayed to a New York gallery but to Toronto, Paris, Tokyo and beyond. Wall clocks show the times in different zones. Messages and faxes pour in from as far afield as Latvia. Orlan replies to them. The suspense mounts as Dr Kramer marks Orlan's face with dots to indicate the line of surgical cuts and the sites of implants. Injections follow and the world-wide audience winces. Orlan is asked about this from some end of the world and confesses to some pain.

She sits up, her Issey Miyake dress drawn up to just below her knees. She is serene as she lies down. More injections; she is taped up. Before the first incision she talks on and on . . . her future plans, Graeco-Roman iconography. Her ear has cotton-wool stuffed into it. On and on she talks . . . about champagne. More injections . . . in the ear, in the head . . . a fax from Barbara Rose . . . a fax from Paris says 'Let's give Orlan a hand'.

As the knife cuts she goes on talking . . . about friends. The surgeon cuts for ten minutes, producing a number of flaps – in front of the ear, behind the ear, behind the temple. The ear begins to come away from the face. The body of suffering is produced in the spectator, if not in the patient. Orlan demands that the yellow sheets under her be lifted and displayed. We see a bloody patch which drips. Flaps are enlarged. At last an implant is inserted over the left brow. 'I am very pretty?' she quips.

There is still more. An injection in the neck and a small tube inserted into her face to separate the skin from the flesh. Kramer's finger follows, separating. Now her lipstick is removed so that her lips can be injected. Finally it seems that Kramer can't go on and we are spared any more.

The dominant effect of the video on at least this viewer is horror. The effect of the needles piercing flesh, of the knife severing the face, of the blood leaking from incisions. Above all, the treatment of the face to the point where we see that the face is *detachable*. Finally, the horror at seeing this, at not knowing where all this seeing will end. How are we to understand the provocation of such anxiety in the spectator? Is she mad? Certainly this question filled a special issue of a French journal of mental health.[2]

Cosmetic surgery aims at a refiguration of the face or figure. To this Orlan adds the constraint that the images to which refiguration is directed come from her choice of features from Old Master paintings. She is turning herself into an art historical 'morph'. She is an image trapped in the body of a

woman. When she speaks of 'woman-to-woman transsexualism' that is exactly right. She is changing, not from one thing into another – metamorphosis – but from one register to another. What is at stake is abstraction through *art*, both the art of the image and the art of the scalpel. She claims to be flesh become image.

Refiguration touches on the psychotic. In the case of the man who is convinced he is a woman trapped in the body of a man, the transsexual act is the attempt to avoid psychosis. Yet it involves not the empirical wish to be a woman rather than a man, but the omnipotent denial of sexual difference as such. For frequently the urge to refiguration involves a wish not to become a woman, but to become The Woman.[3] That is, to *become* the phallus through castration. Clearly Orlan works differently. They both submit to the knife, but in Orlan's case it is not to cross the frontier of sexual difference, but as 'a woman-to-woman' transition – that is from her individuality (what we are helplessly *given*) to what she artfully chooses. Now the fact that she uses representations of the same sex doesn't settle the issue of psychosis – she might still be aiming to be The Woman, to become the Phallus with all the help she can muster in the galleries of Western representations of women. Rather, the question of psychosis touches the issue of completeness. By becoming The Woman the transsexual is convinced that he will be complete. Something of this wish informs all desire to be surgically altered. It can be thought of as turning the knife against castration. The question is: where does Orlan's work fit in with this psychotic strain in the denial of sexual difference and the wish to be the Phallus? My own thoughts about this concern, not some pseudo-diagnosis of Orlan ('She must be mad'), but a concern with the effects of her work upon the spectator. How are we to understand this *cosmimesis*? Especially in repect to sexual difference.

The famous debate between Freud and Jones concerned whether a woman is born or made. In some ways the debate has been repeated so often that it has almost lost its meaning; they seem two different routes to the same destination – being a woman. For Orlan these terms seem irrelevant – being a woman is dependent on continuously being born through surgery. Birth and making are conflated in art. Orlan is only the new Orlan. She is a picture whose origin erases the difference between being born and being made. In *Omnipresence* there is a moment which captures this in a literal way. The beginning of her operation starts with the removal of her make-up. It is

'taken off' at the hands of another in a way which prefigures the moment when her 'face' is partially detached from its customary base. She is then remade, reborn, as the image of an image. The first question is: is this the same as the conventional economy which governs cosmetic surgery, of having your face 'fixed', or is this a *cosmimesis* which obeys a different structure?

The economy of cosmetic surgery is always towards completeness. It is not just that one type of nose is preferable to another; it is that only the new nose will complete my image. Until I have surgery I am unfinished. The usual experience of being unfinished is that I am too much myself and too little of the image which will complete me. No matter what strange imperatives drive Orlan to the surgeon's knife, I wish to argue that its effect on the spectator is quite different from the narcissistic optimism of cosmetic surgery. She may become an image, but the image in question is made empty by the operation. Her work shows the emptiness of the image, not the triumph of completeness that the dominion of the image seeks to induce.

In this sense Orlan's work undoes the triumph of representation. During her operation Orlan's face begins to detach itself from her head. We are shocked at the destruction of our normal narcissistic fantasy that the face 'represents' something. Gradually the 'face' becomes pure exteriority. It no longer projects the illusion of depth. It becomes a mask without any relation of representation. In turn this disturbs a fundamental illusion concerning the inside and the outside, that the outside provides a window onto what is represented. In this sense Orlan uses her head quite literally to demonstrate an axiom of at least one strand of feminist thought: *there is nothing behind the mask.*[4]

Indeed feminist criticism has for some time been seized by the problematic of the operating theatre and the dissection of female corpses. Annette Michelson discussed the 1792 *Waxen Venus* of Susini and Ferrini and reproduced it in its three different states in her October 1984 article. Her description of *The Waxen Venus* as the culmination of a tradition of anatomical models is perfectly described:

Her balance, her posture, her ever so-slightly parted lips, her long, gleaming tresses, her pearl necklace, the tasseled silken coverlet upon

which she lies – these and the presence of pubic hair (none of these indispensable for the purpose of anatomical demonstration) – fashion an object of fascinated desire in which the anatomist's analytic is modulated by the lambent sensuality of Bernini. This Venus yields, responds, one feels, to the anatomist's ruthless penetration with the ecstatic passivity of Saint Theresa or the Blessed Ludovica Albertoni to the ministrations of the Holy Spirit.

(Michelson 1984: 11)

This same Venus pops up again on the cover of Slavoj Zizek's *Metastases of Enjoyment* (1994). Now it is without its lid, it is agape with its organs exposed. This figure permits, indeed invites our sexual predatoriness as the response to its passivity. Not only can she be devoured by the eyes; the meal she presents exists layer by layer, course by course. This gustatory penetration of the eye also dictates Ludmilla Jordanova's description quoted in G. Bruno's *Streetwalking on a Ruined Map* (1993). She describes the unveiling of the female corpse in a painting:

A particularly vivid example . . . is the German painting and lithograph of a beautiful woman, who had drowned herself; being dissected by an anatomist, Professor Lucae (1814–1885). . . . A group of men, comprising both artists and anatomists, stand around the table on which the corpse is lying. She has long hair and well-defined breasts. One of the men has begun the dissection and is working on the belly and chest. He is holding up a sheet of skin, close to her breast, as if it were a thin article of clothing so delicate and fine in its texture. . . . The picture leads us to the idea that dissection is itself a process of unveiling.

(quoted in Bruno 1993: 273)

But this whole description of the predatory eye and the layers of the corpse leaves the normal distinction between inside and outside undisturbed. The 'unveiling' version of clinical anatomy in which the woman is a passive structure of layers permits a mapping of the woman's body which in respect to any one layer maintains the distinction between inside and outside. It would persist right down to the microscopic sections of the woman's tissues. By contrast, Orlan is not unveiled or stripped bare. There is no signifying interior to be discovered. Rather, the detachment of her face, a manoeuvre

which reveals it as pure exteriority, is one which casts a doubt on representation, which insists on its emptiness.

Psychoanalysis has often used the distinction between the inside and the outside as an index of and a means for describing mental states. Indeed its entire vocabulary of internalisation and externalisation positively requires not just a description of those conditions but a theoretical justification of the terms. Unfortunately, most psychoanalytic theory is unable to make a problem of these terms, much to the detriment of current conceptions of 'internal space'. For example, in Donald Meltzer's work (1975) on the autistic child, he claims that the autistic child's problem stems from the lack of a clear boundary between the inside and the outside. As an example of the lack of distinction he turns to Tintern Abbey as an architectural ruin which forms a correlate of the lack of distinction. He claims that in its ruin the boundaries between the inside and the outside have become confused. The lack of a roof invites the sky in; through the damaged walls and glassless windows the landscape enters; the grass floor of the ruin belongs to the outside. From without one can 'see through' the building in the many places which would normally convince the eye of its solidity. Meltzer tries to put this into the context of the relation between a geography of phantasy and a geographic type of confusion experienced by the autistic child. He chooses the image of Tintern Abbey as an analogy for the child's mother, a 'paper-thin' mother 'without a delineated inside'. But Tintern Abbey ruined does not work like this. Many buildings in this century, glass houses for instance, invite the sky in, solicit the landscape to enter, deliberately juxtapose the ground and the roof without thereby confusing the inside and the outside. The 'inside' depends on a regime of representation and experience in which it is inferred from the outside as what is isomorphic with the outside. If anything, the ruin of Tintern Abbey strengthens and makes strange the distinction between inside and outside. It is stripped of the clues which clutter the normal regime without destroying it. It strengthens the distinction by making it minimal. Indeed Meltzer's own evidence proves the point when he puts his interpretation to bear on a child's drawing: on one side is 'an ornate house seen from the front . . . a house in Northwood' and on the other side 'a back-view of a pub in Southend'. And he says 'when you enter by the front door you simultaneously exit by the rear door of a different object. It is in effect an object without an inside' (Meltzer 1975: 18). No, it

147

is not; it is a door with two different outsides which do not match any space. It is two incompatible spaces welded onto a door. Tintern Abbey is not a crazy door. What is lacking is space, not an inside, for there is no outside of the door. Or rather the inside is *inside the door* and as such inaccessible. The inside is pure impermeability. There is simply the sequence of objects which lie beyond the door. The child is locked in a relation to a door which can only open but cannot disclose.

We are not here concerned with such disturbance, but in unhinging the very relation between inside and outside which Meltzer demands as the condition of normality. The interest of psychoanalysis is precisely in its demonstration that psychically the condition is *never* met. It insists that far from being complementary opposites, inside and outside rely on a certain coincidence rather than on opposition. We can trace this both in Freud's idea of the *unheimlich* and in Lacan's concept of *extimité*. Mladen Dolar in his article on Frankenstein's monster, 'I Shall Be With You On Your Wedding Night: Lacan and the Uncanny' (1991), claims that Lacan had to make up the term *extimité* because French had no term equivalent to *unheimlich*. You will know that Freud, in his paper 'The "Uncanny"', starts by considering *das Unheimlich* to be the opposite of *heimlich*, but finds he is wrong with the aid of a dictionary. At one point the opposites are identical:

> 'The Zecks [a family name] are all "heimlich".' '"Heimlich"? . . . What do you understand by "heimlich"?' 'Well, . . . they are like a buried spring or a dried-up pond. One cannot walk over it without always having the feeling that water might come up there again.' 'Oh, we call it "unheimlich"; you call it "heimlich". Well, what makes you think that there is something secret and untrustworthy about this family?'
>
> (*SE* XVII: 223)

The word *heimlich* can travel from the comfort and familiarity of the homely and the known all the way to the hidden and the dangerous. It is there that Lacan locates the point of *extimité*. This is how Mladen Dolar puts it:

> It points neither to the interior nor to the exterior, but is located there where the most intimate interiority coincides with the exterior and becomes threatening, provoking horror and anxiety. The extimate is

148

simultaneously the intimate kernel and the foreign body; in a word, it is
*unheimlich*.

(Dolar 1991: 6)

What could be further from a simple opposition between the inside and the
outside? Not only are the terms radically implied in each other, but they
resist all notions of the 'fit' so beloved of psychological and sociological
reasoning. Within such reasoning the subject, a space of interiority, estab-
lishes a relation with the world, a space of exteriority which consists in just
the right amount of internalisation and externalisation for normality to exist
and persist. Linked but separated, the interior and exterior worlds 'fit'
because of a preordained isomorphism. The internal and external spaces are
always already made for each other.

The psychoanalyst Judith Kestenberg uses notions of inside and outside
(internalisation and externalisation) centrally in her case presentations of
girls in the developmental account of the transition from pre-genital stages
to the phallic stage, and from latency to adolescence. This account is
governed by the norm of the sexuality of the adult woman:

> The vagina, as a middle organ with qualities of expansion and shrinking,
> and a readiness to be desexualised when it serves expulsion and to be
> sexualised when it serves reception, is uniquely and sensitively calibrated
> to shift from externalisation to internalisation and vice versa.
>
> (Kestenberg 1968: 257)

We can follow Kestenberg's analytic constructions in the case of Magda,
whom she saw from the age of nine to her early teens. At nine she
experiences an overwhelming excitement (ibid.: 251) but is thought to
have no psychical means to organise her sexuality. Later she is able to
distinguish an outside and inside, and experiences the excitement as belong-
ing to the 'inside'. The inside takes the form for Magda of a box in which
'Sit' hides. 'Sit' is a cripple who tortures Magda with his control of her
inside. Kestenberg interprets 'Sit' as Magda's illusory penis which controls
her inside. Outside, Magda has control, but her clitoral masturbation ('skin
and bones') has no connection with 'Sit'.

Kestenberg shows how within analysis Magda tries to externalise the
excitement. 'Playing delivery' she cannot penetrate far into her uterus

and exclaims: 'He wants to stay there, he does not want the box in which he hides to be broken' (ibid.: 252). Instead of getting into the box (and how does Magda think of this?), 'when you put the tip of your finger there, there is nothing' (ibid.: 252). It seems that there are two problems: 'Sit' doesn't want to come out and there is nothing in there to come out.

The analyst tries to repair this topography. The first move is to lend a sense of structure to the 'nothing' inside. It turns out that Magda does have some sense of the walls of the uterus and their capacity for suction and distension. She also experiences these actions as having effects which are strongly localised. She becomes very excited while playing with puppets during her session. For the experience has made her want 'to experience the vagina as an active, outer organ she could touch and feel' (ibid.: 252). This can be thought of as a transitional moment in the construction of an active inner organ; it now needs to be internalised. What needs to happen now is to work on what might be called the 'fit': 'Sewing clothes for the doll she worked through her worries about the size of the vagina, about its expansion and contraction' (ibid.: 252). The question of scale is important not in terms of cognition but in terms of the psychical representation of the topography of organs. By now Magda has a new representation of the box; it is no longer nowhere. The 'nothing' she encountered is now a scaled object. By providing herself with a stable representation of it, she is calmer. The internal and external worlds have begun to fit round the experience of sexuality which has a scaled topography in which things 'fit'.

Now without criticising this at a descriptive level, there are some notable theoretical conditions to this work. The analysis works as a kind of topographical education. Magda is seen to have a deficit of experience; she does not experience the inside and the outside as she must if she is to accede to a successful femininity. Her account of space needs to be repaired. What is absent from this account is any symbolisation of lack, of the idea of castration. Now it is certainly true that the concept of castration has fallen upon hard times. It has given offence to so many that even within standard analytic work it has moved to the sidelines of theoretical and clinical writing. But for Lacan, as for Freud, it is a central concept. It informs not just an element of the account of sexuality; it defines the very nature of the subject and the object. It is not an optional extra for metapsychology; it is the

150

insistence on lack that constitutes the human order. This world requires a different topology of the subject.

Such an account might take its initial bearings from the Lacanian account of the *object*. This account radically undermines the simple opposition of subject and object, an opposition between a space of human interiority and social objectivity. The subject is always already bound, in Lacan's account, to being the subject of the signifying chain. The object by contrast is not something that is 'meant' or 'referred to' within the order of signification. It is a point of resistance for the subject, something which Lacan calls the left-over of the Real. In this sense the object is not part of the signifying chain; it is a 'hole' in that chain. It is a hole in the field of representation, but it does not simply ruin representation. It mends it as it ruins it. It both produces a hole and is what comes to the place of lack to cover it over.

This is an object quite apart from the commonsense definition of an object. It is not a thing in space. It is not an object which language refers to. Nor is it what psychoanalysis calls the object of desire, that the wish is for this or that, to do which and what with. Lacan's teasing formulation, which so irritates our sense of causality, is that the object is the *cause* of desire. Desire is not directed towards the object; it does not come at the object from behind. Desire is in front of the object. It feels like one of those philosophical questions, 'Can causes come after their effects?' The answer is yes. For the object we are speaking of is not the object of philosophical inquiry but an object of anxiety. As such it occupies a different topological location from an object of desire. The exemplar in psychoanalytic theory is separation from the breast; it is a model for what happens to the interior of the infant when it experiences a separation from an external object, the mother. But what founds this empirical separation as the model of separation? Outside the humanist conception of the separation of lovers, where or when is the separation? What is its action? In his seminar on anxiety (1962–3) Lacan claims that it occurs somewhere between the breast and the maternal body. The breast is still part of the infant and is also part of the mother. Now clearly this is not exclusive to Lacan; it could be part of the object relations description of the mother/infant dyad. But what Lacan is determined to think through is the ruination of the inside/outside distinction which this situation implies. Inside and outside are not exclusive terms. The object, which we philosophically call a breast, is to be conceived both as

151

something from which the infant is to be separated externally at the same time as it is internally separated from it.

Taking something from the adult orally will always awaken the same economy. The double register internal/external corresponds not to an isomorphic anxiety – 'I fear I may be deprived' – but to the fact that the breast is both an object of desire and a point of anxiety in the Other, the anxiety that the mother lacks. Somewhere between the mother and the infant, lack emerges. Lack is not a disease carried by mothers or infants; it is a function of separation.

This thing – the breast – is not just a crucial organ between the mother and child. It is a Freudian 'topos' – a thing around which one teaches various lessons. As such it takes its place around other Freudian objects whose inventory Lacan extends. These objects are not things; they are in part causes, stories and also parts of the body. Freud installs the breast, faeces and phallus. Lacan adds the voice, the gaze and the 'nothing' (*le rien*); *objet du rien* as J.-A. Miller puts it in *Extimité* (1985–6). Now the objects voice and gaze operate at the level of castration and the Oedipus complex, and they are crucial to an understanding of Orlan's art.[5] But first we must address the prior level of 'nothing' as it manifests itself in Magda's case. This is crucial to the interpretation of the problem in Magda of 'lack' and its relation to castration and sexual difference. Magda's 'nothing' does not have a topography. The so-called 'externalisation' turns her lack into a fetish. In this case the girl's response to the Oedipus complex may, contrary to conventional accounts, be taken as a moment when the 'object nothing' is nothing but a substitute; the object always borders on lack, being compelled only to represent itself in one way or another. Viewed from one angle the object, including the 'object nothing', is always a fetish and this object by definition comes to cover over the lack. But the name of what covers over 'nothing' can starkly be called lack. Lack is not a deficit but a structure of a wish-to-complete which includes the denial of incompleteness. It is an economic rather than a phenomenological reality. This structure of the concept of lack means by definition that the lack is neither manifestly 'inside' nor 'outside'. The idea of lack is thus freed from the idea of a deficit or that it is a property of an object or a place. It is a property of the structure as such.

A central issue here is the question of the emptying out of the place of the

object, the moment at which the subject can apprehend the character of the structure and find the leeway to change. Rather than pursue this question through the obscurity of 'nothing', it will be easier to do this through the question of the gaze. When the gaze supports the place of the Other, the girl's castration is covered over. But there can develop a moment when there is an emptying out of the place of the object. The object which covers over the point of anxiety in the Other shifts from its place and a space of lack opens up. As long as the gaze supports the place of the Other everything in the world is seamless and logical. The distinction between phallic and castrated is in place; the distinction between the inside and outside is fixed. But at a certain moment, the anamorphotic moment, the gaze detaches from the Other. Suddenly all these distinctions and their framework collapse. We will see in Orlan's *Omnipresence* that the phallic and the castrated become simultaneous, not mutually exclusive, terms. Such a simultaneity has an important consequence in understanding sexual difference. For to consider the object is by definition to consider difference, including sexual difference. Orlan's work provides a means of thinking this.

But how can Orlan's 'woman-to-woman transsexualism' in her operations bear upon sexual difference? After all, at least in a man-to-woman transsexualism the question of sexual difference is surely put, even if the answer is unexpected in that the phallus is what the transsexual wishes to *be*, and losing the penis is the route to that. Certainly castration is relevant to both. Both use the knife to refigure the body; both seek signification at the price of the body. Indeed, castration is always in the service of meaning. But such transsexualism is nevertheless a way of denying castration and therefore sexual difference. The *Woman* is the uncastrated one, the phallus. But of course in this scheme the phallic and the castrated continue to be poles apart. Not so with Orlan; her 'woman-to-woman transsexualism' does not obey the same logic. It shows that the image is a mask and that there is nothing behind it. The power of her work is here, in the surgical manipulation of her face, rather than in the conscious programme of art historical references which really are no more than rationalisations. It is here on the operating table that castration occurs; not in the act of cutting, not in the drama of the knife, not in the barely suppressed frenzy of it all, but in the space which is opened up. In the space in which the face is unmade. It is the space between the bloodied place which we see all around her ear and the

face as it lifts from its customary base. Something flies off; this something is the security of the relation between the inside and the outside. It ceases to exist. There is, suddenly, no inside and no outside. There is an emptying out of the object. It is the moment, a horrifying moment, of the birth of a new space which ruins habitual space. Orlan's urge to create can be summarised: *Let there be space.*

Of course this is not Orlan's account. Her subjective account is that with each operation she becomes more distant from her body. It is as though she sloughs off her body to enter the pure subjectivity of speech. It is as though the body is surgically severed from speech. You might think she undergoes pain and anguish, but the operation hurts her only a little. True the injections hurt, but aspirin suffices. While lying on the surgical table, what she experiences is the overwhelming desire to communicate. Faxes flood in from Russia, Latvia, Canada and France. She speaks to the 'intellectuals' at the Pompidou Centre. She sets off on the highway of information. But the spectator is forced to tarry in this circus, in this staging of speech, to witness something else, the something else which insists.

The spectator does not gain a divorce from Orlan's body. The effects of what the spectator sees of the exposed cuts and cavities can be best described by recalling Lacan's gloss on a moment in the founding dream of psycho-analysis – Freud's dream of Irma's injection. It is the moment when he looks down her throat:

> what he sees in there, these turbinate bones covered by a whitish membrane, is a horrendous sight. This mouth has all the equivalences in terms of significations, all the condensations you want. Everything blends in and becomes associated with this image, from the mouth to the female sexual organ, by way of the nose – just before or just after this, Freud has his turbinate bones operated on, by Fliess or by someone else. There's a horrendous discovery here, that of the flesh one never sees, the foundation of things, the other side of the head, of the face, the secretory glands *par excellence*, the flesh from which everything exudes, at the very heart of the mystery, the flesh in as much as it is suffering, is formless, in as much as its form in itself is something which provokes anxiety. Spectre of anxiety, identification of anxiety, the final

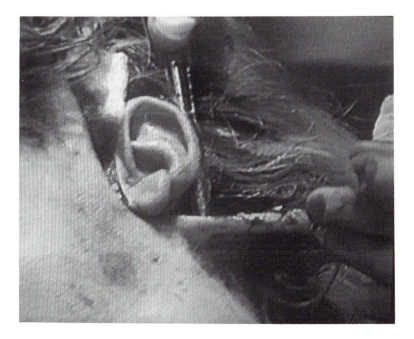

Plate 16 Orlan, *Omnipresence* II.

Plate 17 Orlan, *Omnipresence* III.

revelation of *you are this — You are this, which is so far from you, this which is the ultimate formlessness.* Freud comes upon a revelation of the type.

(Lacan 1954–5: 154)

Orlan as Irma, horrifying us by way of the outer ear.

So while Orlan experiences little pain, she makes sure that *we* experience a more substantial pain. It is the pain of *jouissance.* For Orlan's operation has, for us, the effect of splitting the body from the signifier as a ceaseless re-enactment of castration, from the vantage point of where *it has already happened.* We are confronted with the horrifying spectacle of the rawness of the passion, of the *jouissance* of the body as such, the jubilation of meat. She produces a confrontation with the Real and a fear that we will be swallowed into the full space of plenitude in which there is no room for us. Many spectators will turn away and close their eyes; others will denounce the scene as cruel and horrific. If this were all, they would be right. But these defences cannot obscure the fact that something else has also happened.

This something else is the emptying out of the place of the object as the object gaze detaches from the Other. A gap is opened up in Orlan, a gap which is localised between her curled ear — isolated between expanses of raw and bleeding flesh — and her face. This of course is the opposite of the transsexual's triumphant accession to the phallus. While the phallus sustains representation, the emptying out of the place of the object means that the structure of representation has collapsed. Consider how Orlan produces these effects: on the one hand, with her choice of images of Old Masters, the rhetoric of beauty and the woman, there is a standard phallic representation of the woman's portrait. Yet at the same time there is an eruption from another side which ruins the scene. She works across such a gulf, between the phallic woman and the suspension of the very space in which the phallus can appear. We find ourselves unhinged in a space that refuses to organise an inside and an outside. It is exactly the register of the object, of the left-over of the Real, that Orlan exploits so effectively. She is not simply refiguring herself in the mould of the Mona Lisa's forehead or the lips of Moreau's Europa. She is disfiguring the image; the image comes apart from itself in the surgery.

Nothing 'fits' any longer. Her operation destroys the distinction between the inside and the outside. The inside no longer lies patiently within the

*Plate 18* Orlan, *Omnipresence* IV.

outside, contained and stable and a guarantee that the world is just the world. (This is one reason why spectators get so upset.) She is not the nested Russian dolls that lie within each other, nor is she like the anatomical models with their organs dutifully resting under their lids awaiting your prying eyes. Nor is she like Tintern Abbey. How is this?

Consider the specific moment in *Omnipresence* when the left part of the face begins to come away. From what? Obviously the unseen stuff behind it which we can assume to be just as raw as the exposed flesh that frames the ear above and below. Someone who saw this scene with me remarked defensively that she was not frightened because she 'knew' that the camera wouldn't dwell on the raw stuff. A strange remark, because it *does* dwell on such stuff. *But it doesn't dwell on such stuff behind the face.* There is a boundary which marks off the face from the frame in which it is habitually located. So there is raw stuff on the one side. But what is on the other side? A mask.

*Plate 19* Orlan, *Omnipresence* V.

What the viewer senses and the camera knows is the difference between the space of the Real and the space vacated by the object. The emptying out of the place of the object produces that lack that was described earlier as not manifestly belonging to either the inside or the outside. What is shown is a face as an appearance without essence, an appearance which borrows from famous models. We can't ask what is behind it. At this moment Orlan's point about the mask takes effect. An unfillable gap opens at the moment that the face is lifted.

This emptying out of the place of the object collapses the distinction between inside and outside, a distinction which is a regime. A mask, in the very associations which it calls up, suggests a *face* behind the mask. It does not imply what is relevant here – a *gap*. Her transsexualism with its implants is not concerned to move from one sex to another sex, but to transform the confident *existence* of one sex, the imaginary completion of the body image,

towards the gap in representation which disfigures sexual difference. It doesn't deny it; rather it shows the copresence of the phallic and the castrated that the 'real' world (that is, the world of the Imaginary) insists are exclusive of each other. This belongs not to psychosis but to an artistic labour.

Watching the video up to the moment of the lifting of the mask, the spectator is driven by the suspense of horror. I expect to see something more unspeakable than I have already seen. I am anxious. If Orlan doesn't feel pain, I certainly do. I am invaded by the experience of the body, heavy with its density. But then I am relieved and my watching is freed from anxiety. I did not see what I dreaded. I saw a face become a mask. A gap opened. The lifting of Orlan's face made this gap literal. We are acutely aware of the mask-like character of the face and we apprehend it as an object which will be replaced, refigured. The successive character of the face underlines that there is nothing beneath the mask. Like Cindy Sherman's early work, the series of images is in principle without end. This has the effect of opening onto, or rather circling, a void. So for Orlan there is no original and no end. This is far from those advertisements for cosmetic surgery which employ the structure of 'Before' and 'After' to effect a closure of refiguration. The face which is not original and is not even seeking an end is one that many find difficult to tolerate.

The effects of Orlan's work are not confined to the images on the video alone. Consider her own physical presence, in her conference presentations, in front of the very video image of herself on the screen. The contrast between this Orlan – theatrical and artificial in her long gown, in possession of herself – and the other Orlan, cut, bleeding and supine on the operating table – is stark. This situation of Orlan before Orlan completes the point I have been trying to make. Here the succession of the moments of anamorphosis are presented simultaneously. The gap between the two images empties out the object. It is not that surgery has transformed her, but that surgery has changed our experience of the image. Of course this is only one instance of emptying the image. The space which has opened is radical and has always been there. It is savagely inconvenient. But it is the space which is new from the point of view of knowledge.

# Notes

## 1 Symptoms and hysteria

1 *The Standard Edition of the Complete Psychological Works of Sigmund Freud*, trans. and ed. J. Strachey, London: The Hogarth Press, 1954–74, is referred to throughout as *SE* followed by the volume number.
2 See S. Freud, *Studies on Hysteria* (1895), *SE* II, pp. 288–90.
3 It could be said that though Freud never subscribed to the psychiatric notion of the symptom, nevertheless there was room for a significant development in his concept of the symptom. In this chapter my argument is that it is the development in Freud's own work that is crucial to the identity of hysteria.
4 Freud himself noted in 1905 in *Fragment of an Analysis of a Case of Hysteria* (1905), *SE* VII, p. 24, that Dora was only a case of *petite hystérie*. In 1920, in *The Psychogenesis of a Case of Homosexuality in a Woman*, *SE* XVIII, he finds even less pathology – 'the girl had never been neurotic, and came to the analysis without even one hysterical symptom' (p. 155).

## 2 Per os(cillation)

1 This point is forcefully made by M. Borch-Jacobsen in the first chapter of *The Freudian Subject*, Stanford, CA: Stanford University Press, 1988. I develop it specifically in relation to the hysteric and the instability of her object choice.

## 3 Of female bondage

1 See J. Lacan, 'Propos directifs pour un congrès sur la sexualité féminine', *Ecrits*, Paris: Editions du Seuil, 1966, pp. 725-36; J. Lacan, 'Dieu et la jouissance de la femme', in *Encore, Le Séminaire XX, 1972–3*. Both are translated in J. Mitchell and J. Rose (eds), *Feminine Sexuality: Jacques Lacan and the Ecole Freudienne*, London:

Macmillan, 1982. The question of feminine *jouissance* is also addressed in M. Montrelay, 'Inquiry into Femininity', trans. P. Adams, in P. Adams and E. Cowie (eds), *The Woman in Question*, Boston: MIT Press, 1990, pp. 253-73; trans. from 'Recherches sur la fémininité', in *L'Ombre et le nom*, Paris: Minuit, 1977.

2 See G. Deleuze, 'Masochism: An Interpretation of Coldness and Cruelty', introduction to L. von Sacher-Masoch, *Venus in Furs*, New York: Zone, 1991; J. McDougall, *A Plea for a Measure of Abnormality*, New York: International Universities Press, 1980; J. Clavreul, 'The Perverse Couple', in S. Schneiderman (ed.), *Returning to Freud: Clinical Psychoanalysis in the School of Lacan*, New Haven, CT: Yale University Press, 1980.

3 Entities may be differentiated in different ways. The homosexualities that are traditionally held to be the same from the Greeks to modern times can be differentiated psychoanalytically because it can be argued that Greek 'homosexuality' is not a perversion. Without making the particular theoretical point that I am emphasising, Georges Devereux, the well-known anthropologist and psychoanalytic psychotherapist, has argued just this. See G. Devereux, 'Greek Pseudo-Homosexuality and the "Greek miracle"', *Symbolae Osloenses*, 1967, vol. 42.

4 P. Califia, 'Feminism and Sadomasochism', *Heresies*, 1981, vol. 3, no. 4, issue 12; Samois (ed.), *Coming to Power*, Boston: Alyson, 2nd edn, 1982; P. Califia, *Sapphistry: The Book of Lesbian Sexuality*, Tallahassee, FL: Naiad Press, 2nd edn, 1983.

# 4 Waiving the phallus

1 For a fuller account of separation in analysis see 'The Art of Analysis: Mary Kelly's *Interim* and the Discourse of the Analyst', this volume, pp. 71–89.

2 We can already suspect that equivalences will be rife in Deutsch's account from the very outset where an equivalence is set up in the oral phase between the mother's breast and the father's penis, an equivalence established on the basis of sucking. Both breast and penis will be simultaneously involved in coitus through the action of sucking, with the mother's vagina sucking the father's penis. Both breast and penis are active while the mucous membrane of the mouth is passive. In the anal-sadistic phase the penis is the equivalent of the faeces and so the equation breast-penis-faeces can be set up. These are all sources of stimulation and it is the penis on which the task of stimulating the vagina falls. Not surprisingly, the vagina is assigned the role of the sucking mouth, a role conceived as passive. But at the same time the vagina is also active since it is identified with the penis of the partner – for it takes over the role of the clitoris to the extent that it secretes and contracts. *So the penis is part of the female body.*

Note that all this is so far about coitus only, which for the woman is merely the first part of the sexual act which yields final gratification only through pregnancy

and at parturition. The passive role of the vagina in this first part of the sexual act involves the repetition and mastery of weaning and the repetition and mastery of castration. In coitus there is the fantasy of sucking at the *paternal* penis and 'ultimately coitus represents for the woman incorporation (by the mouth) of the father' (Deutsch 1925: 410).

Deutsch proceeds with an 'identification-series' which she realises may seem 'far-fetched'; certainly it is difficult to follow the steps in her argument which leads to the conclusion that in coitus the woman plays the parts of both mother and child *and* the partner also plays the part of the child.

It would seem that the woman, having overcome weaning and castration, is full with the penis, with the father and with child in the final act of the play which began with coitus.

Deutsch's conflation of woman and mother is best illustrated by a quotation from the same article:

> In its role of sucking and incorporation the vagina becomes the receptacle not of the penis but of the child. . . . The vagina now itself represents the child, and so receives that cathexis of narcissistic libido which flows onto the child in the 'extension' of the sexual act. It becomes the 'second ego', the ego in miniature, as does the penis for the man. A woman who succeeds in establishing this maternal function of the vagina . . . has reached the goal of feminine development, *has become a woman*.
>
> (1925: 411)

If some of the processes that lead to the equivalences are not quite clear, none the less what we have with startling clarity is a picture of *The Mother*.

## 5 The truth on assault

1 Catherine MacKinnon was interviewed on Channel Four by Sheena McDonald, who said that she didn't believe her husband read pornography and that her newsagents didn't stock it and that she herself didn't see any pornographic programmes on television. She didn't feel 'subordinated by sexually explicit material, directly, in my life. How does what you are saying affect me?'

To this MacKinnon replied, 'Well, first of all you didn't cover what happened to her [*sic*] when she was a little girl, a child' (*The Vision Thing*, 25 July 1994).
2 See J. Lacan 1977a; also 'Father, can't you see I'm filming?', this volume, pp. 90–107.

## 6 The art of analysis: Mary Kelly's *Interim* and the discourse of the analyst

1 *Interim* was on show at the New Museum in New York during February–March 1990. *Interim* is made up of four major sections: *Corpus*, *Pecunia*, *Historia*, *Potestas*.

I make reference to the first two: *Corpus* consists of photographs of five articles of clothing laminated onto perspex; each article is presented in three different foldings and each is accompanied by a framed text. *Pecunia* consists of four sub-sections, *Mater*, *Conju*, *Soror*, *Filia*, each consisting of five galvanised steel plates with silkscreened texts.

2 This has appeared in book form: M. Kelly, *Post-Partum Document*, London: Routledge & Kegan Paul, 1983.

3 It should be noted that interpretation could also be conceived as a cut that produces the analysand as subject of desire. Through the equivocation of the analyst's signifiers, the weight of the presence of the object emerges in the gaps between signifiers. So interpretation itself is one of the ways in which the full silence of the analyst is made present. In this chapter, mainly for purposes of exposition, I contrast interpretation and silence.

4 I am grateful to Mladen Dolar for this point which J.-A. Miller first made in an informal seminar in Paris.

## 7 'Father, can't you see I'm filming?

1 I am grateful to Gerry Sullivan for drawing my attention to the passages on Andre Gide and his choice of love object in Lacan's unpublished '*L'Angoisse*, le séminaire X', 1962–3.

2 See 'The three (dis)graces', this volume, pp. 122–3.

## 8 The violence of paint

1 See 'The Art of Analysis: Mary Kelly's *Interim* and the Discourse of the Analyst', this volume, pp. 70–89.

2 For an elaboration of this theme see 'The three (dis)graces', this volume, pp. 122–31.

3 Reproduced in *Passage de l'image*, Paris: Editions du Centre Pompidou, 1990.

4 There is no explicit indication that there is a mirror in *Figure in Movement*. Yet intuitively one feels that van Alphen is right about the dark, black oblong behind the figure in movement. Of course one may think simply that it is his own mistake which he overlooks because the repetition of the figures startles him and thwarts his expectations of some kind of mirror reflection. But I think there is more to it than that and I discuss the mirror function of large areas of black and white in Bacon's work further on in this chapter.

It should be noted that Gilles Deleuze also takes blackness as mirrors: 'Bacon's mirrors are everything one wishes except reflecting surface. The mirror is an opaque, sometimes black thickness (une épaisseur opaque parfois noire)' (G. Deleuze, *Francis Bacon: Logique de la sensation*, Paris: Editions de la Différence, 1984, p. 17).

5 It is Deleuze who has analysed Bacon's work in the greatest material detail and, while his framework is very different from that adopted in this chapter, his text is indispensable for many reasons, including his careful distinction between Bacon and abstract art on the one hand and 'action painting' on the other. While Bacon's 'actions' are very important, it is the deformation of the body that is central to an endeavour where, strangely enough, the recognisability of the person in the portrait is also a goal.

6 The quotation on p. 111 from Seminar XI about the skull in Holbein's painting referred to the 'question of a quite different eye – that which *flies* in the foreground of *The Ambassadors*' (Lacan 1977a: 89; my emphasis). Notice that now it is the lamella that is referred to as 'something that flies off'.

## 9 The three (dis)graces

1 See 'The Art of Analysis: Mary Kelly's *Interim* and the Discourse of the Analyst', this volume, pp. 71–89.

## 10 The bald truth

1 See J. Lacan, 'Seminar of 21 January 1975', in J. Mitchell and J. Rose (eds), *Feminine Sexuality: Jacques Lacan and the Ecole Freudienne*, London: Macmillan, 1982; trans. of 'Séminaire du 21 janvier 1975', *Ornicar?*, May 1975, no. 3, pp. 104–10.

2 The first model dates from 1958 and is elaborated in 'Guiding Remarks for a Congress on Feminine Sexuality' and 'The Meaning of the Phallus', both in J. Mitchell and J. Rose (eds), *Feminine Sexuality: Jacques Lacan and the Ecole Freudienne*, London: Macmillan, 1982. See also J. Lacan, 'The Subversion of the Subject and the Dialectic of Desire in the Freudian Unconscious', *Ecrits*, trans. A. Sheridan, London: Tavistock, 1977, pp. 292–325.

3 These ideas can be represented topologically by the use of a Moebius strip, the single surface that none the less has a right side and a reverse side. On a Moebius surface you can start from a point on the surface and your finger travels to the reverse side and out again to the right side without your losing contact with the surface. For Lacan, a signifier can never be identical to itself since the return to the starting point on the surface is effected via a route that traces the outline of a space that is usually left unrecognised – Lacan's internal eight (*The Four Fundamental Concepts of Psychoanalysis*, London: The Hogarth Press and the Institute of Psycho-Analysis, 1977, p. 270) is the gap of the unconscious and the space of desire. There is no repetition of the signifier outside the space and time of the unconscious.

But the 'cut' of interpretation goes beyond this fact of a repetition that differs from the repeated. In topological terms it is like the cutting of a Moebius strip

along its length, which yields a single structure of two bands with signifying and signified sides, which is not itself a Moebius strip. But the empty space left by the cut takes the shape of a Moebius strip. This newly created, empty Moebius space now functions as the opening of the unconscious. The moment of the cut itself allows desire to emerge just when it disappears again with the maximum identification of the subject with the signifier, which the new structure of the two bands produces. See J. Granon-Lafont, *La Topologie ordinaire de Jacques Lacan*, 2nd edn, Paris: Point Hors Ligne, 1986.

4 This is related to the separation between phallus and penis – see 'Of female bondage', this volume, pp. 27–48.

## 11  Operation Orlan

1 My argument about inside/outside draws on the lectures on *Ugliness* given by Mark Cousins in his Friday morning series at the Architectural Association in London, 1994–5.

2 *Revue Scientifique et Culturelle Santé Mentale*, Sept.–Dec. 1991.

3 See C. Millot, *Horsexe: Essai sur le transsexualisme*, Paris: Point Hors Ligne, 1983; trans. as *Horsexe*, New York: Autonomedia, 1992.

4 See L. Mulvey, 'Pandora: Topographies of the Mask and Curiosity', in B. Colomina (ed.), *Sexuality and Space*, New York: Princeton Architectural Press, 1992.

5 I do not take up the question of the voice in relation to Orlan's work. But it should be noted that speech is privileged in a number of ways, none more striking, if not altogether successful, than the scene of liposuction with the surgeon strenuously handling what looks like a hose inserted into her side and a physically buffeted Orlan bravely staying with a reading aloud of Lemoine-Luccioni's *La Robe*. That text concerns appearances and masks. But what is important is not meaning but articulation. Orlan's voice carries on through all the vicissitudes of the operation. Perhaps neither she nor the spectator actually follows the meaning. It doesn't matter. In a sense her reading is a resolute turning away from the body at the very moment when it is critically involved in surgery. It is a way of ignoring her body. She may well be distracted by the force of the suction machine, she may pause, but her voice resumes.

If Orlan's tactic of the voice works, it is not because we are following the philosophical arguments or receiving new meanings at the expense of the old. After all, if all she wanted to do was to lecture us, she could have saved herself a lot of time and trouble. If this use of the voice works, it is because it divorces her from meaning and designates *her*. It is the hypnotic quality of the voice and not what it is saying that matters. Of course the voice is present, not absent; but we are still talking about the emptying out of the object. We could say that Orlan detaches the object voice from the Other and frees herself from the magnetic effects of the signifying system.

# Bibliography

Adams, P. and Cowie, E. (eds) (1990) *The Woman in Question*, Boston: MIT Press.

Barthes, R. (1976) *Sade, Fourier, Loyola*, New York: Farrar, Straus & Giroux.

Berg, C. (1936) 'The Unconscious Significance of Hair', *International Journal of Psycho-Analysis*, vol.17, pp. 73–88.

Bersani, L. and Dutoit, U. (1985) *The Forms of Violence*, New York: Schocken.

Borch-Jacobsen, M. (1988) *The Freudian Subject*, Stanford, CA: Stanford University Press.

Bruno, G. (1993) *Streetwalking on a Ruined Map*, Princeton, NJ: Princeton University Press.

Califia, P. (1981) 'Feminism and Sadomasochism', *Heresies*, vol. 3, no. 4.

——— (1983) *Sapphistry: The Book of Lesbian Sexuality*, 2nd edn, Tallahassee, FL: Naiad Press.

Clavreul, J. (1980) 'The Perverse Couple', in S. Schneiderman (ed.), *Returning to Freud: Clinical Psychoanalysis in the School of Jacques Lacan*, New Haven, CT: Yale University Press.

Deleuze, G. (1984) *Francis Bacon: Logique de la sensation*, Paris: Editions de la Différence.

——— (1991) 'Masochism: An Interpretation of Coldness and Cruelty', introduction to L. von Sacher-Masoch, *Venus in Furs*, New York: Zone.

Deutsch, H. (1925) 'The Psychology of Women in Relation to the Functions of Reproduction', *International Journal of Psycho-Analysis*, vol. 6, pp. 48–60.

——— (1930) 'The Significance of Masochism in the Mental Life of Women', *International Journal of Psycho-Analysis*, vol. 11, pp. 48–60.

Devereux, G. (1967) 'Greek Pseudo-Homosexuality and the "*Greek Miracle*"', *Symbolae Osloenses*, vol. 42.

Dolar, M. (1991) 'I Shall Be With You On Your Wedding-Night: Lacan and the Uncanny', *October*, vol. 58, pp. 5-23.

Freud, S. (1953–74) *The Standard Edition of the Complete Psychological Works of*

*Sigmund Freud*, 24 volumes, trans. and ed. by J. Strachey, London: The Hogarth Press; hereafter referred to as *SE* followed by the volume number and preceded by the date of original publication.

———— (1895) *Studies on Hysteria*, *SE* II.

———— (1900–1) *The Interpretation of Dreams*, *SE* IV, V.

———— (1905) *Fragment of an Analysis of a Case of Hysteria*, *SE* VII.

———— (1919) '"A Child Is Being Beaten": A Contribution to the Study of the Origin of Sexual Perversions' *SE* XVII.

———— (1919) 'The "Uncanny"', *SE* XVII.

———— (1920) *The Psychogenesis of a Case of Homosexuality in a Woman*, *SE* XVIII.

———— (1921) *Group Psychology and the Analysis of the Ego*, *SE* XVIII.

———— (1926) *Inhibitions, Symptoms and Anxiety*, *SE* XX.

———— (1927) 'Fetishism', *SE* XXI.

———— (1933) 'Femininity', *SE* XXII.

———— (1940) 'The Splitting of the Ego in the Process of Defence', *SE* XXIII.

———— (1940) *An Outline of Psychoanalysis*, *SE* XXIII.

Granon-Lafont, J. (1986) *La Topologie ordinaire de Jacques Lacan*, 2nd edn, Paris: Point Hors Ligne.

Hertz, N. (1985) *The End of the Line*, New York: Columbia University Press.

Humphries, R. (1980) '*Peeping Tom*: Voyeurism, the Camera and the Spectator', *Film Reader*, vol. 4, pp. 193–200.

Kestenberg, J. (1968) 'Outside and Inside, Male and Female' repr. in C. Zanardi (ed.), *Essential Papers on the Psychology of Women*, New York: New York University Press, 1990.

Kress Rosen, N. (1978) 'Hélène Deutsch, une théorie de la femme', *Ornicar?*, vol. 15, pp. 41–57.

Lacan, J. (1962–3) '*L'Angoisse*, le séminaire X', unpublished seminar.

———— (1966) 'Propos directifs pour un congrès sur la sexualité féminine', in *Ecrits*, Paris: Editions du Seuil, trans. in J. Mitchell and J. Rose (eds), *Feminine Sexuality: Jacques Lacan and the Ecole Freudienne*, London: Macmillan, 1982.

———— (1968–9) '*D'un autre à l'autre*, le séminaire XVI', unpublished seminar.

———— (1975) '*Dieu et la jouissance de la femme*', in *Encore, Le Séminaire XX*, Paris: Editions du Seuil, trans. in J. Mitchell and J. Rose (eds), *Feminine Sexuality: Jacques Lacan and the Ecole Freudienne*, London: Macmillan, 1982.

———— (1977a) *The Four Fundamental Concepts of Psychoanalysis, Seminar XI, 1964*, trans. A. Sheridan, London: The Hogarth Press and the Institute of Psycho-Analysis.

———— (1977b) 'The Subversion of the Subject and the Dialectic of Desire in the Freudian Unconscious', in *Ecrits*, trans. A. Sheridan, London: Tavistock.

———— (1977) 'The Direction of the Treatment and the Principles of Its Power', in *Ecrits*, trans. A. Sheridan, London: Tavistock.

———— (1982) 'Seminar of 21 January 1975', trans. J. Rose, in J. Mitchell and J.

Rose (eds), *Feminine Sexuality: Jacques Lacan and the Ecole Freudienne*, London: Macmillan.

———— (1988) *The Seminar of Jacques Lacan: The Ego in Freud's Theory and in the Technique of Psychoanalysis, Seminar II, 1954–5*, trans. S. Tomaselli, Cambridge: Cambridge University Press.

———— (1991) *L'Envers de la psychanalyse, Le Séminaire XVII, 1969–70*, Paris: Editions du Seuil.

———— (1992) *The Ethics of Psychoanalysis, Seminar VII, 1959–60*, trans. D. Porter, London: Tavistock/Routledge.

Laplanche, J. and Leclaire, S. (1966) 'The Unconscious: A Psychoanalytical Study', trans. P. Colman, Yale French Studies, 1972, no. 48.

McDougall, J. (1980) *A Plea for a Measure of Abnormality*, New York: International Universities Press.

MacKinnon, C. (1993) *Only Words*, Cambridge, MA: Harvard University Press.

Mannoni, O. (1964) '"Je sais bien . . . mais quand même": la croyance', *Les Temps Modernes*, vol. 212, pp. 1262–86.

Meltzer, D. (1975) 'Autistic States and Post-Autistic Mentality', in D. Meltzer *et al.* (eds), *Explorations in Autism*, Strath Tay, Perthsire: Clunie Press.

*m/f* (1983) 'Feminine Sexuality: Interview with Juliet Mitchell and Jacqueline Rose', no. 8, pp. 3–16.

Michelson, A. (1984) 'On the Eve of the Future: The Reasonable Facsimile and the Philosophical Toy', *October*, vol. 29.

Miller, J.-A. (1985–6) *Extimité*, Cours de Jacques-Alain Miller, unpublished seminar.

Millot, C. (1983) *Horsexe: Essai sur le transsexualisme*, Paris: Point Hors Ligne; trans. as *Horsexe*, New York: Autonomedia, 1992.

———— (1990) 'The Feminine Superego', trans. B. Brewster, in P. Adams and E. Cowie (eds), *The Woman in Question*, Boston: MIT Press; trans. of 'Le Surmoi féminin', *Ornicar?*, 1984, vol. 29, pp. 111–24.

Montrelay, M. (1990) 'Inquiry into Femininity', trans. P. Adams, in P. Adams and E. Cowie (eds), *The Woman in Question*, Boston: MIT Press.

Morel, G. (1988) 'Conditions féminines de jouissance', in *L'Autre Sexe*, La Cause Freudienne, Paris: Navarin Seuil.

Mulvey, L. (1991) 'A Phantasmagoria of the Female Body: The Work of Cindy Sherman', *New Left Review*, no. 188, pp. 136–50.

———— (1992) 'Pandora: Topographies of the Mask and Curiosity', in B. Colomina (ed.), *Sexuality and Space*, New York: Princeton Architectural Press.

*Passage de l'image* (1990) Paris: Editions du Centre Pompidou.

Reik, T. (1941) *Masochism in Modern Man*, New York: Grove Press.

Riviere, J. (1929) 'Womanliness as a Masquerade', *International Journal of Psycho-Analysis*, vol. 10; repr. in V. Burgin, J. Donald and C. Kaplan (eds) *Formations of Fantasy*, London: Routledge & Kegan Paul, 1986.

Safouan, M. (1990) 'Is the Oedipus Complex Universal?', trans. B. Brewster, in P.

Adams and E. Cowie (eds), *The Woman in Question*, Boston: MIT Press; trans. of chapter 8 of *Etudes sur l'Oedipe*, Paris: Seuil, 1974.

Samois (ed.) (1982), *Coming to Power*, 2nd edn, Boston: Alyson.

Silvestre, M. (1987) 'Le Transfert', in *Demain la psychanalyse*, Paris: Navarin.

Solers, C. (1993) Freudian Field Seminar on Feminine Sexuality, held at the Centre for Freudian Analysis and Research, London, summer 1993.

Sylvester, D. (1987) *The Brutality of Fact: Interviews with Francis Bacon*, 3rd edn, London: Thames & Hudson.

van Alphen, E. (1992) *Francis Bacon and the Loss of Self*, London: Reaktion Books.

Williams, L. (1984) 'When the Woman Looks', in M. A. Doane, P. Mellencamp and L. Williams (eds), *Re-Vision*, Washington: American Film Institute.

Zizek, S. (1989) *The Sublime Object of Ideology*, London: Verso.

——— (1994) *Metastases of Enjoyment*, London: Verso.

# Index